PUBLIC FACES
PRIVATE PLACES

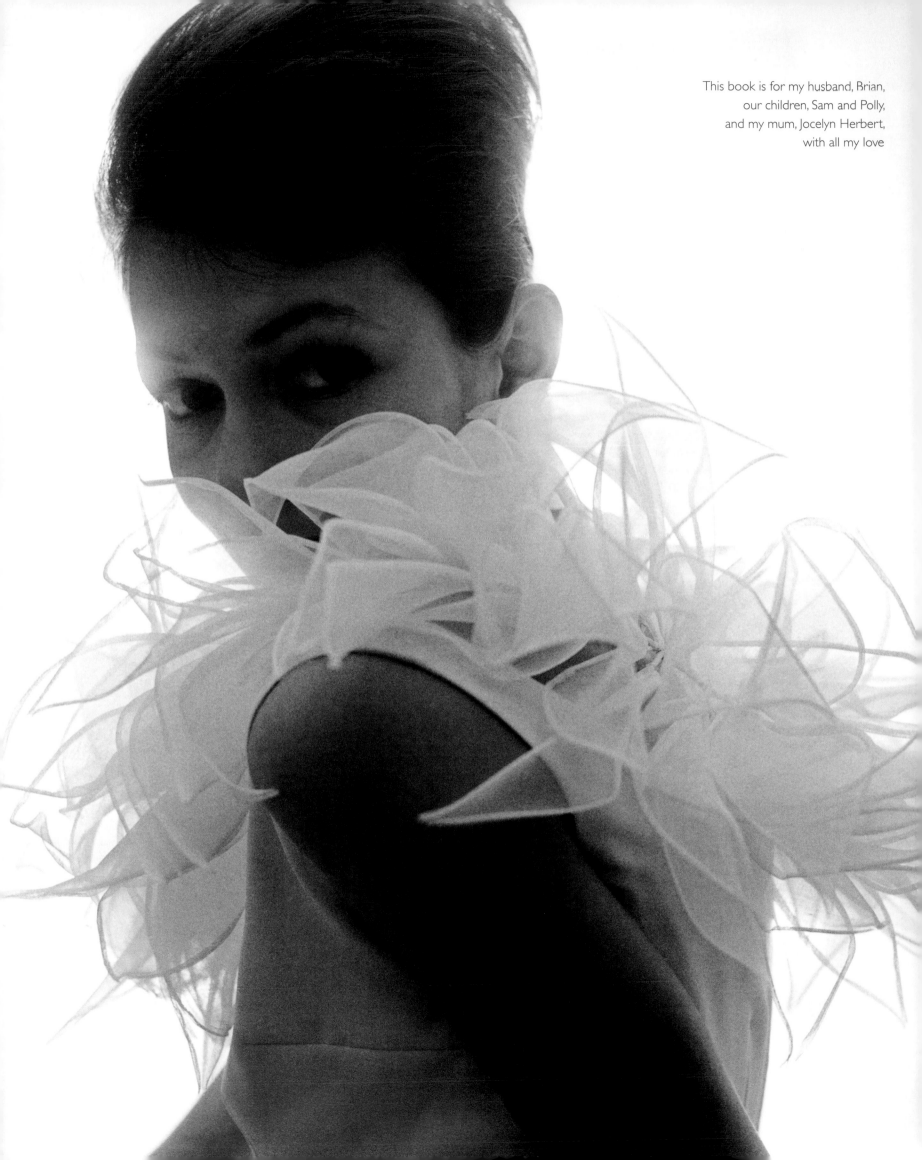

This book is for my husband, Brian,
our children, Sam and Polly,
and my mum, Jocelyn Herbert,
with all my love

PUBLIC FACES
PRIVATE PLACES

Portraits of Artists 1956–2008

Sandra Lousada

F

FRANCES LINCOLN LIMITED
PUBLISHERS

INTRODUCTION

Sandra Lousada owes her career in part to a present she found in her Christmas stocking the year she became sixteen – a *Schoolgirls' Diary* whose pages included a list of career suggestions. Most required more than her single 'O' level, but she read that she was qualified to learn photography. It dawned on her that perhaps the camera was the tool that could solve the dilemma of how to earn a living; even more importantly, it might provide a means to forge the creative language she longed for. The following year she enrolled on a photography course at the Regent Street Polytechnic.

Public Faces Private Places records some of what happened in the following fifty years, as photography became a passion and Sandra grew to be one of the most respected professionals in her field. The selection here draws her portraits together in unusual juxtaposition, embracing individual sittings, her documentation of theatre performances and films in the making, a taste of her extensive contribution to magazines and books, and a sample of her successful advertising work. While her expertise on advertising campaigns meant that sometimes her images were hugely magnified on roadside hoardings, many of her editorial magazine photographs appeared small-scale, shifting on the page to accommodate the texts they accompanied. This book affords these often powerful images proper breathing space and allows us to pay attention to the quality, personality and perceptiveness of the eye which captured them.

The teenage Sandra's acute awareness of the need to find a means of self-expression stemmed partly from the good fortune of her childhood. She grew up alongside the River Thames on Chiswick Mall – the perpetually changing mood of the water and its reflected light playing no small part in the formation of her visual alertness – among a community of neighbours that included the painters Julian Trevelyan and Mary Fedden, film and theatre director Tony Richardson, and actors Michael Redgrave and Rachel Kempson and their children. Within sight, its garden almost tipping into the river, was the house where Sandra's grandfather, the writer and Independent MP A.P. Herbert, lived with his wife, Gwendolen, a talented painter and musician and a formidable personality in her own right. Sandra's father was the solicitor Anthony Lousada, whose clients included Barbara Hepworth and the Royal College of Art. He was also Chairman of the Trustees of the Tate Gallery, and enjoyed taking his children privately round the collection outside opening hours. Her mother was Jocelyn Herbert, who had trained with Michel Saint-Denis and George Devine at the London Theatre Studio before the Second World War; Herbert put her career on hold while her children were young, but joined Devine's company at the Royal Court Theatre as a scene painter in 1956, developing into one of Britain's leading theatre designers in parallel with Sandra's own career.

Painting and theatre were a constant theme as the Lousada children – Sandra, her two sisters and a brother – grew up, whether in the form of the art that hung on the walls of the family home, of first night outings to their grandfather's hit musicals, such as *Bless the Bride* and *Tough at the Top*, or of overheard conversations among the group surrounding George Devine and Tony Richardson as they laid the groundwork for what became the English Stage Company.

It was a world in which great value was placed on commitment to work of a high calibre and, although there was plenty of fun – Thames expeditions on A.P. Herbert's boat the *Water Gipsy*, seaside picnics on holidays in Wales with Alec Guinness's extended family – whether the task was painting, writing, directing or designing it was approached with integrity. A.P. Herbert's musicals were lighthearted but his politics were not (for instance, his intervention in parliament was the main force behind important changes made to modernize the divorce laws), and George Devine's ambition to create a playwright's theatre was spurred in part by his frustration with the shallowness of West End drawing-room comedies. Within the first years of its creation in 1956 the English Stage Company had put on the work of Arnold Wesker, Ann Jellicoe and John Osborne, plays whose contemporary social content and styles of presentation radically challenged the temper of British theatre and of audience expectation.

Sandra absorbed these values. When she set out with her camera, it wasn't with the aim of becoming famous. Her focus has always been on fulfilling the brief and on working as part of a team to deliver what was needed rather than on creating a professional persona whose identity was stamped on her photographs at the expense of their subject matter or the client's requirements. This restraint of ego has been an asset, allowing her style to develop almost subconsciously so that, as this book shows, her identity emerged through the body of her work rather than by calculated imposition. It may also have been something of a disadvantage, as the coherence and value of her output has not, until now, been properly celebrated.

We, the onlookers, have also to some extent been deprived, as Sandra's respect for other people has many times stopped her from photographing them 'off duty', so we can only imagine the images she didn't take – of Samuel Beckett playing (seriously competitive) chess with Gwendolen Herbert, or Peggy Ashcroft relaxing during her stays in Jocelyn Herbert's Hampshire cottage, Andrews Farm (rescued from ruin with Jocelyn's earnings from her work on the film of *Tom Jones*). The attitudes inherent in her upbringing have been as constant in Sandra's life as the buildings of her childhood – her uncle still lives in A.P. Herbert's former home, her

stepmother in the house the Lousada children grew up in, and, now in her nineties, Mary Fedden continues to paint in the studio Sandra first visited as a baby. Continuity, hospitality and loyalty have played as large a part in Sandra's professional life as in her private domain, the boundaries frequently indistinguishable.

If Sandra's childhood sounds enviable, there were downsides too. One was the mismatch of her parents' personalities and the failure of their marriage (Jocelyn stayed until she felt her children were old enough but then left to live with George Devine; Anthony went on to marry the American dancer Pat McBride, a former member of Balanchine's company). More defining for Sandra's future career was the sense of inadequacy that grew in her as she recognized the impossibility of meeting her father's hopes. Anthony wished his children to be slender (Sandra was plump), academically successful (she was unhappy at school and failed miserably at exams) and, preferably, highly accomplished at drawing (she wasn't). With two parents sketching almost as a reflex and siblings who showed signs of following in their footsteps, it seemed that Sandra was doomed always to fall short. She has a particularly vivid memory of an afternoon, not long after she made her application to the Poly, when she, her sister and her father were all drawing a bridge. Disappointed that her Pointillist effort was dismissed by Anthony, she nevertheless registered his suggestion that she might instead take a photograph. His comment reinforced the realization that no one else in the family used the camera with any seriousness, and that photography might open up a pathway to a place where she could stake out territory of her own.

Seeing Sandra arrive at the Regent Street Poly with white lips and black eye make-up and wearing red knee-length stockings, the staff tried to persuade her to switch to the art course instead of photography, but she refused to be deflected. She joined approximately forty fellow students and was possibly the least enthusiastic photographer among them, loathing the plate cameras they were expected to use and finding the intricacies of the craft difficult and dull. She did, however, appreciate the Poly's social life, and she began to mix with students at the Architectural Association and the Slade, and jived to the Temperance Seven at hops held in the Royal College of Art. She got a holiday job assisting the photographer Douglas Glass, growing to understand how he ran his business and observing the careful preparation and research with which he approached portraits. Visits to the darkroom of Eileen Tweedy and Laurence Reverdin, who worked for Skira Books, opened her eyes to the fact that the skills she was picking up at the Poly were much more engaging when they were applied to real tasks.

Getting a job as a female photographer in London in the late 1950s was no easy task. As Willie Landels, at the time an art director with J. Walter Thompson, recalls:

Photographers took on male assistants and male assistants later became photographers. They took on male assistants not because they had anything against women but because they had to carry very heavy cases, and they're stronger. I think older art directors might not have felt comfortable using a woman photographer. In the fifties, in every kind of business in England, there were lots of people who had gone to the war. They came back to their jobs with a pre-war not a post-war mentality, and that affected our industry very badly. The new generation – my generation – was still under the lid of a previous generation with previous conceptions, ideas, and it was quite difficult to push forward. Older art directors and account executives weren't open to new things.

Narrowly escaping expulsion from her two-year course at the Poly, and fearing correctly that she hadn't passed her exams, Sandra urgently needed a permanent job, and she gritted her teeth to demonstrate what she describes as 'brute strength', efficiently carrying a huge 2K spotlight on a stand up two flights of stairs before she was offered the post of assistant to John Lewis and Dudley Harris, whose South Audley Street studio was sustained by photographing handmade ladies' corsets, and whose – necessarily rather exposed – models had lobbied for a female assistant. During her year with the corsets, Sandra gradually began to take her own photographs in the studio, most notably of a group of musicians, the Alberts, with whom she had become friendly, and who played and sang while she experimented with the camera ('I was more amazed than they were that I got something'). At the same time she was improving her skills in retouching photographs, processing and printing, assets which led to her next job at Scaioni Studio in Marylebone Mews, assisting Myrtle Healey, a commercial photographer, and Nancy Sandys Walker, whose clients were mainly editors of fashion magazines.

Healey and Sandys Walker were completely different in their approaches, one dashing and swift, the other slow and careful; Sandra picked up skills from both, supervised by the studio manager, Mr Thompson, who docked her wages if she made mistakes (one week she came away with only £2 out of her potential £10), an effective spur to concentration. Gaining confidence – but nevertheless shocked to find herself taking the step – when she came across the architect Hugh Casson, a family friend, at a

party, she approached him to ask if he would commission a photograph from her. He did – the difficult subject of a large office room – and she, having no equipment of her own, was then faced with the problem of how to go about taking it. Mr Thompson met her request for half a day off and the loan of cameras and lights with a suggestion: that she become a photographer in her own right, working out of Scaioni Studio; on days when she had no work, she could continue there as an assistant on a freelance basis. This conversation precipitated her into her career proper: 'Once I started to earn my living – maybe a job a month – and began to have the courage to go and see a magazine with my portfolio, it all started to happen.'

As Ilse Gray (whose later commissions for *Tatler* were an important step in Sandra's career) remembers, attitudes in the 1950s were light years away from those of the decade that followed.

> It was a different time. When I was at *House & Garden* as an editorial assistant, the *Vogue* people were still coming to work in hats and gloves and they sat at their desks with their hats on. Things began to change slowly at the end of the 1950s when I worked at *Tatler*, though people still expected male photographers at their dos, not females. Unlike the rest of us, Betty Kenward, who wrote 'Jennifer's Diary', continued to appear in the office heavily powdered, impeccably suited, wearing a pearl choker and kid gloves, her bouffant hair fastened with a velvet bow. Peter Townend, editor of *Burke's Peerage*, was always in and out of the office.

Vogue was not welcoming in response to Sandra's enquiry about a commission, telling her 'Only men do Beauty. Women can't.' Undeterred, she kept going: 'I had fishnet tights, a tight black skirt, a black fur hat, and, with great difficulty because of my tight skirt, I biked all over London with my black portfolio in the front. I didn't get work from the magazines for a while but I was doing quite a lot of private portraits, children and friends of friends.'

A turning point came when Richard Hughes asked her to take his portrait for the jacket of *The Fox in the Attic*. Despite the fact that Hughes was due in London shortly, she insisted on heading for Wales, wanting to catch him on his home territory. He had known Jocelyn Herbert when she was a young teenager – one of the characters in *A High Wind in Jamaica* is based partly on her – and Sandra had an unusually intimate knowledge of the head she was to photograph, having been encouraged to stand on it as a child: 'He used to let little children climb on to his back and very slowly he'd move them higher. "You can do one more, on to my shoulder." He'd hold your hands and then he'd say, "Come on now, up on my head," and it was terrific, gaining confidence. You'd have no shoes on, bare feet and he'd help you up to steady you on his head. "Let go of my hands," he'd say.' When she went to Wales with her camera, for all the childhood games, she was nervous. It wasn't just worry as to whether she would come up with an image he liked, but because she was presenting herself anew, as an adult and a professional.

The commission taught her a lesson that proved formative. She spent three days in Wales, taking shots of Hughes at his desk and in other writerly poses, but it was only as she was leaving that she saw what she needed. 'There he was standing outside fiddling with something on a wall with this wonderful scenery behind him. I got a shot of him with Snowdon in the background (page 106). This was probably the first time I made a portrait of someone really being themselves. I got what I wanted in two minutes. He suddenly relaxed and just became himself. It was because I wasn't asking him to do anything.' She still remembers the elation of that moment, and ever since has aimed to elicit as much of the real person in her photographs as possible, even on fashion and advertising shoots, creating circumstances whenever she can where the sitter or the model feels relaxed enough to move and gesture in a way that is true to themselves and habitual, and where they can almost forget they are being watched.

Another legacy of the Hughes commission was that the photograph appeared on the front page of the *New York Times* literary supplement on the day Sandra landed at LaGuardia on her first trip to America. The cover image gave her the courage to visit the art director of American *Vogue*, Alexander Liberman. He sent her to *Mademoiselle*, another Condé Nast title, where she was commissioned to take some pictures of college students. It was the beginning of her working relationship with a number of American magazines, also including *Show, Show Business Illustrated* and *Look*.

Back in London, the top end of the magazine world had been shaken up by Jocelyn Stevens' *Queen*, described by Willie Landels, who had recently joined the staff, as 'a magazine directed at an upper class world but with the intention of saying "Boo" to the Establishment'. Although it poached 'Jennifer's Diary' from *Tatler* and took care not to lose its high society readership, *Queen* kept an eye on the activities of the Royal College of Art, and looked to Carnaby Street as well as to Bond Street for its fashion. This climate change created an opportunity for Sandra.

> I went to *Queen* to see the art director, Mark Boxer. He gave me portraits to do. First I had to photograph a whole series of cooks and then he gave me a lot of other work. By that time I had a car, an *Evening News* van with rubber wings, so I could bump into anything without hurting it. I used to put the equipment I'd borrowed and my camera into the back and trundle off, take the photographs, come back, process and print. It probably took half an hour, an hour to photograph them. Then it took me a day to print and contact and choose one and take it into the magazine, hoping they'd print the one I wanted.

Many of Sandra's magazine commissions have been portraits, often in series around a theme. It was Mark Boxer's successor, David Hamilton, who was to open up a further, fertile subject area: 'He said, "Can you do fashion?" So I said, "Yes". I'd never shot fashion in my life but I had no work at the time. I didn't really have a clue about fashion. In essence, they were portraits of people moving in dresses.' Soon she was getting commissioned by most of the big magazines, even by the once unfriendly *Vogue*, where she worked with Felicity Clark, their new beauty editor, who had trained in New York with Diana Vreeland and was renowned for the sharpness of her eye. Clark is in no doubt about Sandra's contribution:

> She was always optimistic and positive, almost the complete opposite of some of her male contemporaries, who often went into the studio in a negative mood. It was a struggle to get them down to work sometimes. Either they didn't fancy the model or they'd had a bad night the night before. With Sandra, it might be a difficult shoot but it was always going to be possible. She was very kind. She didn't want to scare the wits out of people. Some photographers were pretty foul to

the model. The models were young kids and in awe of them. Sandra would chat to everybody and get to know them a bit. She would talk and walk round and look at different angles and work out the light, making them feel at ease – that way we got much better pictures.

Landels corroborates:

She was bubbling away and noisy and warm and funny. We loved her presence and her skill. What is so extraordinary about Sandra is she has never changed. Every time I see her she is exactly the same. She has the same way of being, which I liked very much. Male photographers like David Bailey (who was wonderful in a different way) wanted to photograph beautiful birds, preferably naked. In Bailey there's a certain aggressiveness, and in Helmut Newton too. Sandra was a lady who didn't think like that. Very different. Women models are very aware of a man who loves them and wants them, desires them, and they respond to the camera differently. Sandra looked in her own way, with tenderness and kindness and understanding.

If Sandra's images spoke in softer tones they were striking in a different way, as Clark recognized:

We liked the soft quality of her results. If we hadn't thought they were bloody good photographs, we wouldn't have published them and we wouldn't have gone on working with her. It's a competitive world. Photographers have only got to send in one set of bad pictures to make people think twice about using them. We were very much trying to be honest. I would use the word 'reality'. With Sandra, the reader started to believe not that the models were some beings from outer space with looks to which they could never aspire, but that there was the possibility of approaching their own look or skin care or beauty and making it better.

These were years of transition in all the areas covered by magazines, and Sandra had the perfect background to span the old and the new. Her understanding, when working for the upmarket glossies, of how the grander clothes should be worn and how they should move was fed by memories of the dress her mother wore to be (reluctantly) presented to Queen Mary, of Jocelyn coming back from Paris in a Christian Dior New Look suit and of her parents' stylish ballroom dancing. The clothes Sandra was now wearing herself helped her realize that the cheaper mini-dresses and jump suits she shot for *Petticoat* were less about the quality and texture of the fabric and more about the clear-cut shapes they made.

The models needed to adapt, as well as the photographers. Sandra remembers:

Some models who were working in the late fifties were queen bees. One or two were able not to worry about their past or their reputation, particularly Jennifer Hocking, who was tall and elegant, absolutely wonderful. An incredible face. I was amazed that she did what I wanted her to do. She was one of those fantastic girls who could just stand not doing anything and look great. And here was I, undoing her security blanket and saying, 'I want you to dance. Can

you do the Twist?' And she did. It was one of the first fashion shoots I ever did, for *Queen*. I had to photograph a lot of rather terrifyingly patterned Pucci tops and if you stood still they went 'blop' and just hung but if you moved, because they were silk they billowed in a wonderful way. Luckily I had Chubby Checker to play. Jennifer did her own make-up and away we went. I remember being quite elated. It was terrifically exciting.

With younger models, who were also learning their trade, there were fewer barriers to overcome. In the early sixties there weren't yet teams of make-up artists and hair stylists accompanying the models, nor banks of laptops allowing instant assessments while the shoots were still in progress; the atmosphere was more intimate, there was plenty of room for invention and the fact that it wasn't until the film was later developed that the results were certain added edge and energy. Sandra remembers being on location with Jean Shrimpton, Marie Lise Grès and Celia Hammond where 'We were all a gaggle of girls having fun. We had a riot of a time, just a giggle – and the pictures showed that.' (See pages 132–3.)

There was, too, a rapport with the younger actors whom she was asked to capture in rehearsal for front-of-house images for the Royal Court Theatre and as photographer on Tony Richardson's films. Her first formal assignment was the 1961 world première of John Osborne's play *Luther*, when she remembers being so innocent about the actors' craft and so caught up in the emotion of the speeches that it didn't occur to her that Albert Finney might be turning on the tear rolling down his cheek (see page 24).

Rigorously honest, Sandra will never exaggerate the depth of a relationship with any of her subjects but she knew many of the Court people through her family and this, combined with her innate understanding and sympathy, helped reassure them that they were as far away from a paparazzi pounce as it was possible to be.

Actors often first came to Sandra to take their photographs for the casting agents' directory *Spotlight*, and this in turn led some to invite her to take images for their private use. Joan Plowright for example, commissioned photographs of herself and Laurence Olivier with their young children at their home in Brighton (pages 114–17).

She wanted herself and Larry doing things with the kids. I just followed them around as they did whatever they wanted to do. Joan with the kids, doing their hair, or taking them down to the beach or for a walk along the front. I was a bit nervous about working with Larry. But he and Joan were lovely together, and he was incredibly fond of his kids, slightly impatient with them sometimes but so loving and mostly very relaxed while I was there. The children were sweet with him.

Sandra's friendship with the Redgrave children, Vanessa, Lynn and Corin, began with shared schooling in Chiswick, and Sandra has photographed Vanessa at intervals over nearly fifty years (see pages 50–53).

It's interesting photographing someone quite regularly and seeing them growing up, watching their face and character develop. She was always striking and extremely lively and beautiful, and now she has developed a much stronger face, full of expression and feeling. I first photographed her in 1962 when she was in *Cymbeline* at

the Aldwych. Then on the set of Tony Richardson's film *The Long Distance Runner.* She'd just married Tony and she was pregnant.

The profile picture in a wool hat was taken on the set of *The Fever* in 2003 on a mountain in Wales by a derelict slate-mining village. The film was directed by Vanessa's son, Carlo Nero, and she needed publicity photographs. There was a great gale blowing and driving rain and I found a small shed with an open end where she could shelter and which helped give the light more direction, as she was under the roof and so it came from the side. It was hard to stand still in the storm and it was the first time I used my digital Nikon, so I was all fingers and thumbs. This image is a strong profile; her face has become more angular, less rounded, more lined. She's weathered, so to speak. I also took a photograph in the crypt of a church, using artificial light. To me, this is the more interesting image. It probably makes her look older, but it is much more dramatic and full of feeling. She's moving slightly, talking to someone and listening to them. She looks a bit craggy. It's quite a stark picture, but for me it's very like her and brings out her strength and determined character.

Theatre-related photographs continue to be an important strand of Sandra's work. Among the most poignant is a series she made of her mother towards the end of Herbert's life, showing her working with – and wearing – some of the masks she had made (pages 66–7).

That afternoon my mother gave me something I'd never seen before. We were alone together in her studio at Andrews Farm and the masks were some of those she'd made for the National Theatre production of *The Oresteia*. I was shooting with film and had just been loading my camera and I turned round to see her standing wearing a mask, waiting to start. Slowly, she looked around and saw my daughter Polly's wedding wreath of dried grasses hanging on the wall behind her, and she took it down and put it on her head. Her body language all the time harmonizing with the mask. Not a word was spoken between us. Everything she did was of her own accord, I didn't ask her for anything. The sun streamed into the room and, not knowing why, I placed the chair beside her and walked back to my camera. She sat down and that's the photograph I took.

As I was putting the cameras away, she put on another mask and moved in front of her large painting on the back wall of the studio. My back was turned and I didn't see this happening, so I got a shock when I turned round to speak. That was the most difficult photograph of all to take because it said so much about her. The painting was probably the first she painted after George's death in 1966, and it was such a clear expression of her feelings from that moment on. It's about eight feet by five, a lot of shrouded figures, bent heads and backs, all greys and browns on a white ground and incredibly sad. She knew exactly what she was doing by positioning herself in front of the painting. With the mask on, she's almost part of the group of painted figures. For me, this is the most frightening photograph. I couldn't work for long, I was moved to tears by the end of it. When she took her mask off I could see she was moved too, but she was wonderfully triumphant about what she had done. She must have planned it all before. I hadn't planned

anything specific. She never let on that she had been thinking about what she wanted to do. It was an honour to be given that series of images.

Rather as Sandra has been closely linked with the theatre without being *of* it, so she has been an involved and informed onlooker on the world of architecture. She first got to know many of the leading players during lunch breaks whilst she was at Scaioni Studio. The nearby Doctors' restaurant in New Cavendish Street had communal tables at which she met James Stirling and James Gowan (page 86) and, from Lyons, Israel & Ellis, the nearby practice where they had formerly worked, other young architects who were later to rise to eminence – Alan Colquhoun, David Gray, John Miller and Neave Brown among them (page 89). ('Your daughter's mixing with a bad crowd,' Hugh Casson told Anthony Lousada.) Stirling was the first to take her on site to explore a modern building, his science block at the University of Leicester, and she found herself becoming more and more intrigued by the discussions among the architects, preferring their conversation, however technical, to that of her fellow photographers.

In 1965 she married an architect, Brian Richards. Brian took her to the meetings of Team X, a group much given to rigorous and sometimes unforgiving debate. 'Don't speak, you don't know enough,' was his admonition, at which point Sandra took up her sewing, her stitches getting huger and more irregular as the urge to chip in rose and self-restraint grew more difficult. Alison and Peter Smithson, who were among the founders, didn't join the Team X gathering the year it met in Urbino because they were angry over a point of policy. 'We are not a Team without an agreed start point,' they wrote stiffly to that year's convener, the Dutch architect Aldo van Eyck. Sandra did attend, coming back with a series of revealing informal pictures. As they got to know one another better over the years, the formidable Alison, who had initially argued against Sandra's being admitted to the meetings, eventually asked her to take a joint portrait of her and her husband (page 90). (Although she declares herself not to be a photographer of architecture itself, Sandra's pictures of Le Corbusier's Chandigarh, brought back from her honeymoon, were good enough to trigger Landels to commission an article to go with them.)

Many people would have been more than satisfied with portrait and magazine commissions, but Sandra has always hated repeating herself and, once she has mastered a skill begins urgently to seek further challenges. On a practical level, she knew, too, that if she wanted to have children she was going to need to earn more money. So in 1963 she joined Jeanne Whitecross of Whitecross Studios, setting herself on track for a lucrative and highly successful series of advertising campaigns that included (among many others) De Beers, Smarties, Cow & Gate, Marks & Spencer, Mothercare and Andrex (puppies). Shunning tripods in favour of keeping her Rolleiflex hand-held, and preferring black and white film, the use of daylight and the exploitation of lots of contrast and graininess, she had up until now so far as possible avoided using colour and flash, but by accepting advertising work she forced herself to confront both, greatly helped at first by John Cook, a colleague at Whitecross. Equipment was changing fast. As an assistant at Scaioni she had loaded the vehicles with plate cameras, slides, flash bulbs and flash guns, reflectors, tripods, stands and light meters, but by now Polaroid had been invented, new types of film were appearing on the market, and Sandra came to love the Hasselblad that Whitecross provided for her. Soon she had an assistant of her own.

By this time Sandra had won not only her father's admiration and friendship but also the respect of her peers; her reputation for photographing children was second to none. Landels recalls:

> She was the leading person, infinitely better than anyone else in the market. There were some social photographers, Bond Street photographers, who were very stiff. No comparison. I think she was able to control the children very well and to make them react yet be unaware of the camera. They were very natural, not posed. Sandra was patient enough to let them relax and become themselves and then she would come into it very slowly without disturbing them.

It was partly the pressure of running a home as well as a high-powered career that led Sandra to leave Whitecross after eighteen years and take the risk of setting up a studio in the basement of her home. (Before resolving to do this, she asked her children, Sam and Polly, if they would prefer her to become a full-time mother. 'What about the perks? We like them,' they choroused.) Needing help with negotiating fees as well as finding clients, she made a fresh start with a new agent, Susan Griggs, who, like her current agent, Bo Steer, remains one of the critics Sandra most respects, as well as a much-valued friend. New developments post-Whitecross have enabled Sandra to collaborate on books as well as undertaking magazine and advertising work, opening up sustained relationships with authors and allowing her to explore subjects – such as London's parks and gardens – in depth. She professes herself as nervous (very) when photographing a park as when preparing for a portrait.

With more than five decades of achievement behind her Sandra is a highly rated figure among her contemporaries, but she has avoided being trapped within her own age group, continuing to make new relationships and to conquer changing technology (embracing digital technology was at first a necessity and later a pleasure). She has always remained sought after in the notoriously youth-hungry magazine world. Lottie Johansson, who entered the business as a fashion editor in the 1980s and went on to work with Sandra for the next eighteen years, describes their first encounter.

> I don't think I'd worked with female photographers until I joined Condé Nast's *Brides* in 1987. When I first arrived I had all these grand ideas of what I wanted to do. The editor, Sandy Boler, said, 'That's fine, but you *have* to work with Sandra Lousada,' because she admired her so much. As a young fashion editor, nobody really likes to be told what to do, you want only to work with young photographers and only male photographers at that. Then Sandra bowled into the room (she never enters a room quietly, she comes flying in) and I thought, 'Hello. You're different.' She scoops you up and has all these brainstorming ideas. This amazing woman was also technically so brilliant and she approached everything with such intelligence; she would really analyse what was needed. She inspired me. For me it was the start of a very different way of looking at things, meeting Sandra.

By 2004 Sandra had reached a point when she could confront the hardest self-set challenge of all. She began to take photographs that involved no other eye than her own and no client but herself. With great modesty, she enrolled on the MA Postgraduate Photography course at Central Saint Martins College of Art, eventually embarking on the images that have evolved into her ongoing collection, *London Light*. Triggered by noticing the reflections in a puddle outside her house during a thunderstorm, the pictures often involve water (the Thames is again a player) and are mostly taken after dusk and before dawn. When she was part way through the Saint Martins course, Sandra's husband, Brian, died very suddenly. Rocked to the core, she nevertheless continued photographing (her daughter christened them the 'crying photographs') and the series brings together in its imagery and its spirit an extraordinary conjunction of the need to withdraw into privacy balanced by determinination and a courageous openness to life, by strength and by the discovery of light in darkness. But these are for another book.

Sandra is not only a witness of her time but is an embodiment of it. Many-faceted within a profession which loves to pigeonhole its practitioners, she resists labelling. During the many hours of recordings we made in preparation for this essay, a particular phrase kept recurring – 'I was in a bubble, just with excitement about life' – and a floating, reactive, fragile but nevertheless intact transparent sphere is perhaps the most fitting habitat she could have made for herself.

Cathy Courtney, London, 2009

Cathy Courtney is a writer and oral historian. Her publications include *Jocelyn Herbert: A Theatre Workbook*, *City Lives*, *Speaking of Book Art* and *Richard Slee*. She runs the oral history project *Artists' Lives* for National Life Stories at the British Library Sound Archive and has conducted recordings for the Sound Archive's *An Oral History of British Photography*.

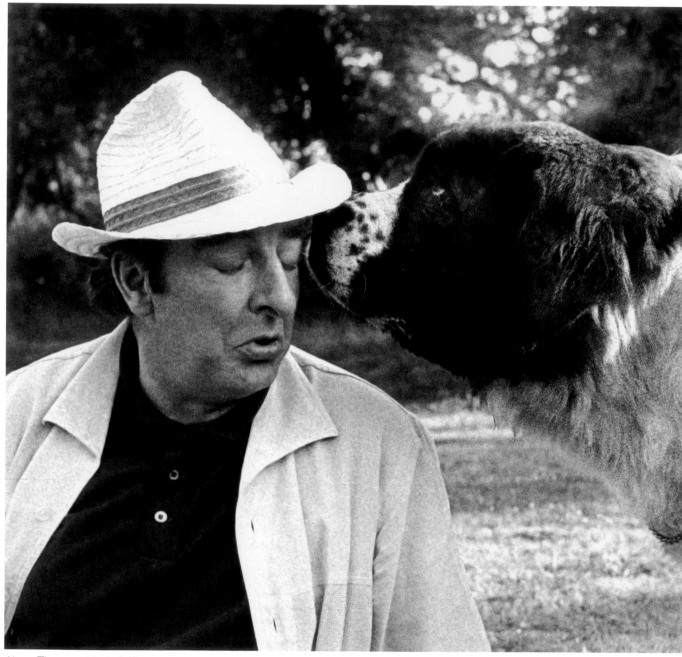

Above The actor Hugh Griffiths, with a St Bernard who had taken a liking to him,
while he was filming *Tom Jones*, 1963

Right Actor Dudley Sutton in his flat in Notting Hill Gate, 1961

Pages 10–11 Olivia and Julian Lousada at home in Chiswick Mall, Christmas 1956
This is a student photograph from my time at the Regent Street Polytechnic. My
brother and sister – who are twins – had dressed up for a play on Christmas Day.

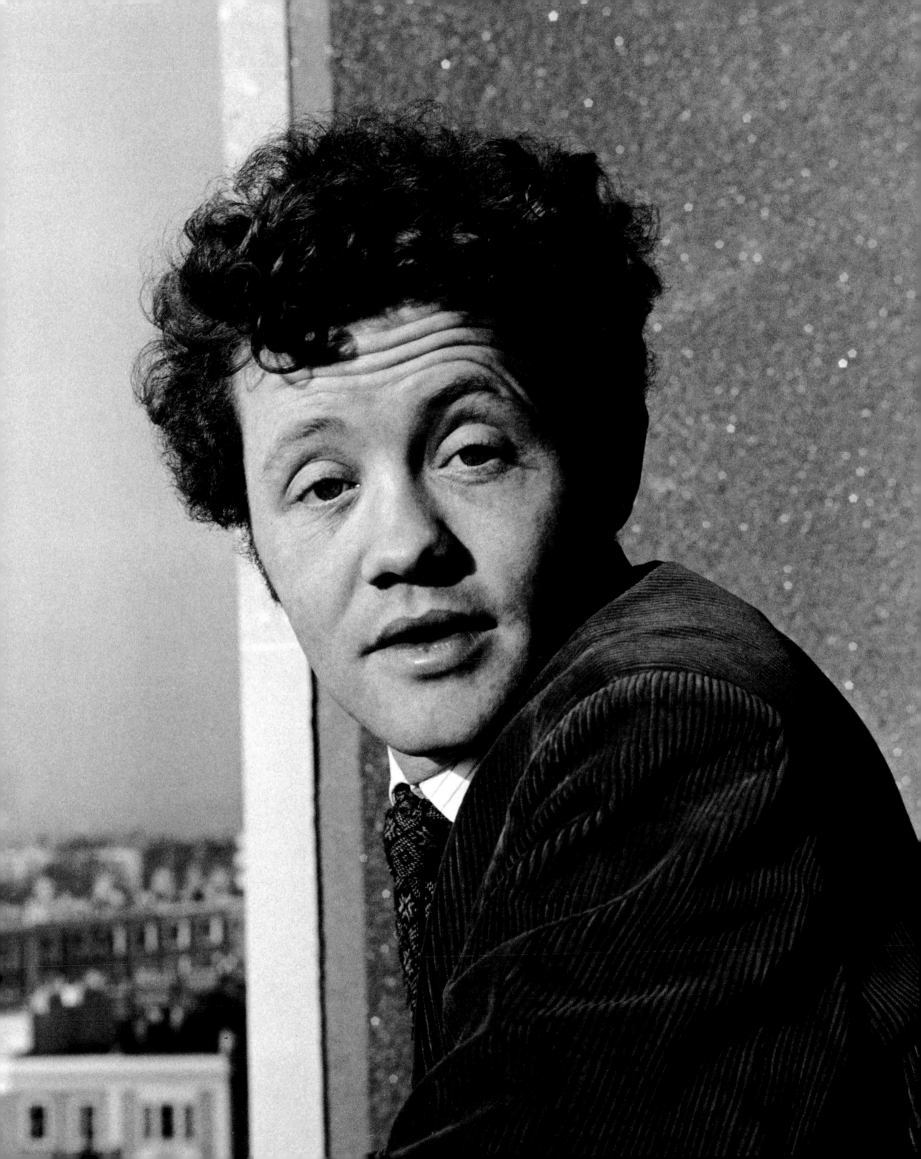

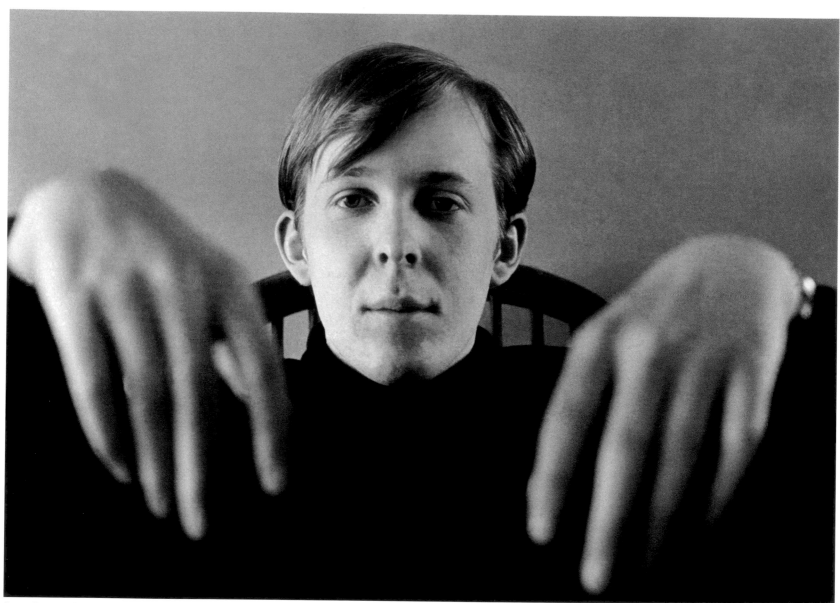

Peter Eyre, studio portrait for *Spotlight*, 1961

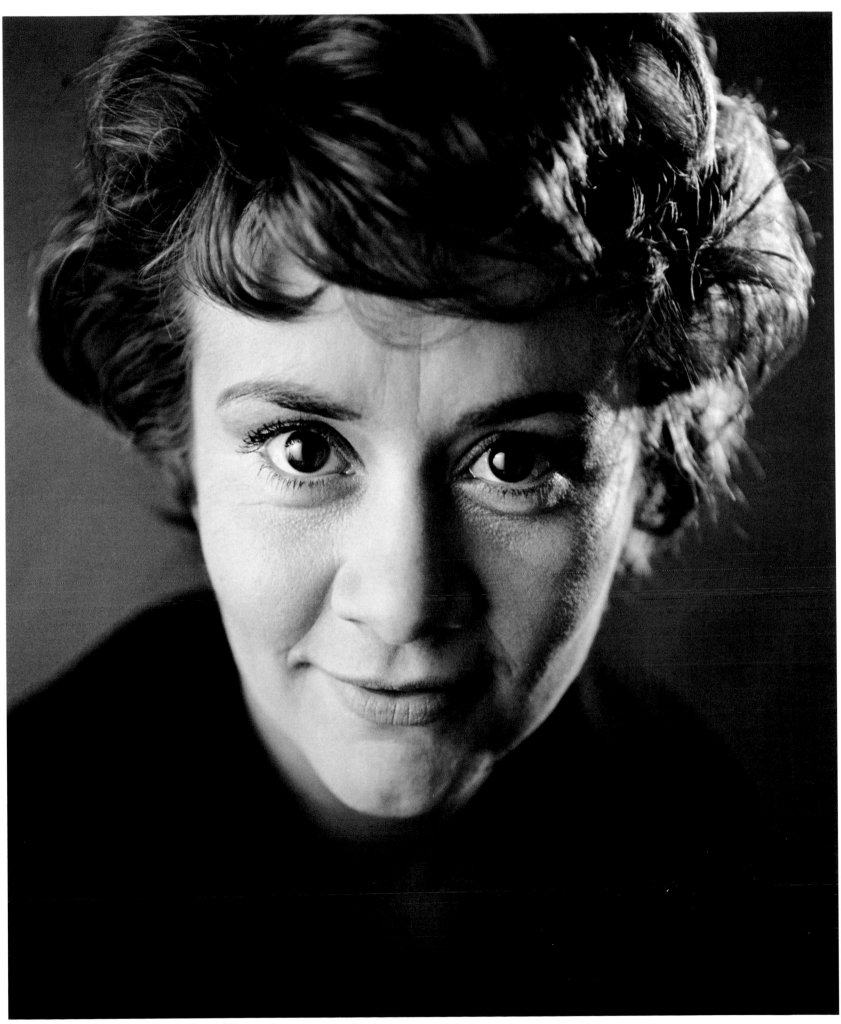

Joan Plowright, studio portrait for *Spotlight*, 1961

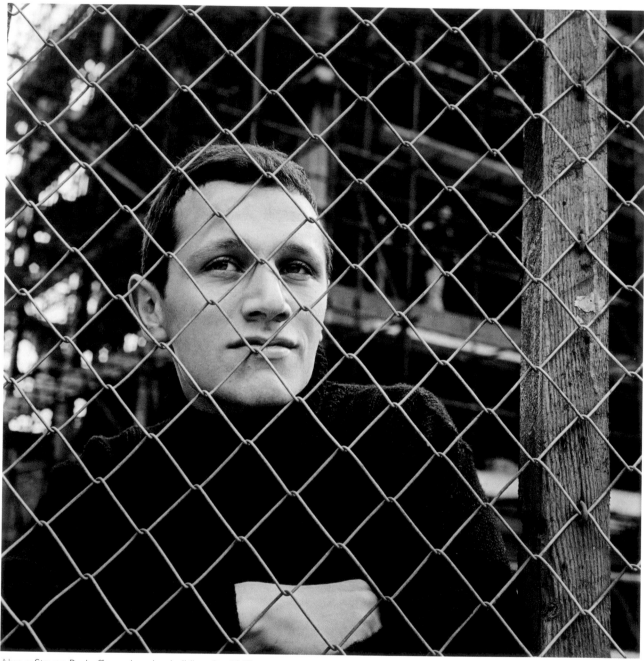

Above Steven Berkoff on a London building site, 1960

Right James Bolam, studio portrait for *Spotlight*, 1959

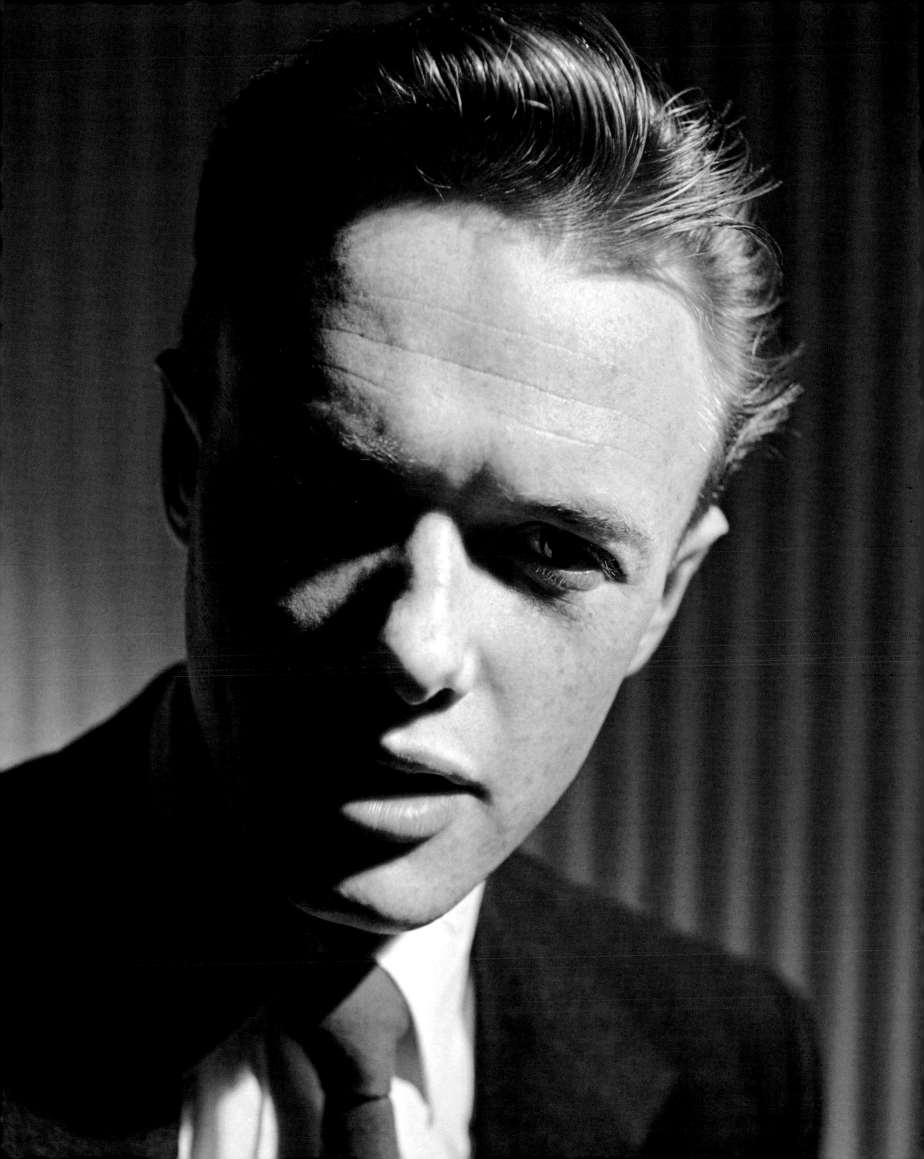

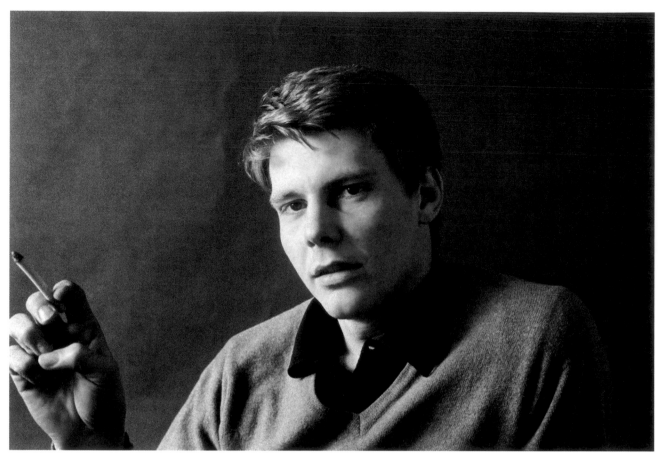

James Fox, studio portrait, 1961

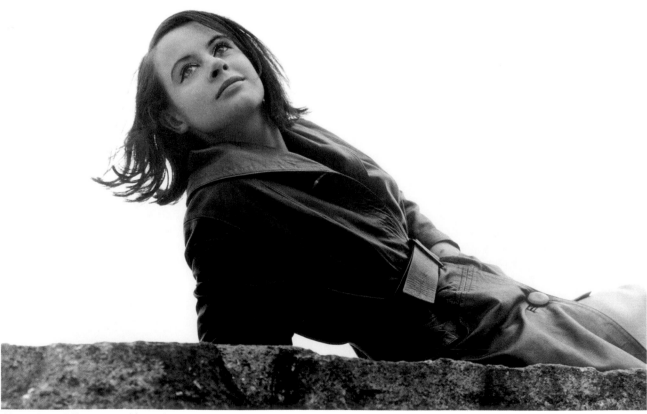

Above Sarah Miles on an old warehouse bomb site opposite what is now Tate Modern, 1961

Right James Fox and Sarah Miles in the studio, 1961

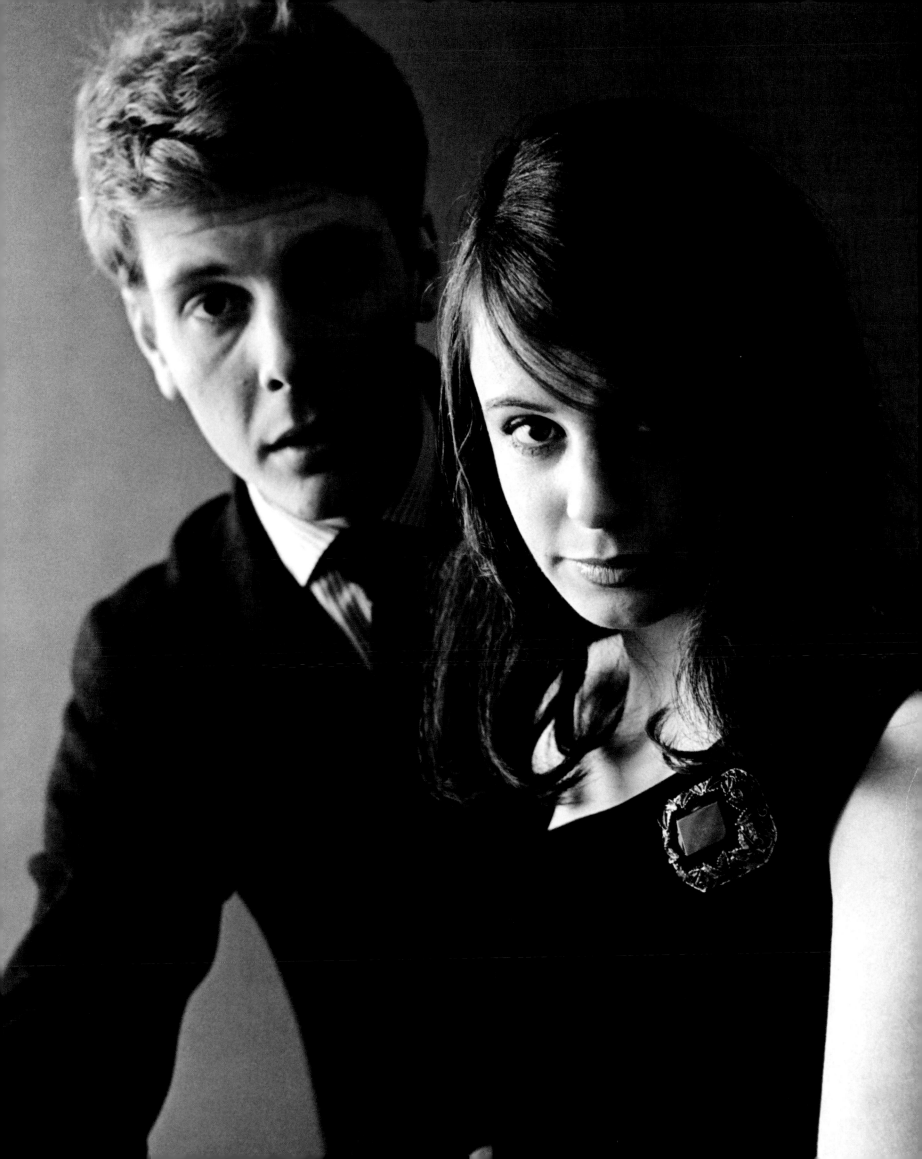

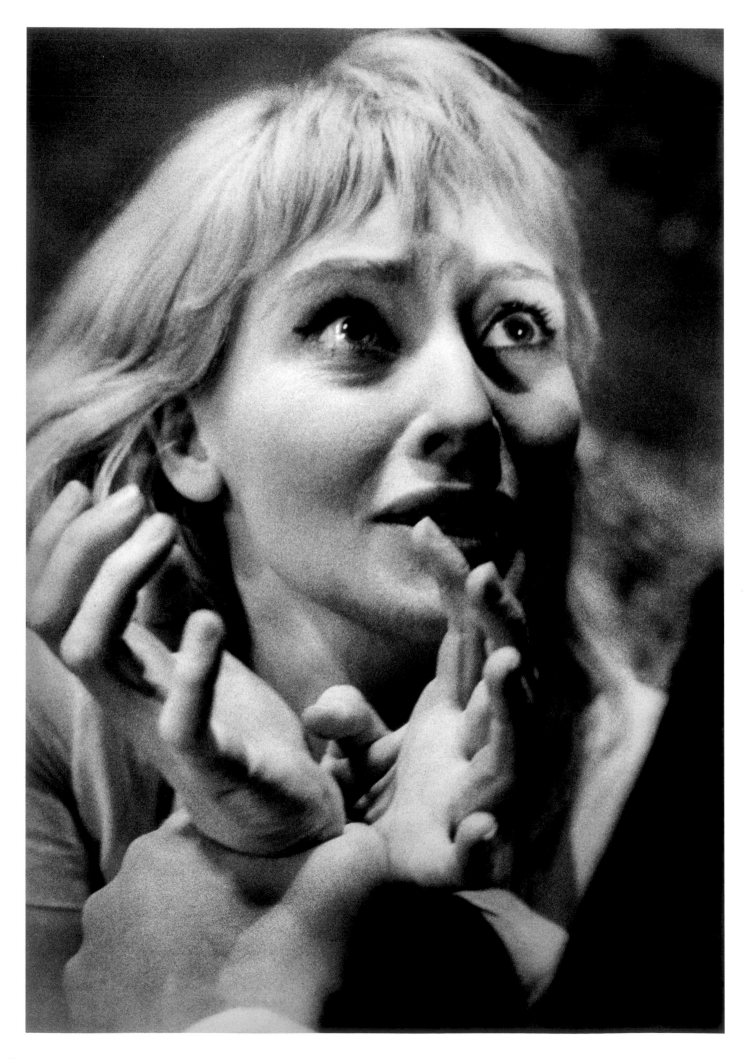

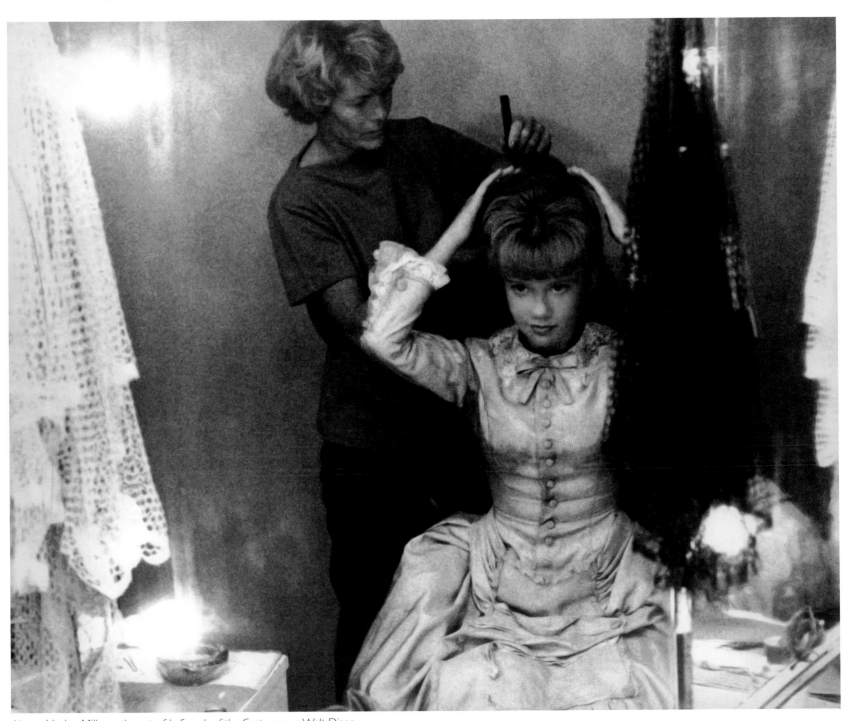

Above Hayley Mills on the set of *In Search of the Castaways*, a Walt Disney production filmed at Pinewood Studios, 1962

Left Diane Cilento in a rehearsal of Pirandello's *Naked*, directed by David Williams at the Royal Court Theatre, 1963

Pages 22–23 Leslie Caron in her dressing room, 1961

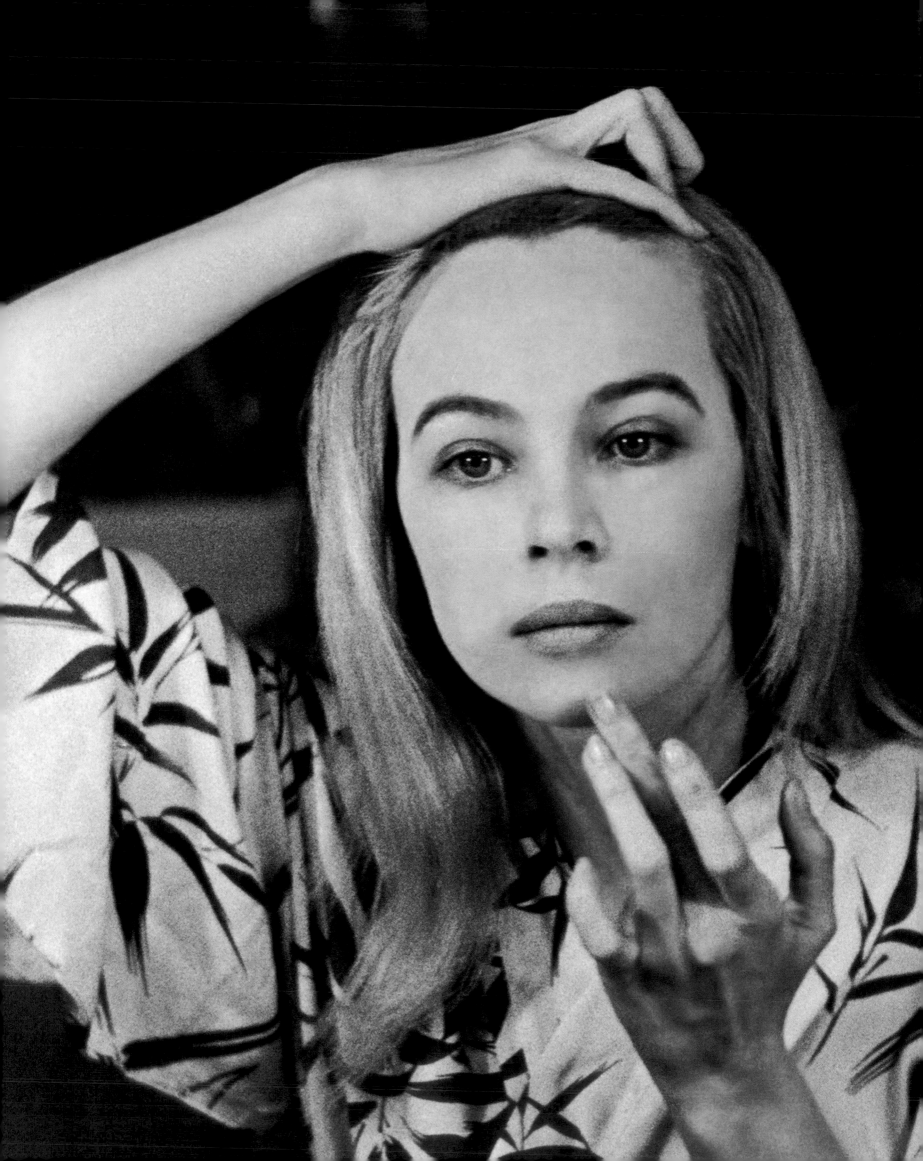

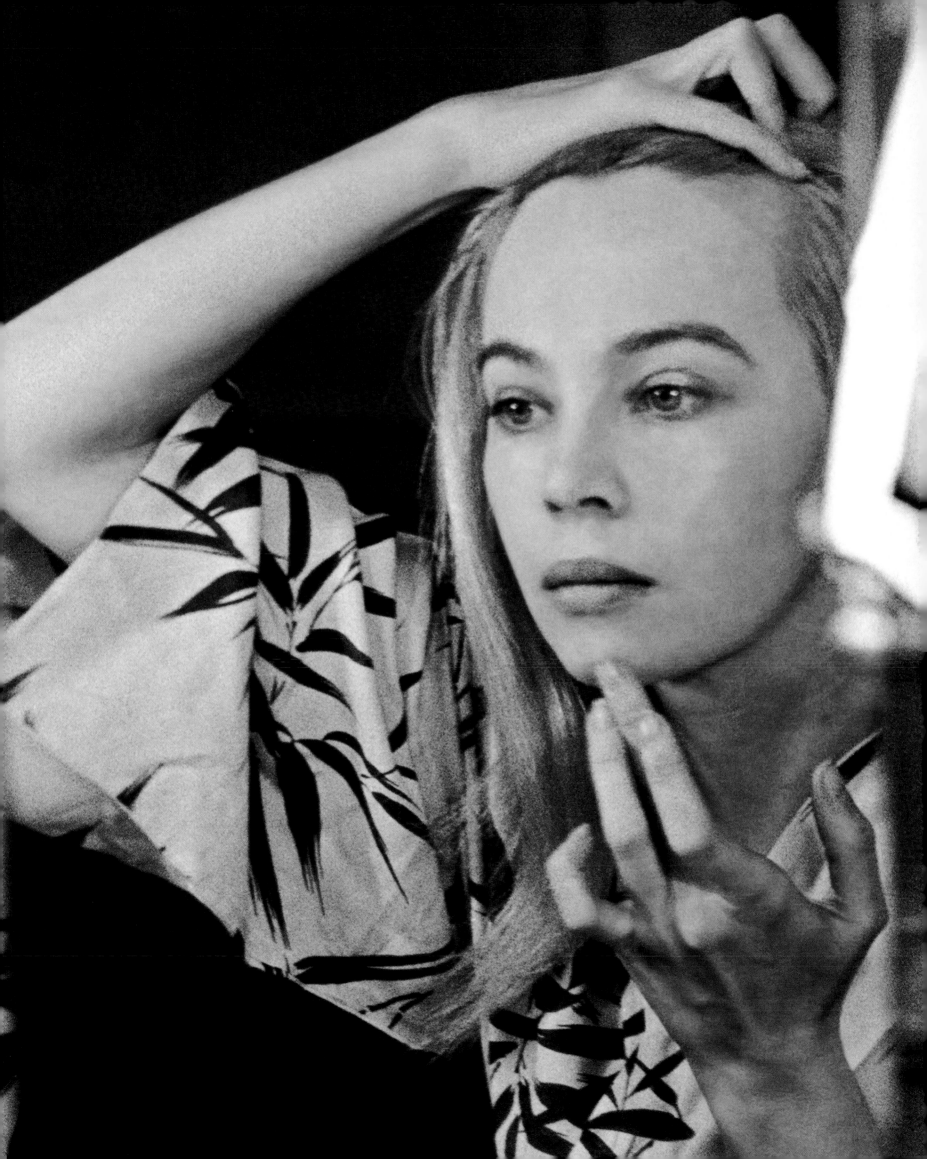

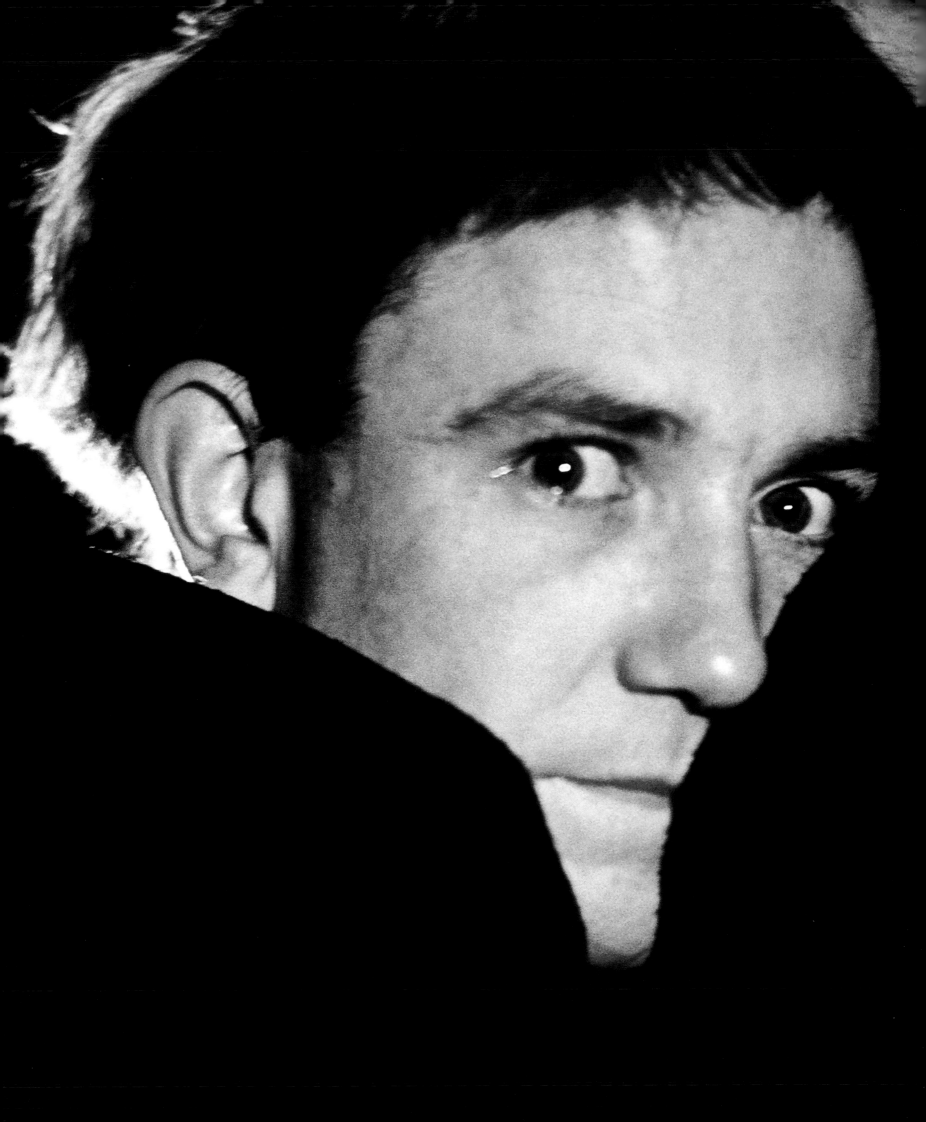

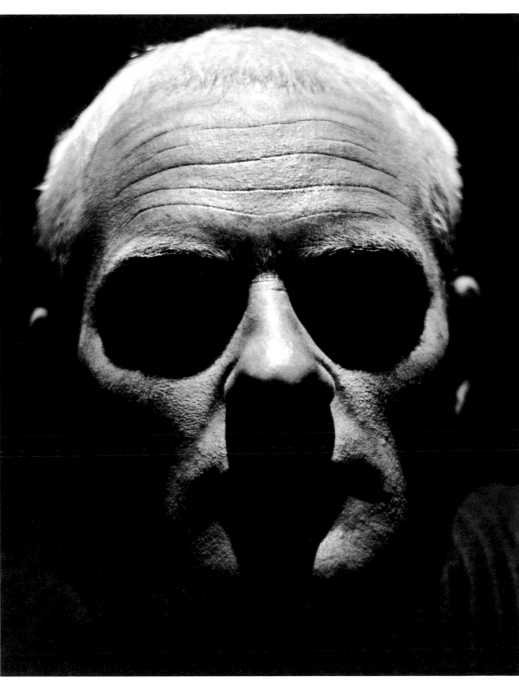

Above Julian Glover in *Luther* by John Osborne, directed
by Tony Richardson, at the Royal Court Theatre, 1961

Left Albert Finney in *Luther*

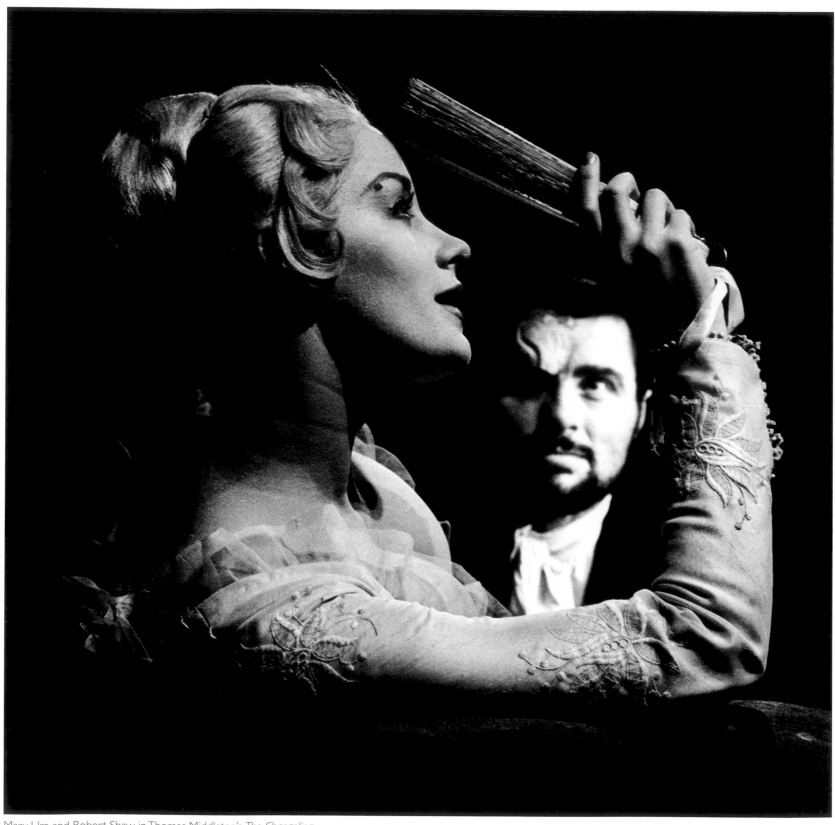

Mary Ure and Robert Shaw in Thomas Middleton's *The Changeling*,
directed by Tony Richardson, at the Royal Court Theatre, 1961

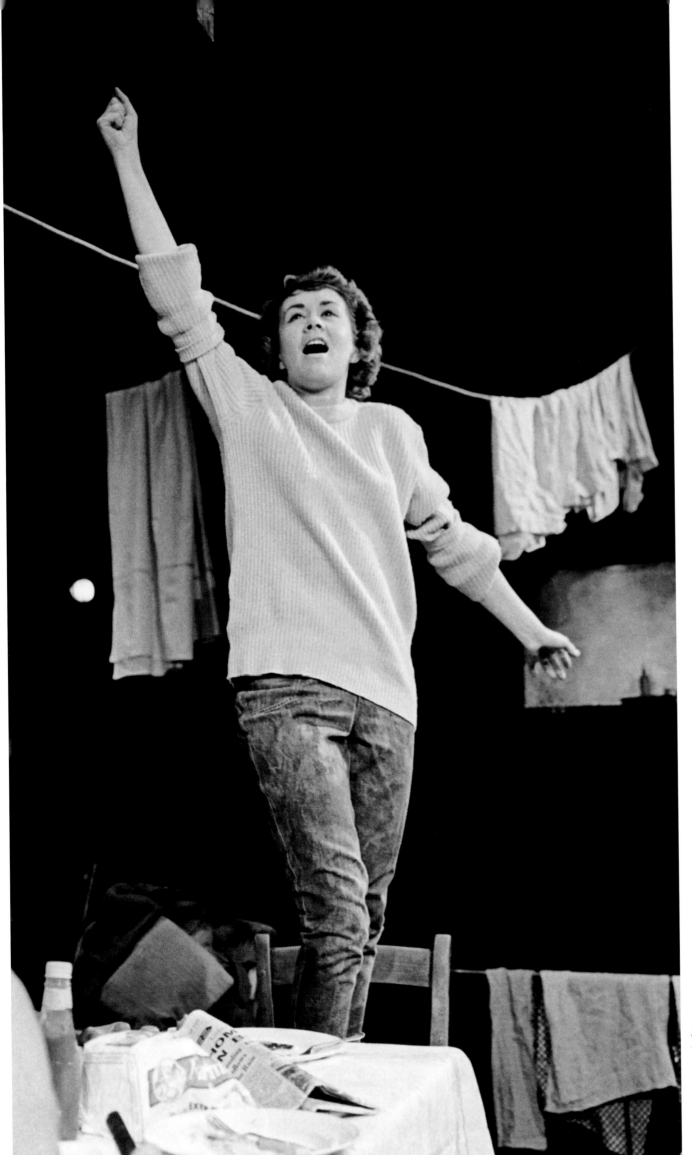

Joan Plowright as Beattie in
Arnold Wesker's *Roots*, directed
by John Dexter, at the Royal
Court Theatre, 1963

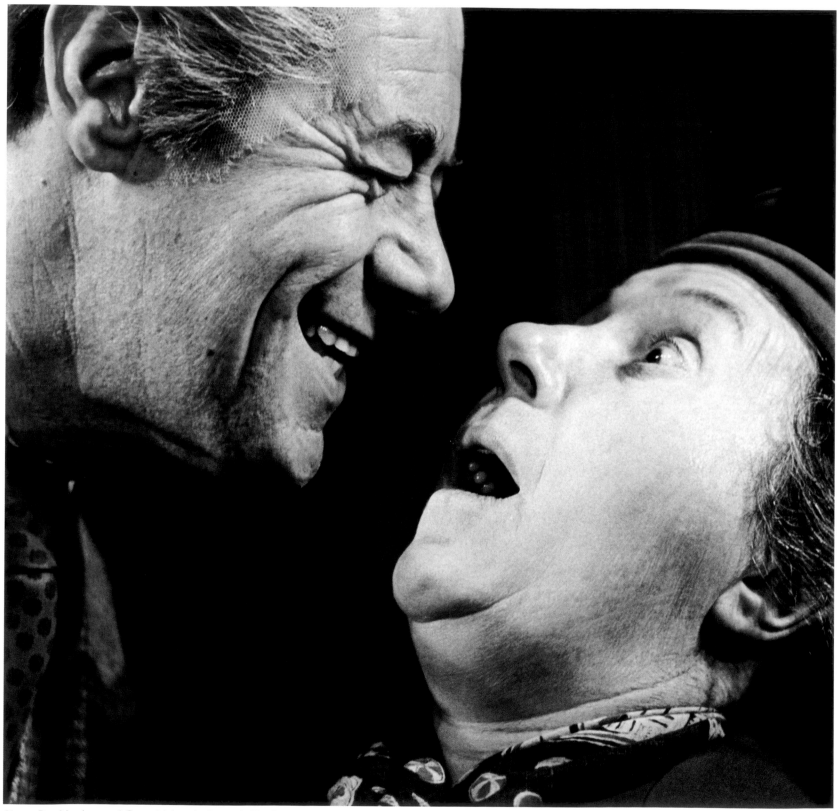

Above Rex Harrison and Gwen Nelson in *August for The People* by Nigel Dennis,
directed by George Devine, at the Royal Court Theatre, 1963

Right Rachel Roberts and Rex Harrison in *August for The People*

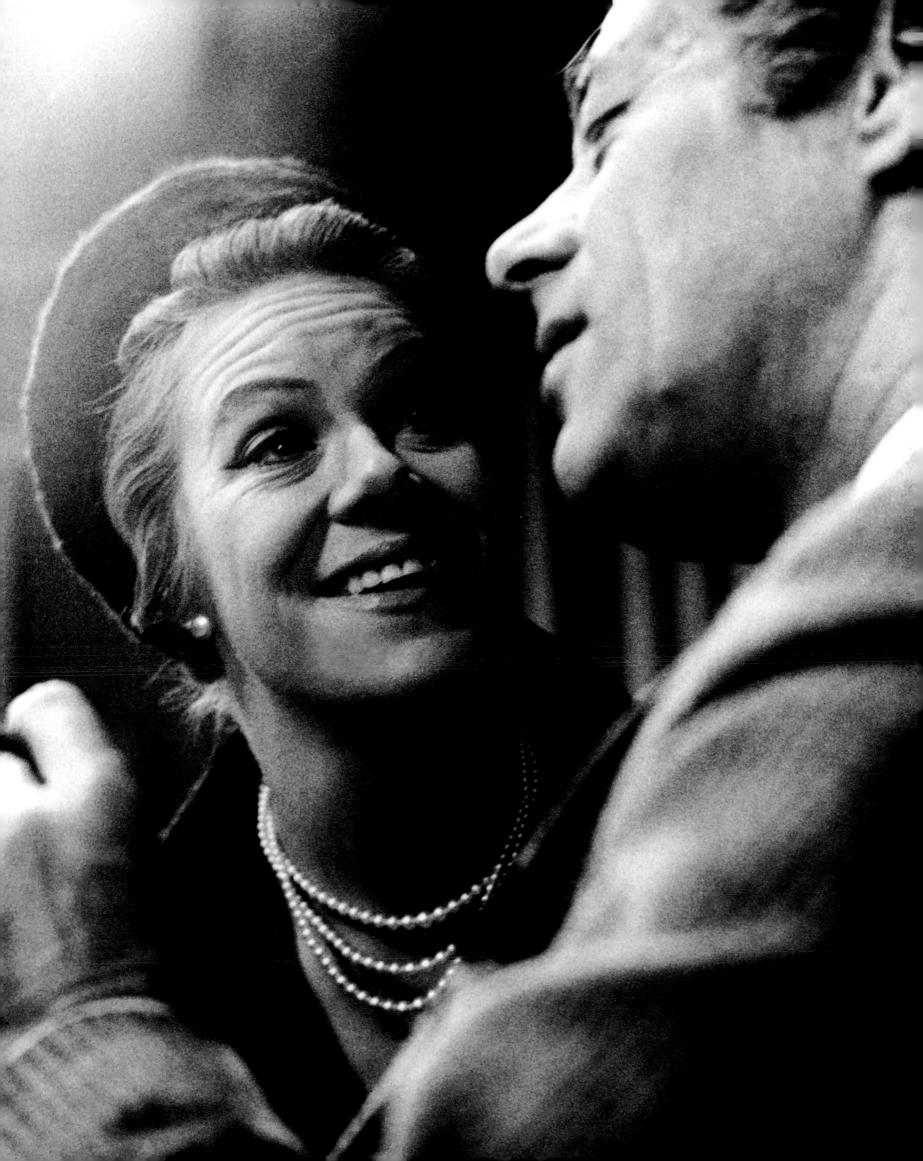

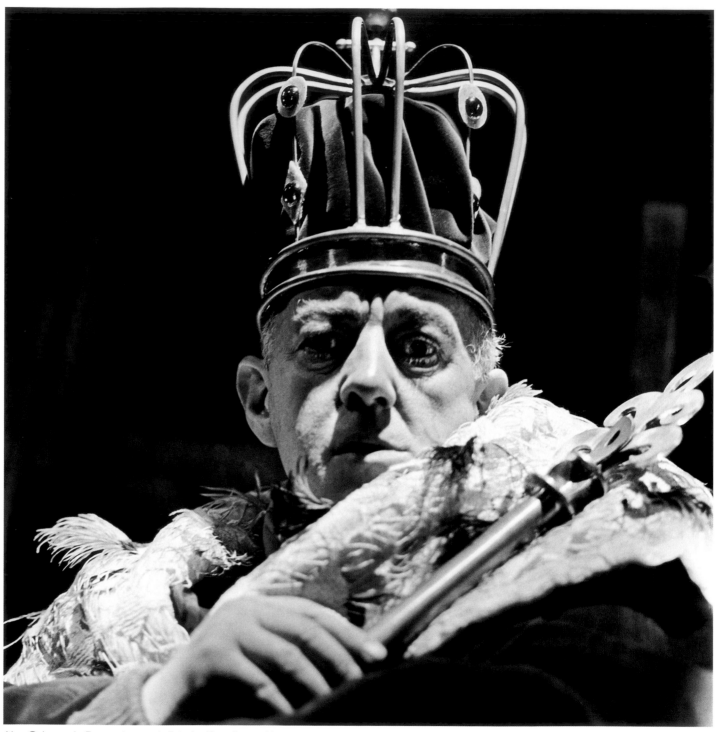

Alec Guinness in Eugene Ionesco's *Exit the King*, directed by
George Devine, at the Royal Court Theatre, 1963

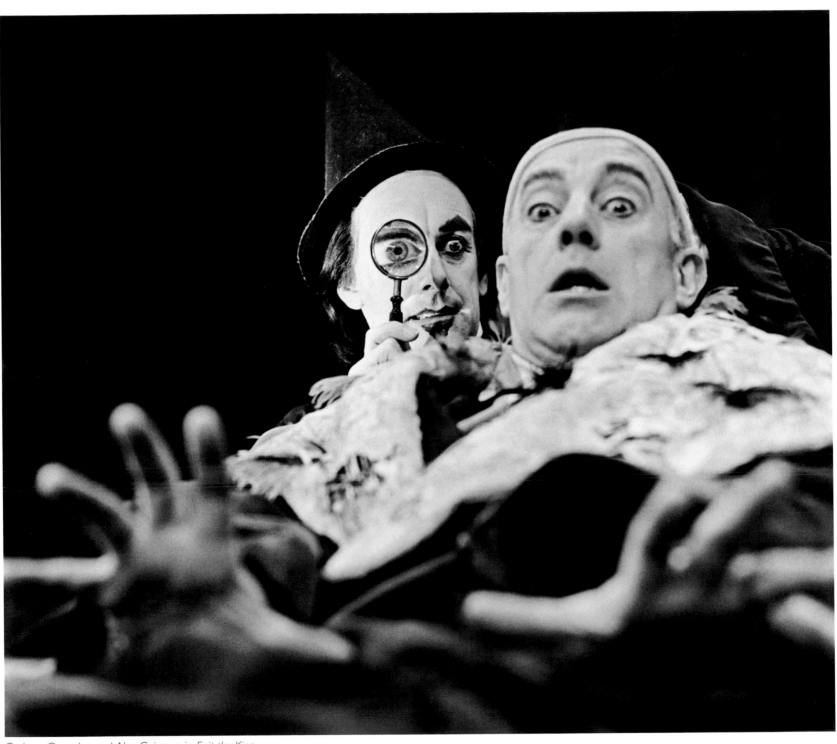

Graham Crowden and Alec Guinness in *Exit the King*

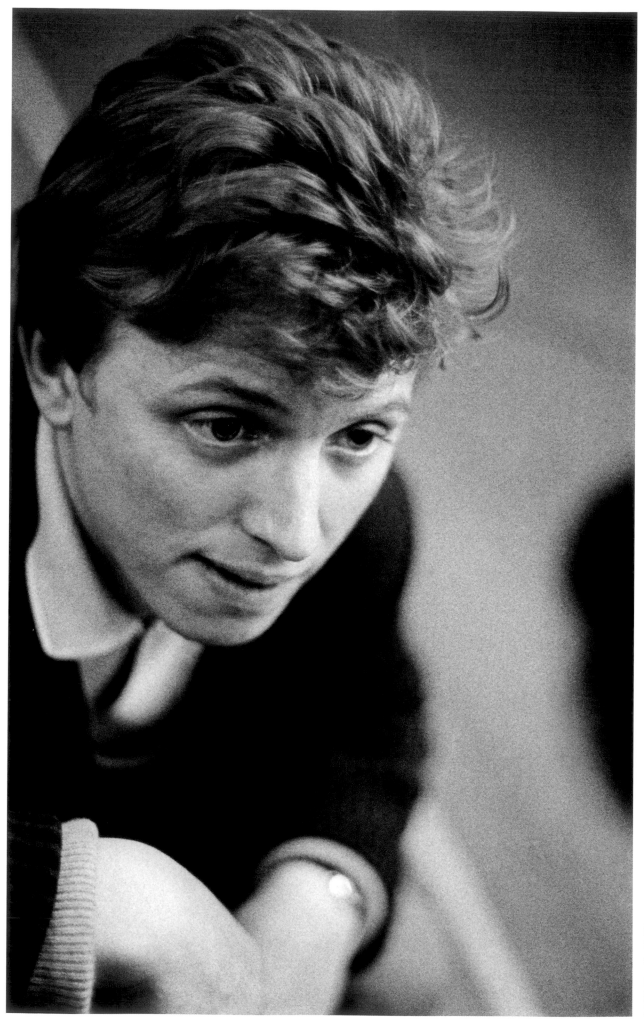

Left Tommy Steele, during rehearsals for
Half a Sixpence, directed by John Dexter,
at the Cambridge Theatre, 1963

Right Lotte Lenya, in a rehearsal for
Brecht on Brecht, directed by George
Devine, at the Royal Court Theatre, 1964

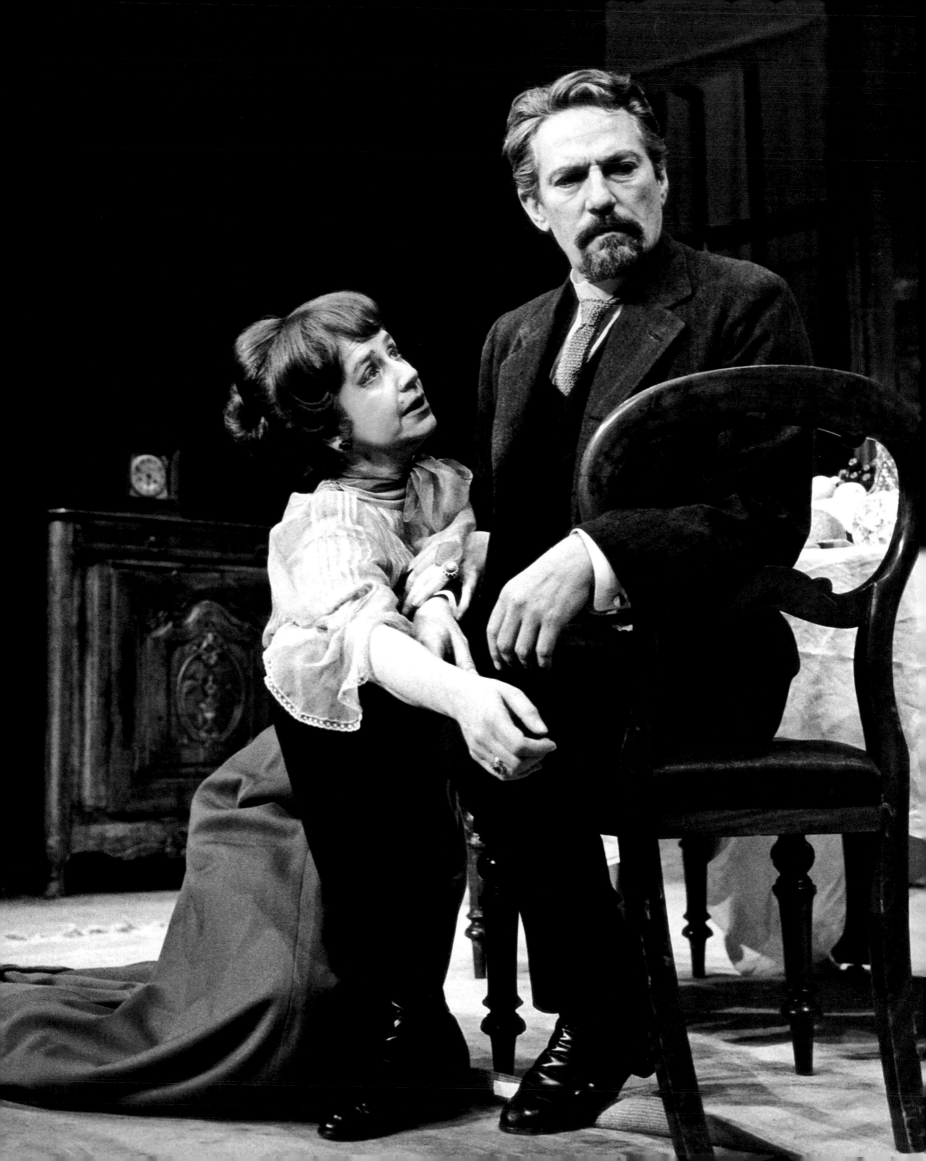

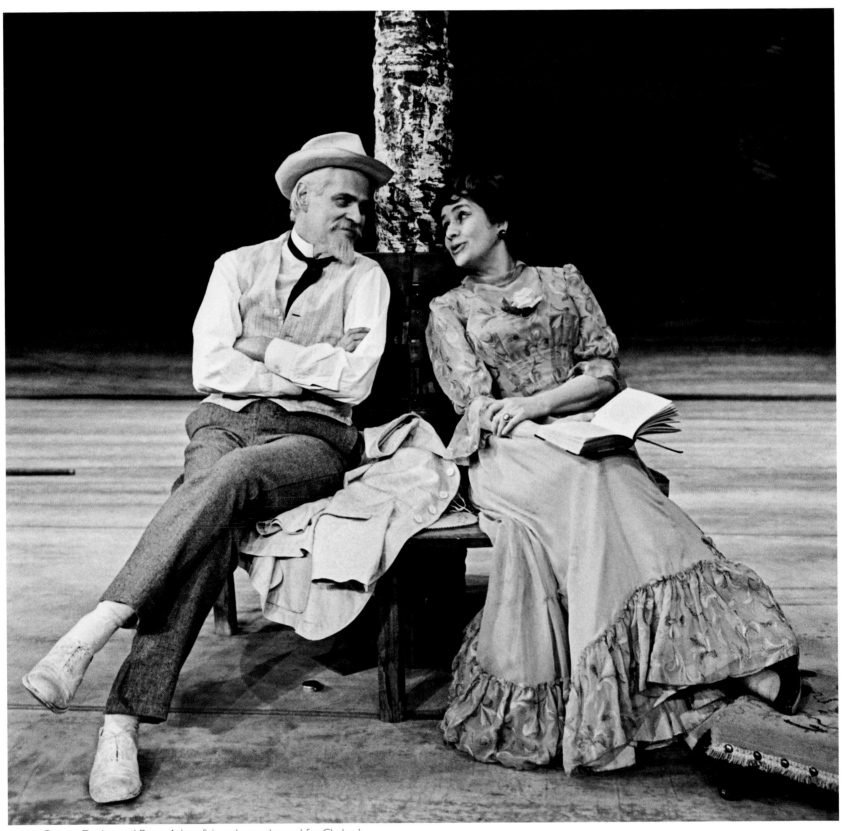

Above George Devine and Peggy Ashcroft in a dress rehearsal for Chekov's *The Seagull*, directed by Tony Richardson, at the Queen's Theatre, 1964
Although they are actually speaking their lines, this is really a photograph of two close, very dear friends. It's how they were in real life as well as being at this moment in character. There was an ease between them that was lovely to see.

Left Peggy Ashcroft and Peter Finch in *The Seagull*

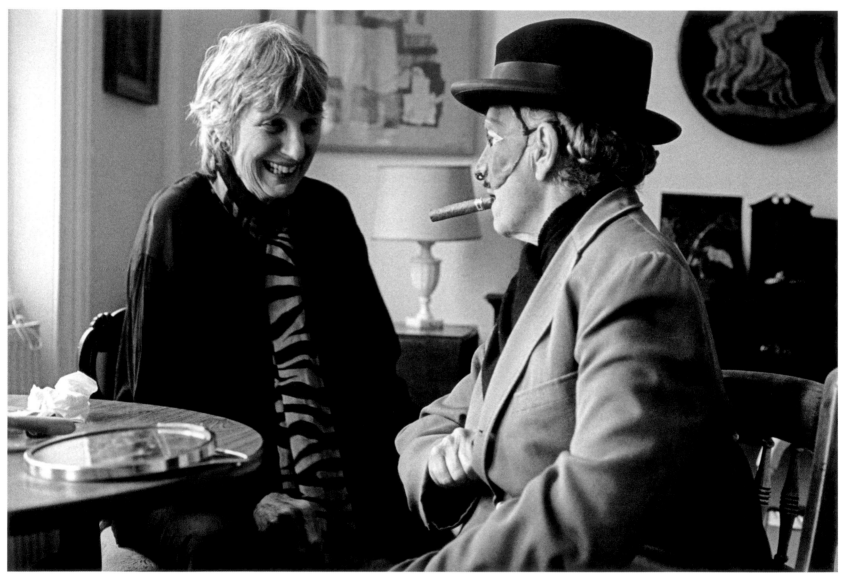

Jocelyn Herbert and Peggy Ashcroft, in Peggy's flat, 1988
My mother wanted a picture for her own workbook of Peggy in this mask,
which she had made for her to wear in Brecht's *The Good Woman of Setzuan*
at the Royal Court in 1956. As soon as Peggy put on the mask she went
immediately into the character she had played over thirty years ago. The
mask looked old and crabby and Peggy said, 'It's got as old as me.' They
laughed till they cried. They were like a pair of schoolgirls together.

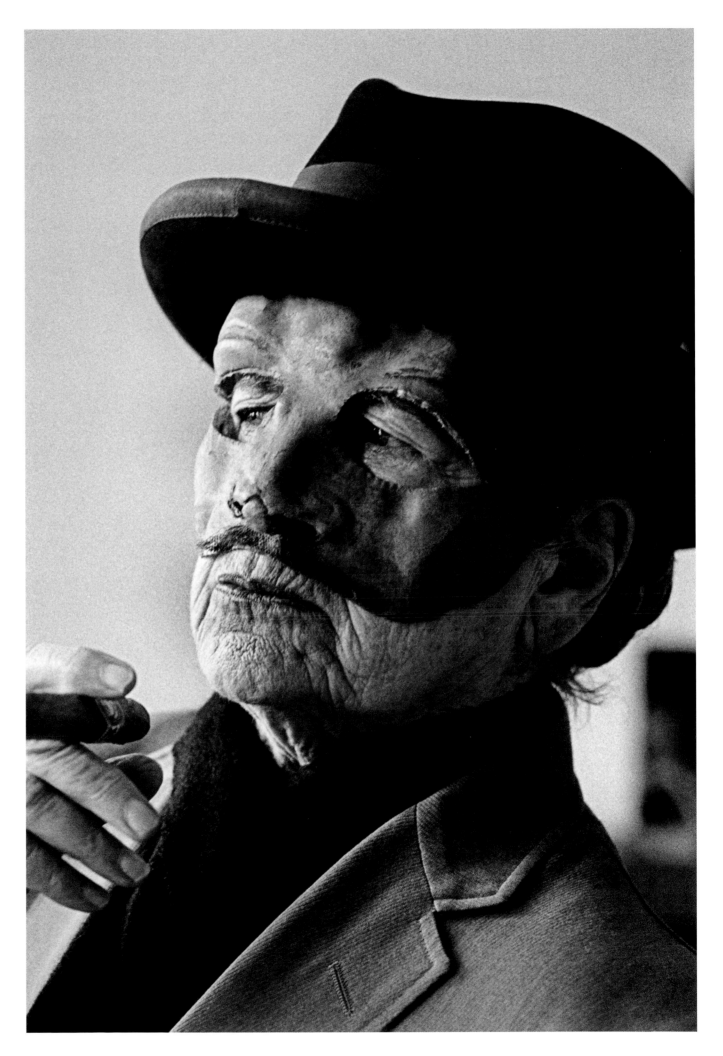

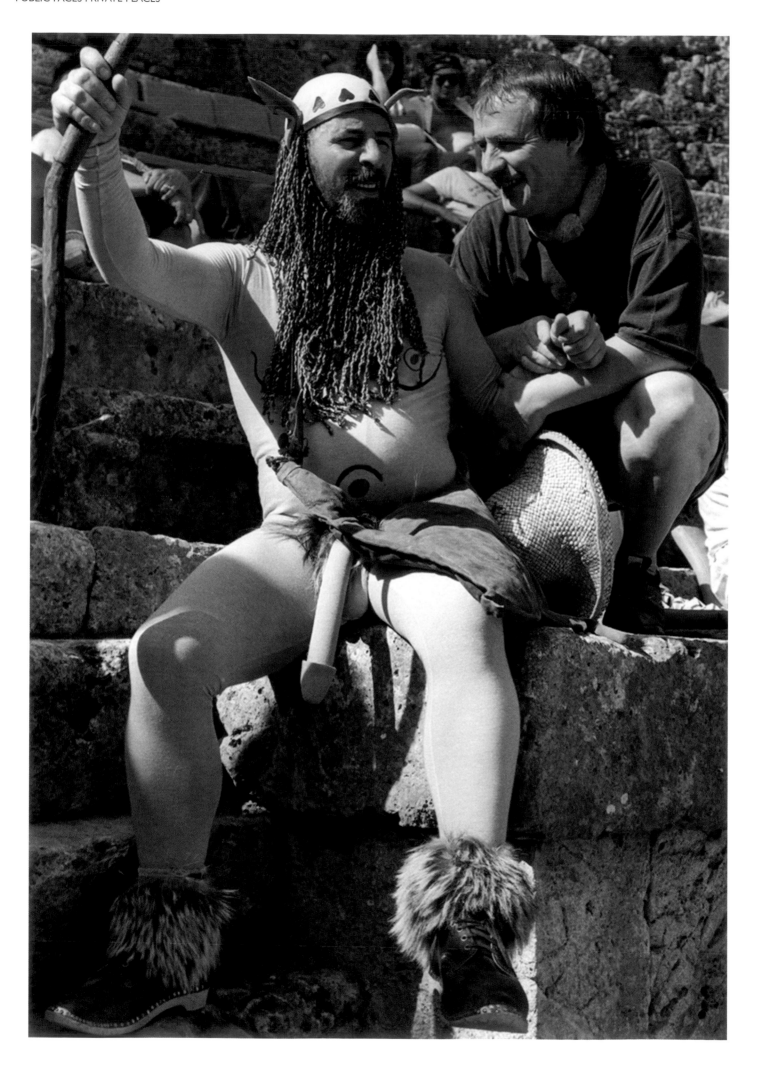

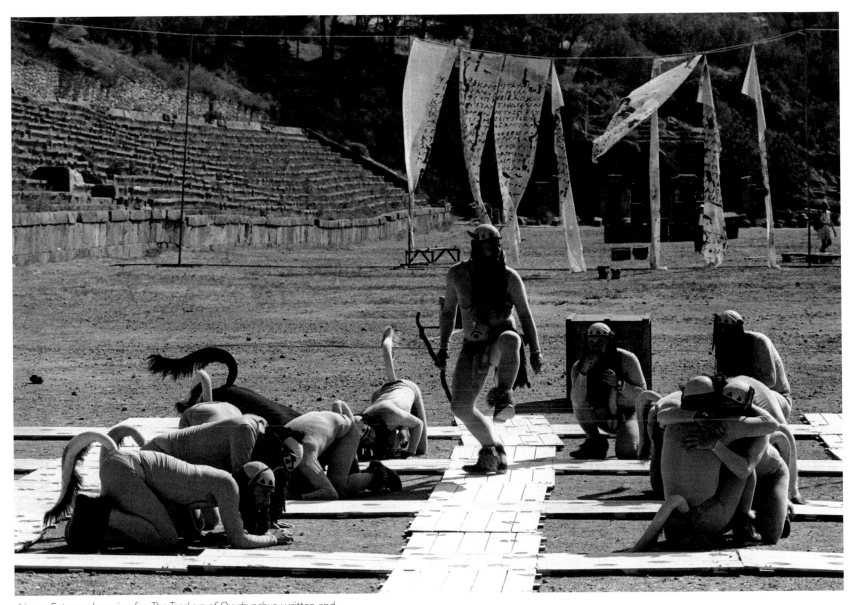

Above Satyrs rehearsing for *The Trackers of Oxyrhynchus*, written and directed by Tony Harrison, in the Stadium at Delphi, 1988
The backdrops had been shredded by an angry wind blowing down from Mount Olympus during the evening rehearsal.

Left Barrie Rutter in his Satyr costume, with Tony Harrison

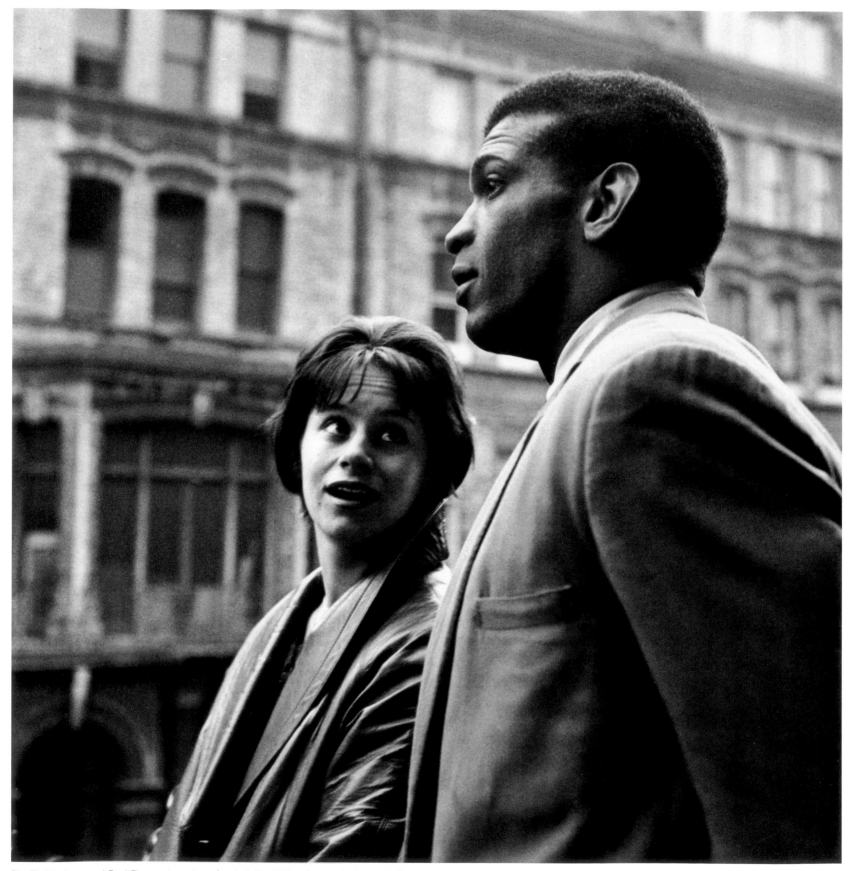

Rita Tushingham and Paul Danquah on location in Salford, Manchester, during their film test
for Shelagh Delaney's *A Taste of Honey*, directed by Tony Richardson, 1961

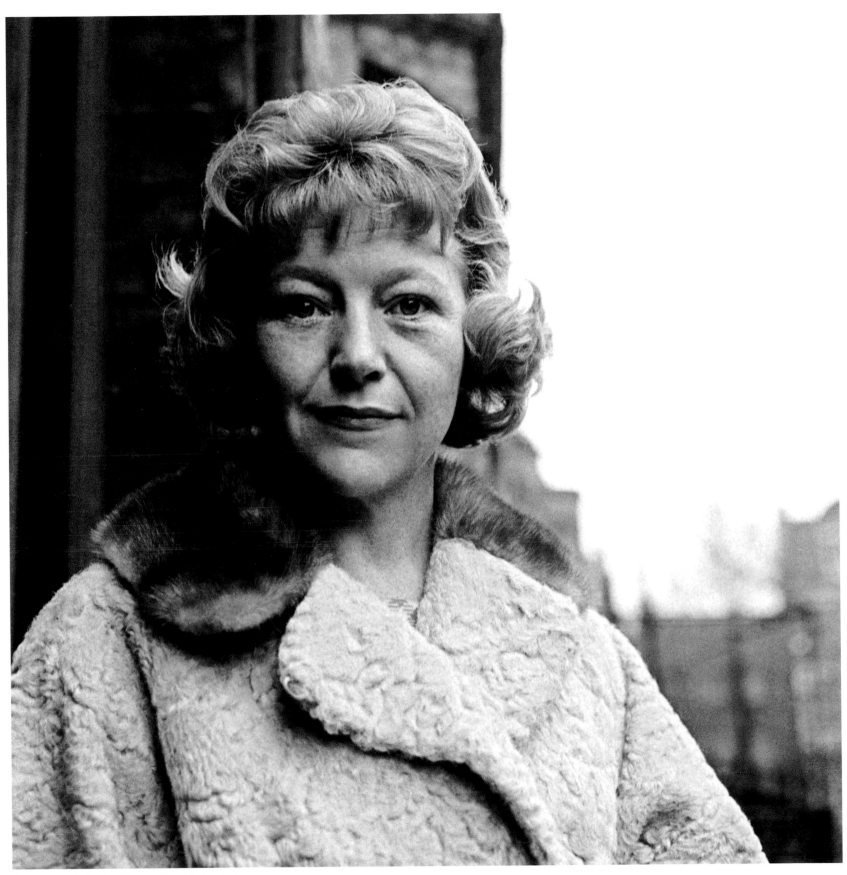

Dora Bryan during her film test for *A Taste of Honey*

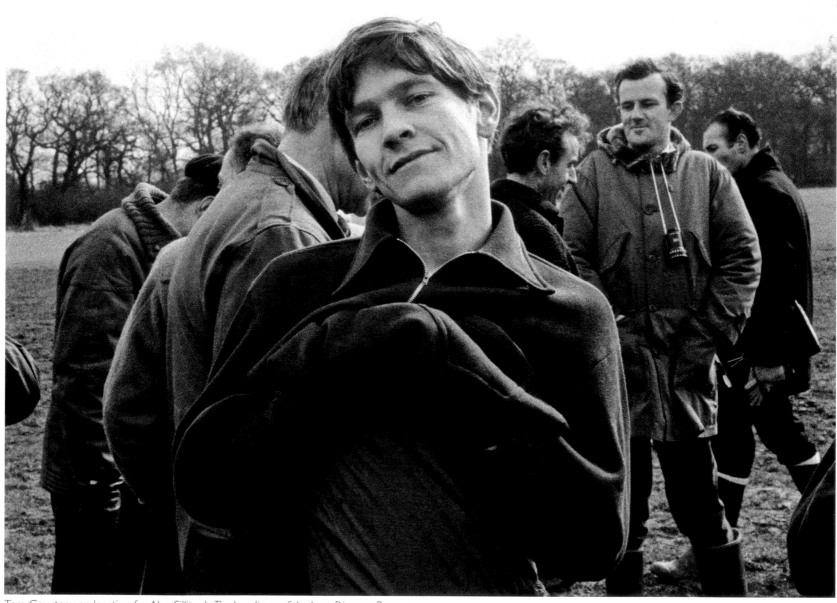

Tom Courtney on location for Alan Sillitoe's *The Loneliness of the Long Distance Runner*, directed by Tony Richardson, 1962
Tom was standing, waiting to work. He suddenly turned, hands wrapped in his jacket against the cold, and there was my shot. He saw me and gave me a smile, slightly cocky, exactly as he was – magic.

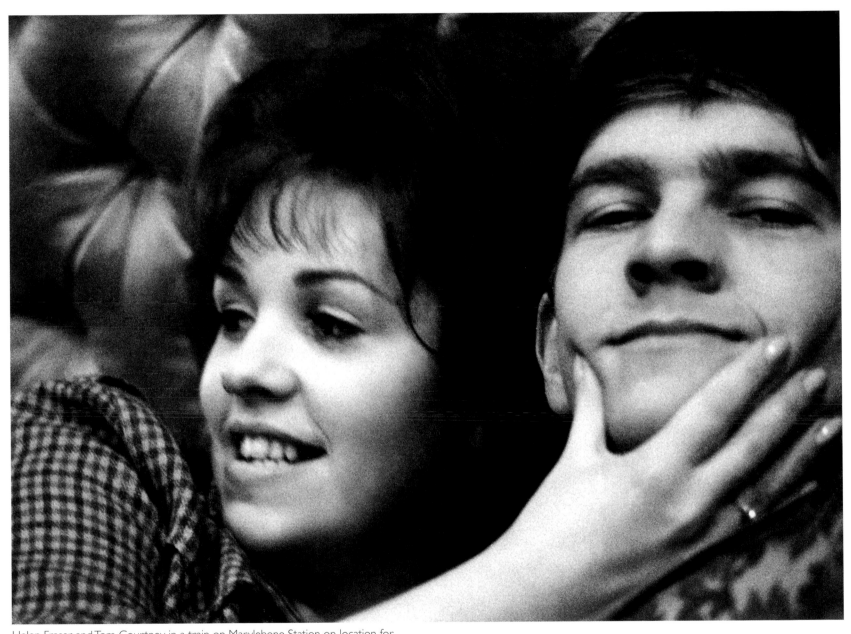

Helen Fraser and Tom Courtney in a train on Marylebone Station on location for
Keith Waterhouse's *Billy Liar*, directed by John Schlesinger, 1963
I got on the set and found Helen and Tom in the railway carriage. They were old
friends and she was teasing him, squashing his cheeks. He looked at me slyly out of the
corner of his eye, trying to make out where he'd seen me before. I would normally
have said hello before I started work, but if I'd waited I'd have missed the shot.

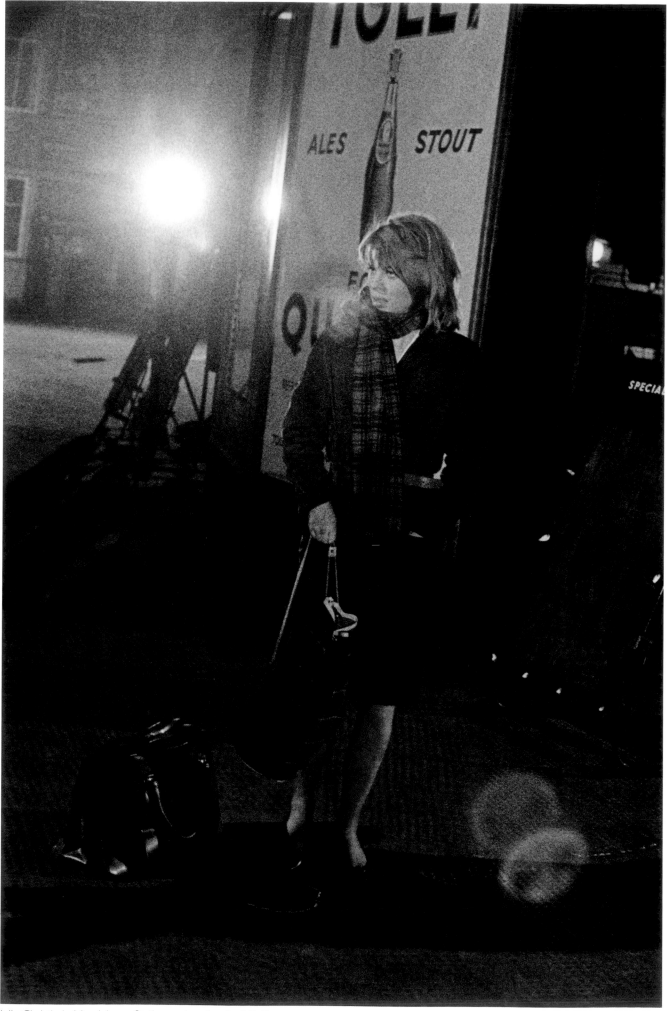

Julie Christie in Marylebone Station on location for *Billy Liar*

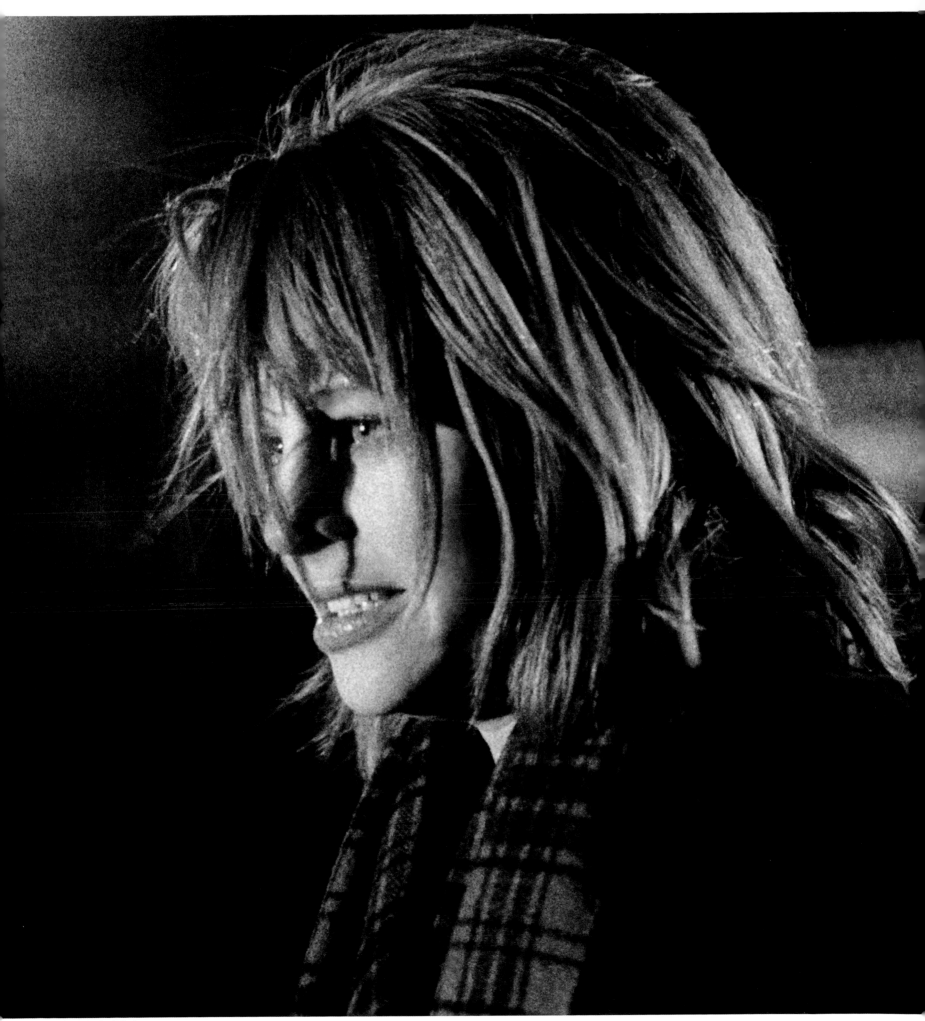

Julie Christie in *Billy Liar*

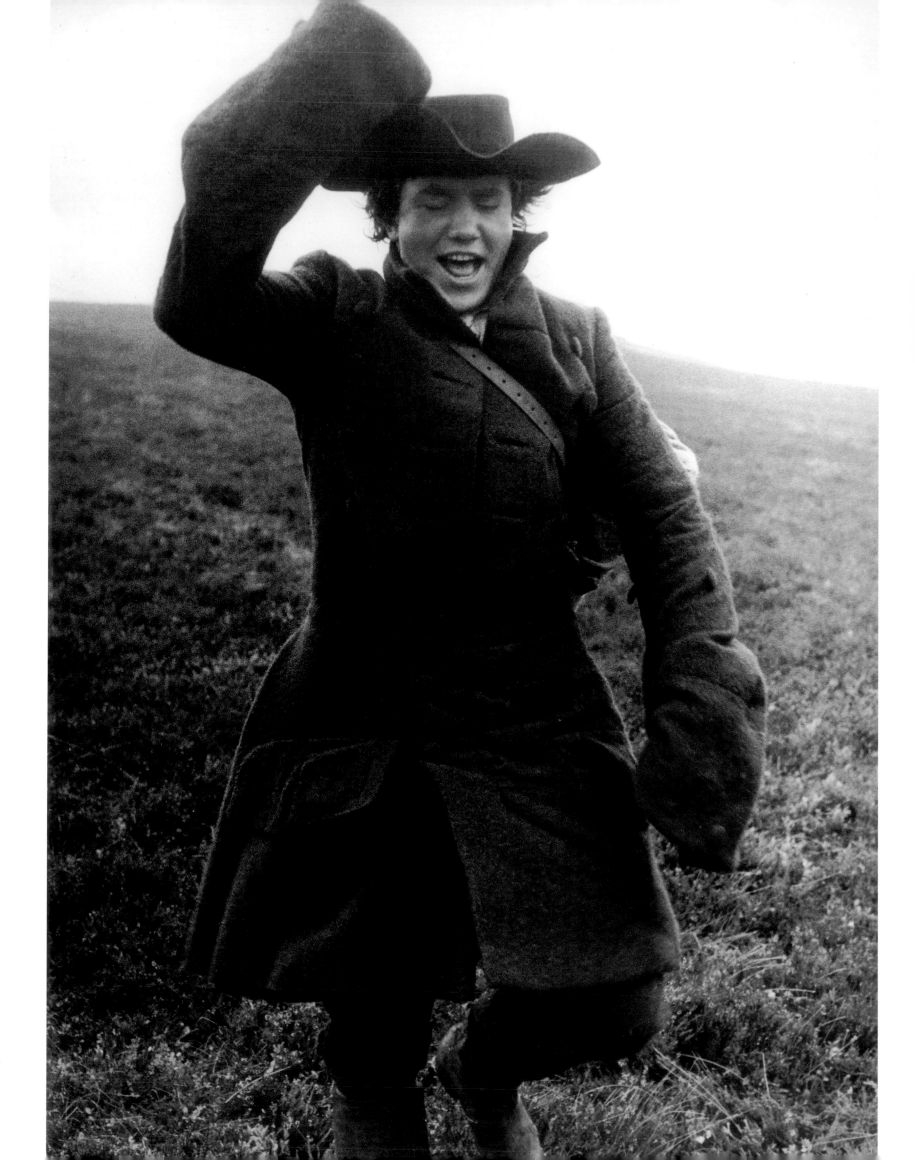

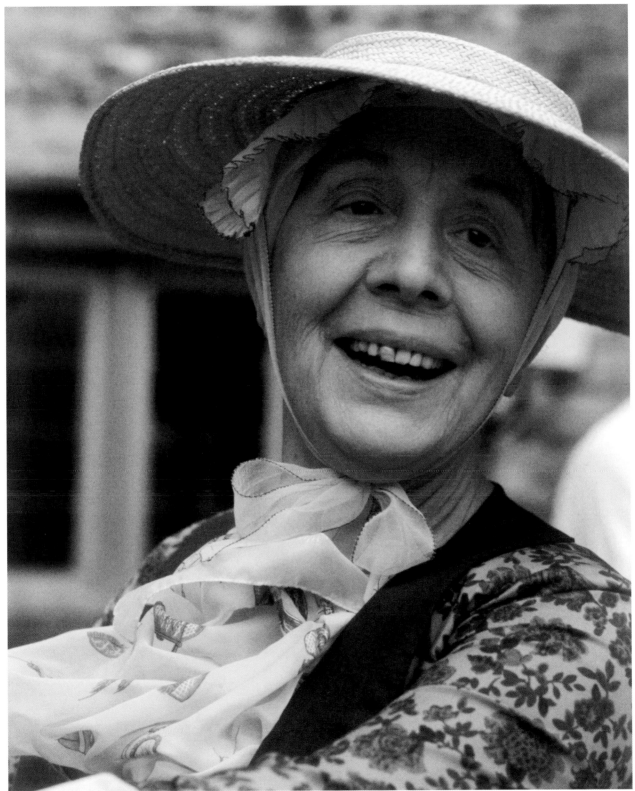

Above Edith Evans on location in Dorset for *Tom Jones*, with film script by John Osborne
from Henry Fielding's novel, directed by Tony Richardson, 1962
Edith was in the middle of a farmyard. She was enjoying herself batting some hens
around. She was always flouncing around on the set, whamming into animals and laying
into things generally. Very game. Exactly what her character needed.

Left Albert Finney as Tom on his walk to London in *Tom Jones*

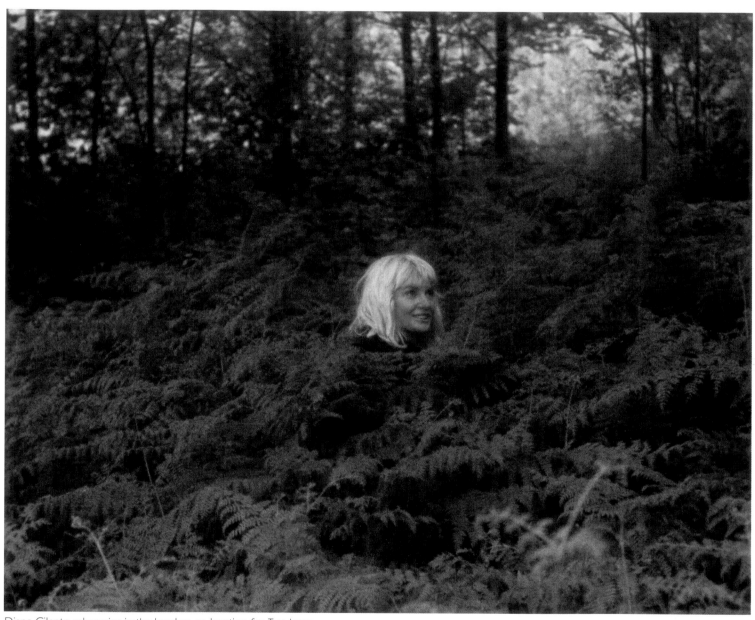

Diane Cilento rehearsing in the bracken on location for *Tom Jones*

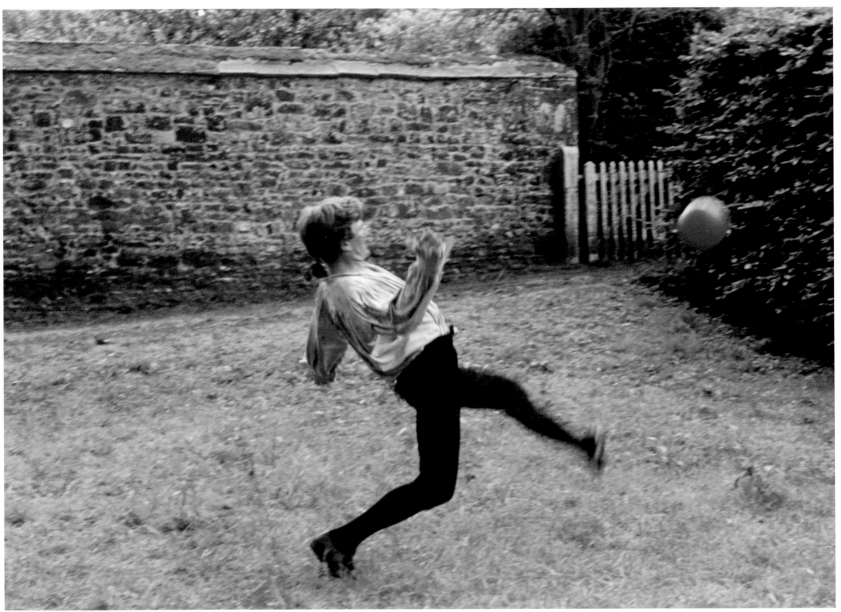

Albert Finney playing football in his tights between shots while filming on location for *Tom Jones*

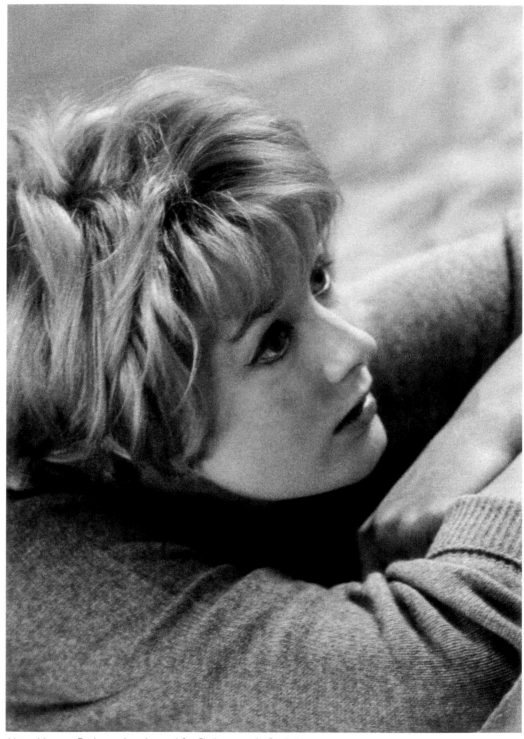

Above Vanessa Redgrave in rehearsal for Shakespeare's *Cymbeline*,
directed by William Gaskill, at the Aldwych Theatre, 1962

Right Vanessa Redgrave on location for *The Loneliness of the Long Distance Runner*, 1962
She came on the set with this little tiny dog, who was shivering, and she pushed him
inside her coat so all you could see was his head.

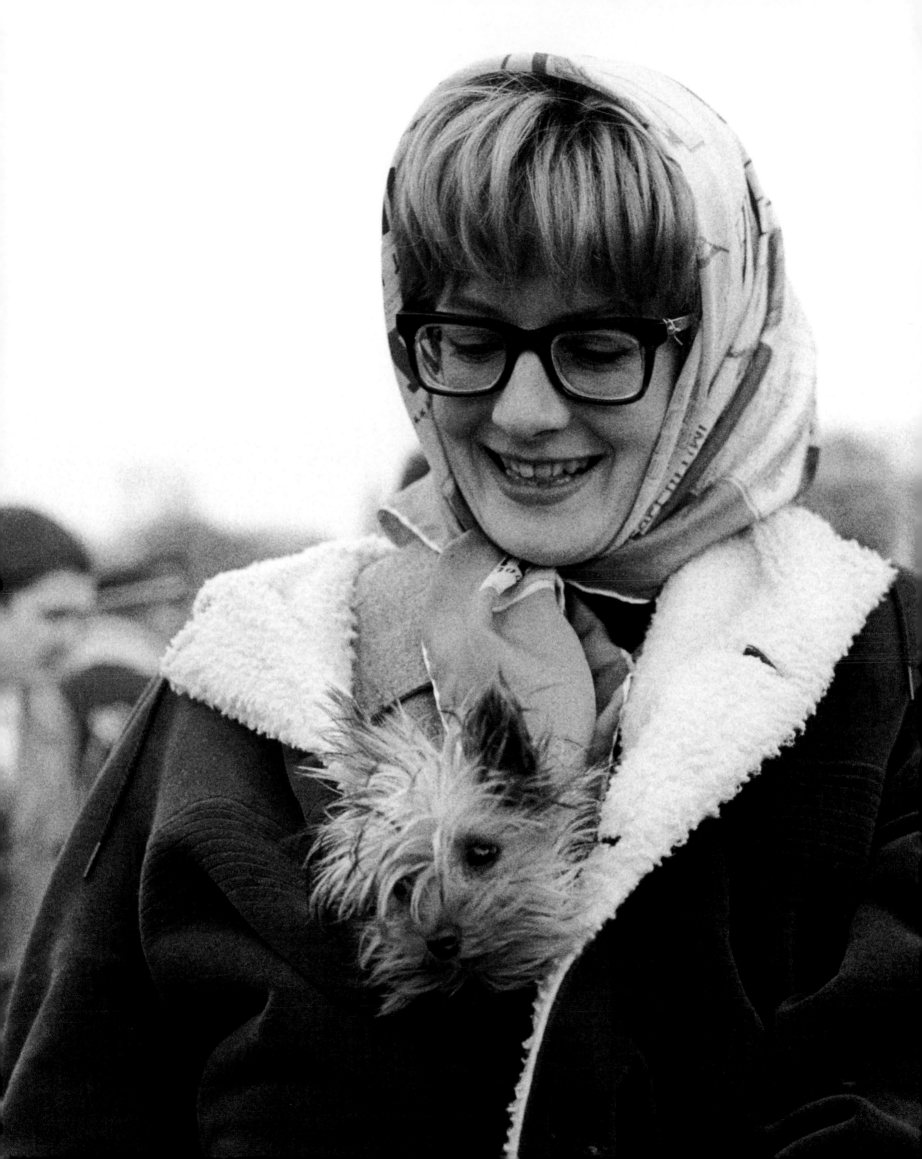

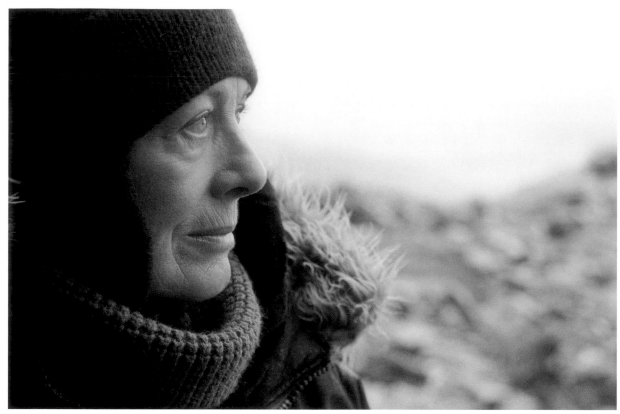

Above and right Vanessa Redgrave on location in Wales for *The Fever*,
based on a play by Wallace Shawn, directed by Carlo Nero, 2003

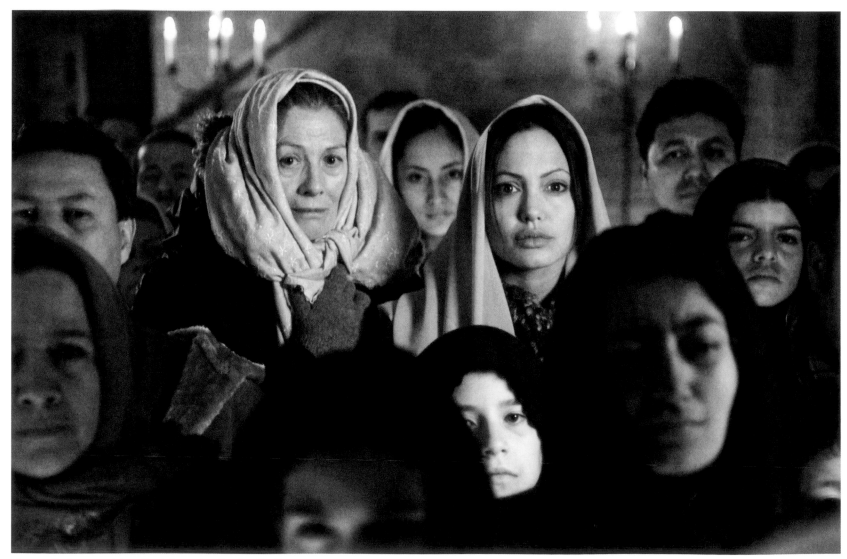

Vanessa Redgrave and Angelina Jolie on location for *The Fever*

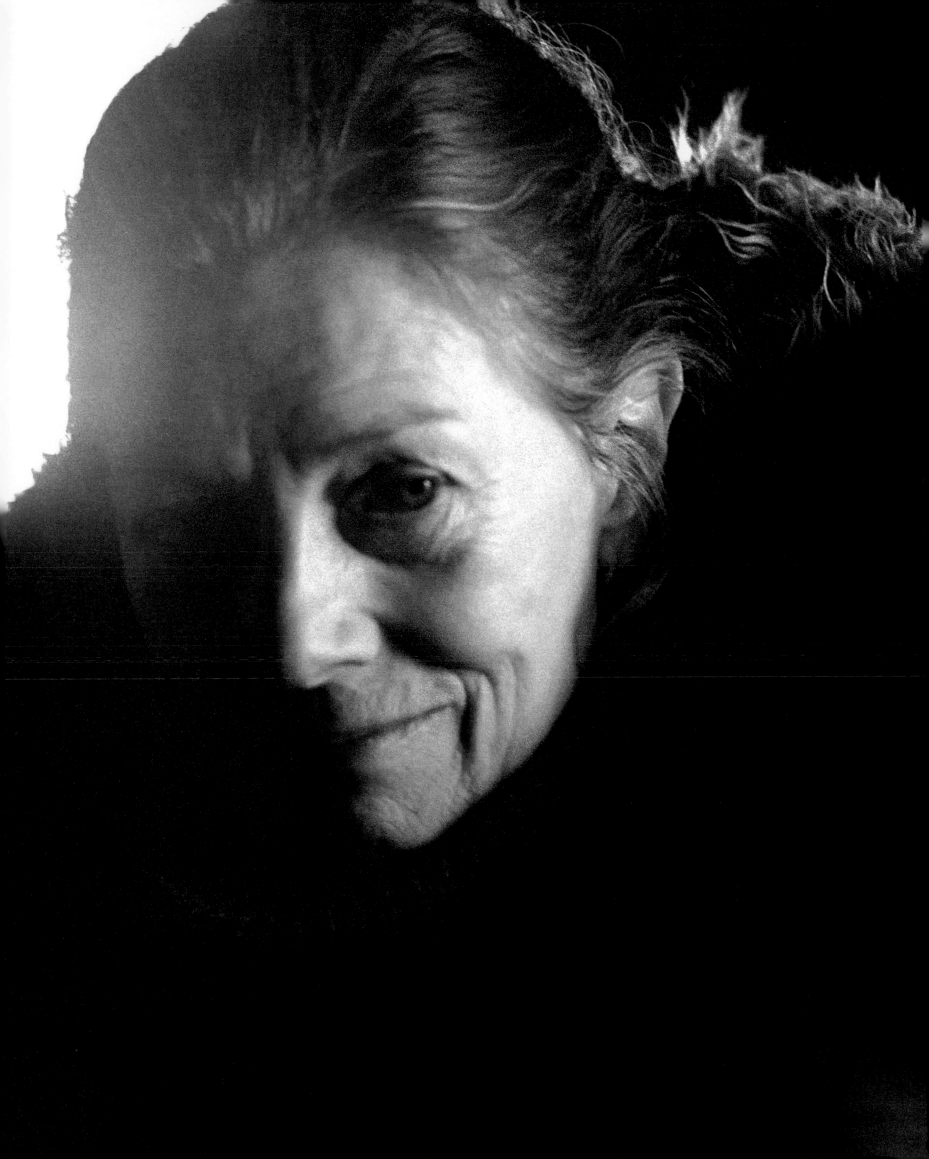

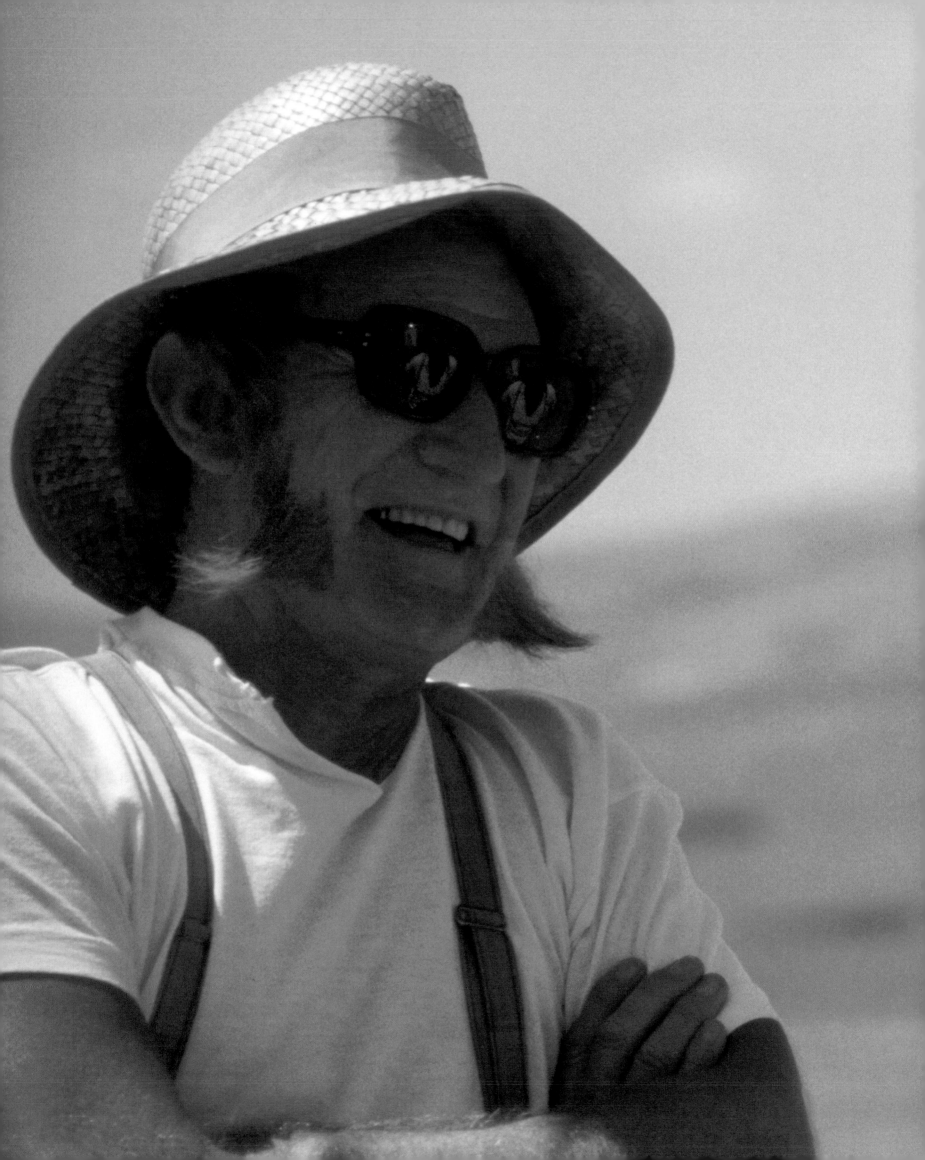

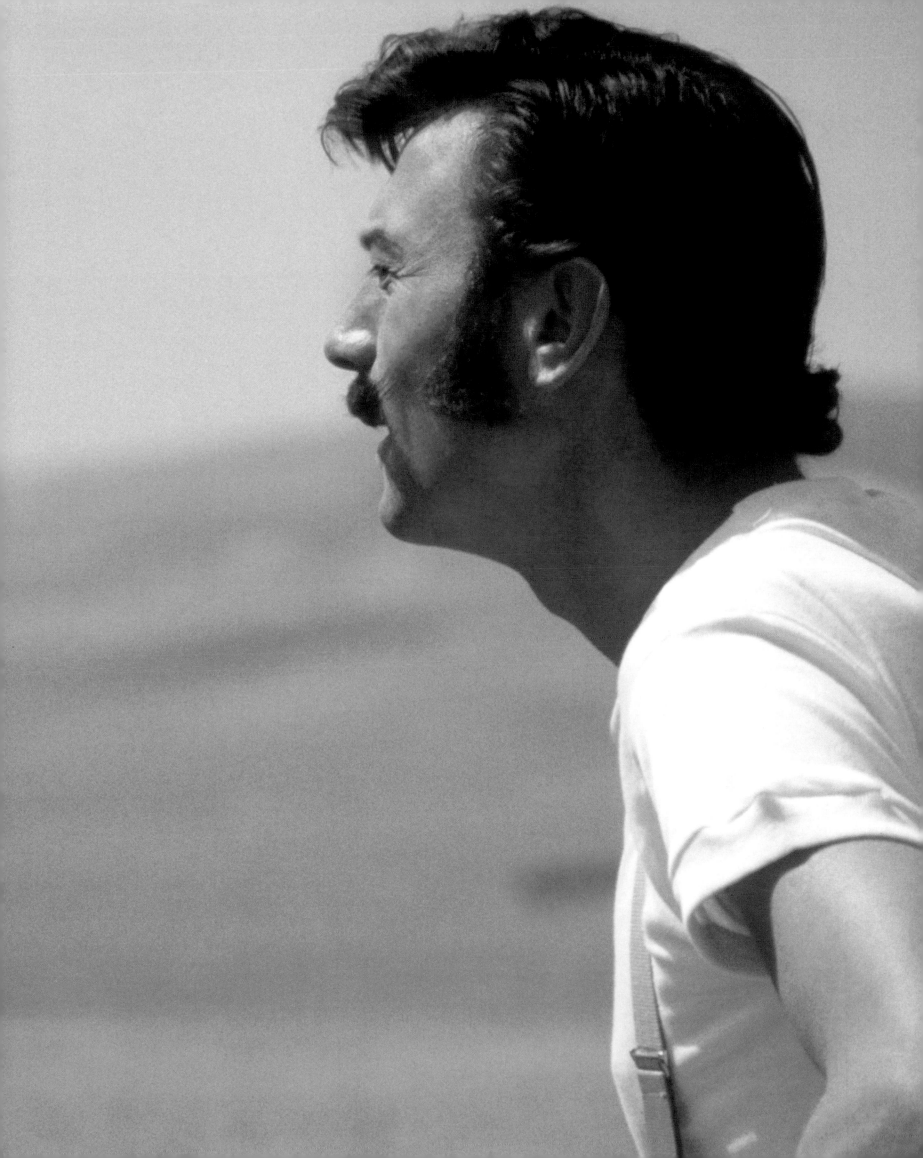

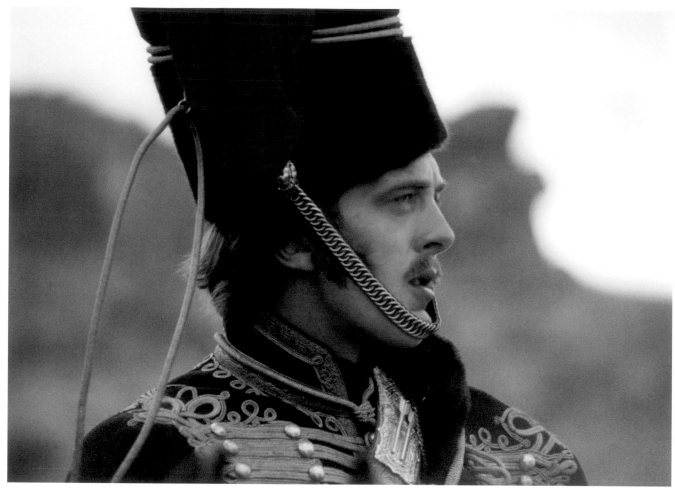

Above David Hemmings in *The Charge of the Light Brigade*

Below David Hemmings riding his horse on the set of *The Charge of the Light Brigade*
Tony Richardson had the whole valley ploughed because the green of the grass was too vibrant.

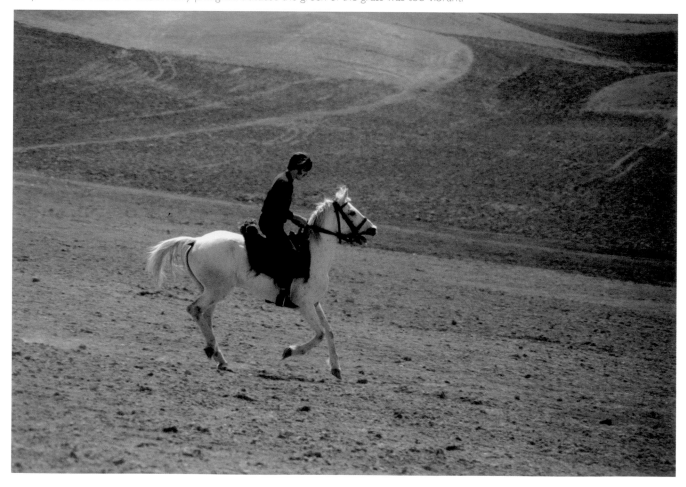

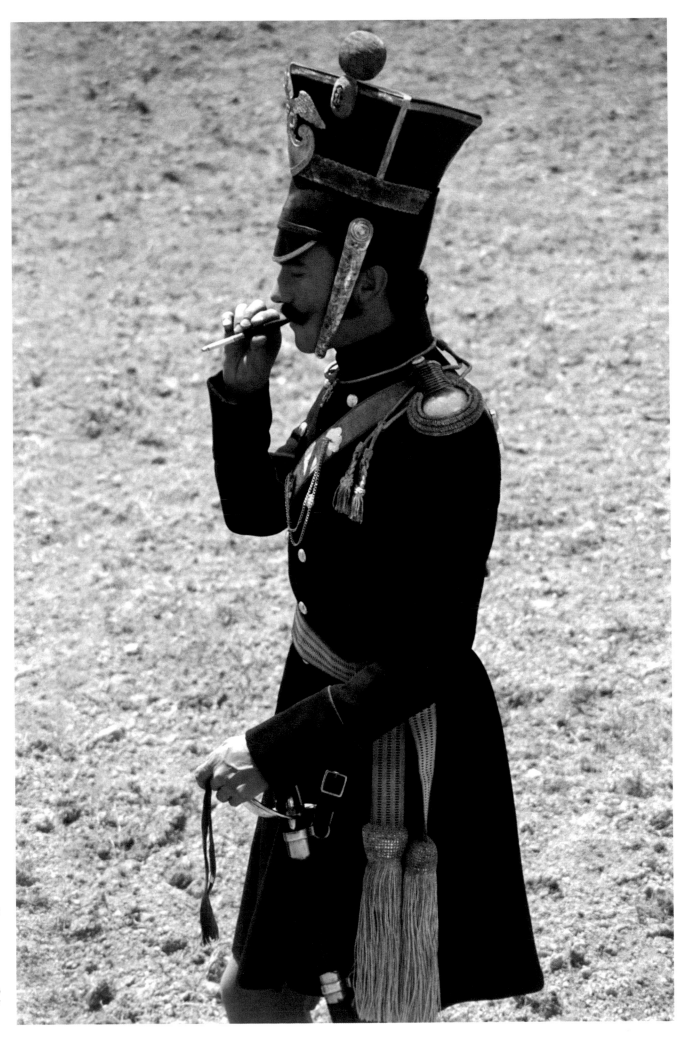

Pages 54–55 Trevor Howard
and Laurence Harvey on location
in Turkey for *The Charge of
the Light Brigade*, screenplay
by Charles Wood, directed by
Tony Richardson, 1967

Right Laurence Harvey waiting to
work on the set of *The Charge of
the Light Brigade*

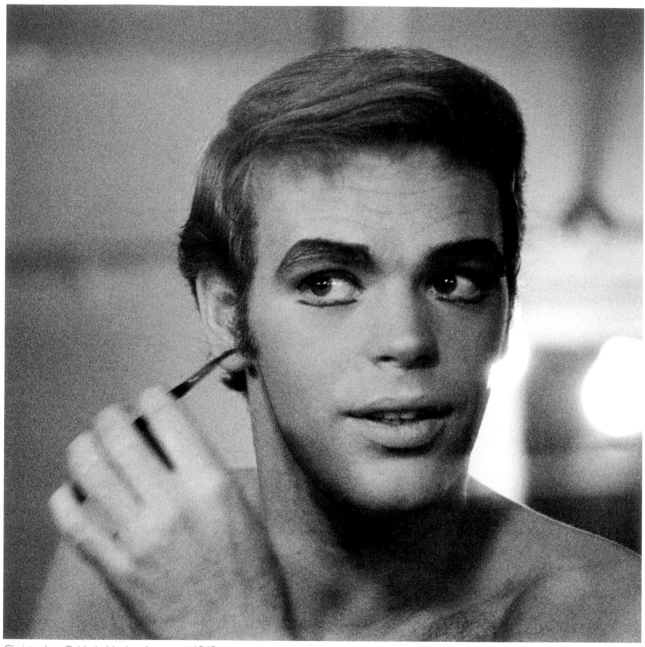

Christopher Gable in his dressing room, 1963

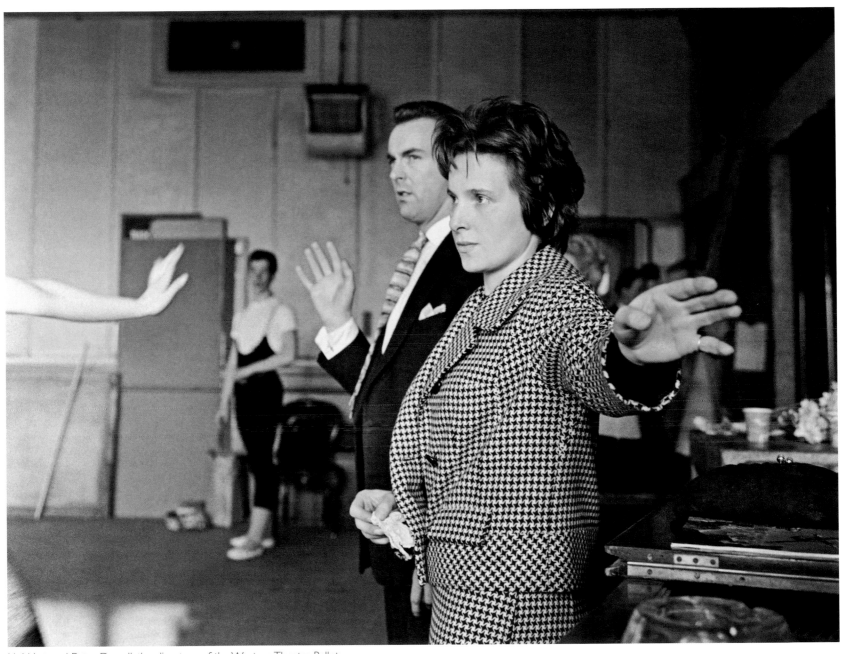

Liz West and Peter Darrell, the directors of the Western Theatre Ballet, taking a rehearsal while on tour with company, 1964

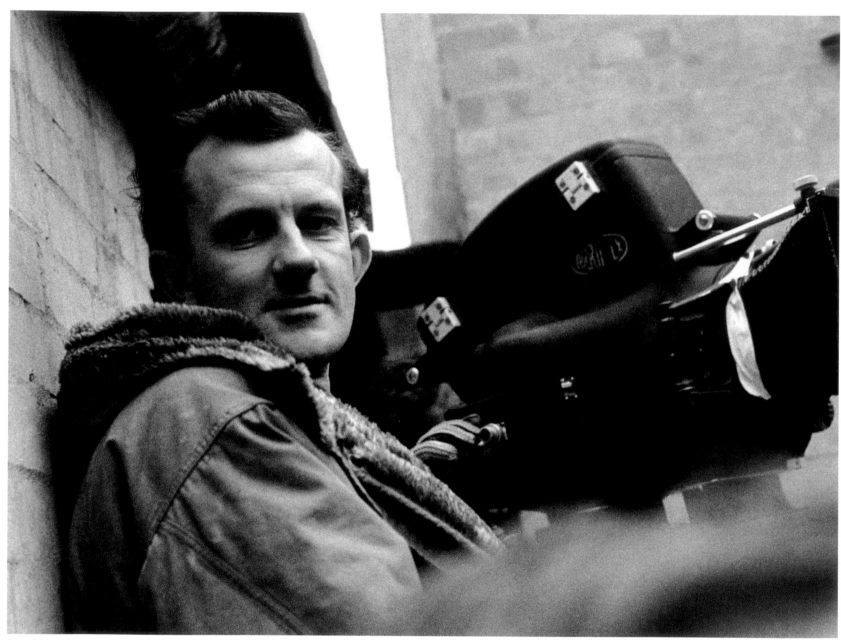

Tony Richardson on the set of *The Loneliness of the Long Distance Runner,* 1962

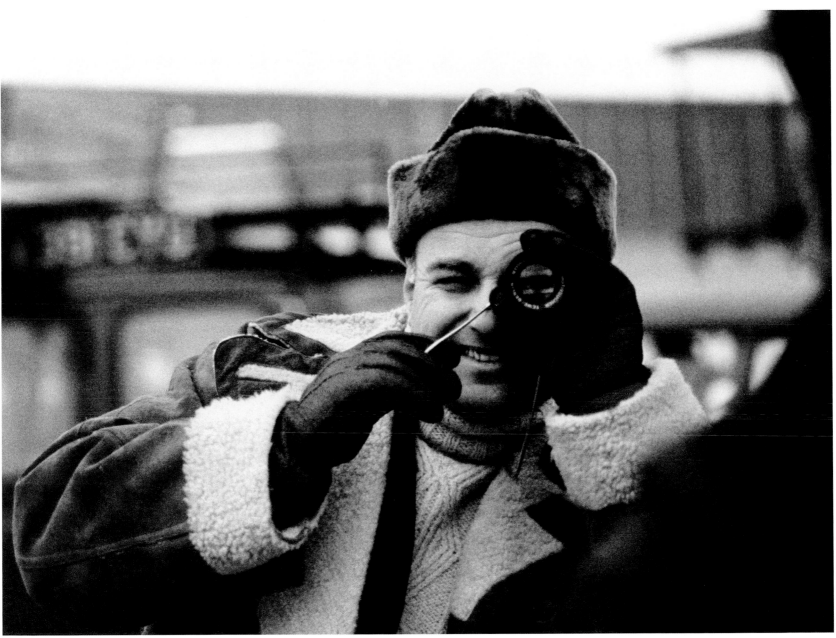

John Schlesinger on the set of *Billy Liar*, 1963

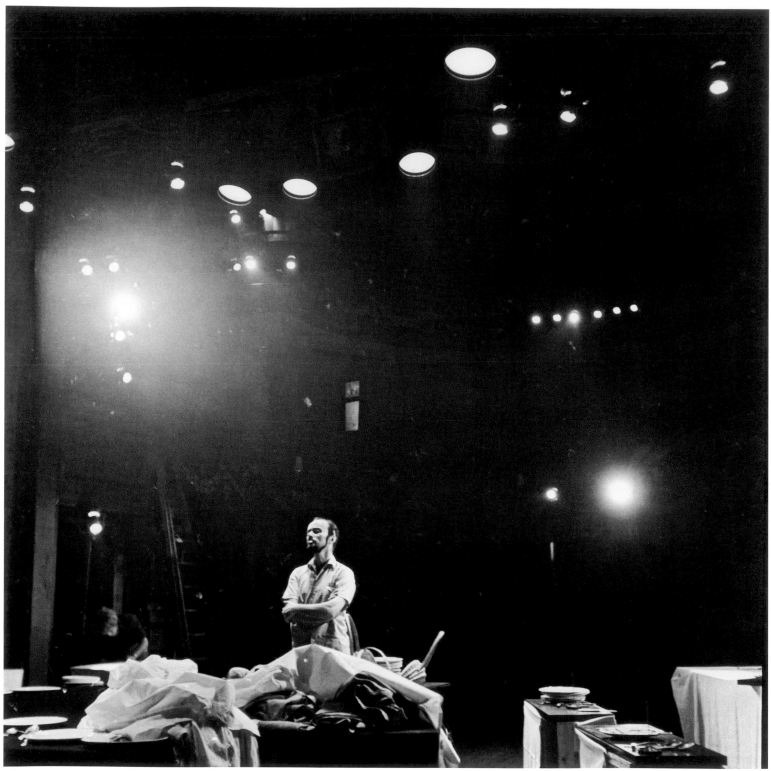

John Dexter on the set of *The Kitchen* by Arnold Wesker, at the Royal Court Theatre, 1959

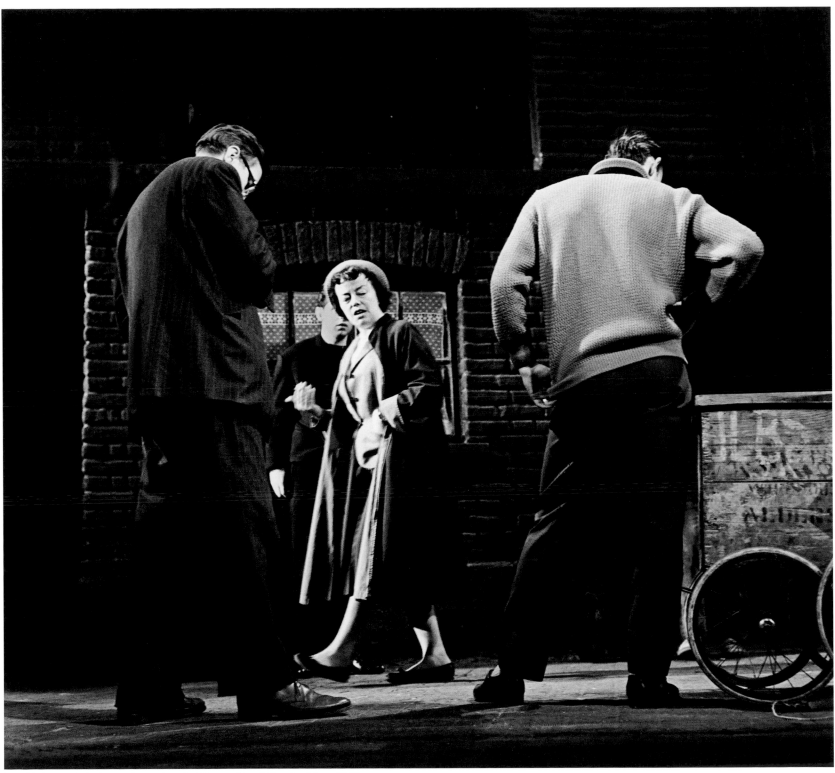

Joan Littlewood during a rehearsal at the Theatre Royal, Stratford East, 1962

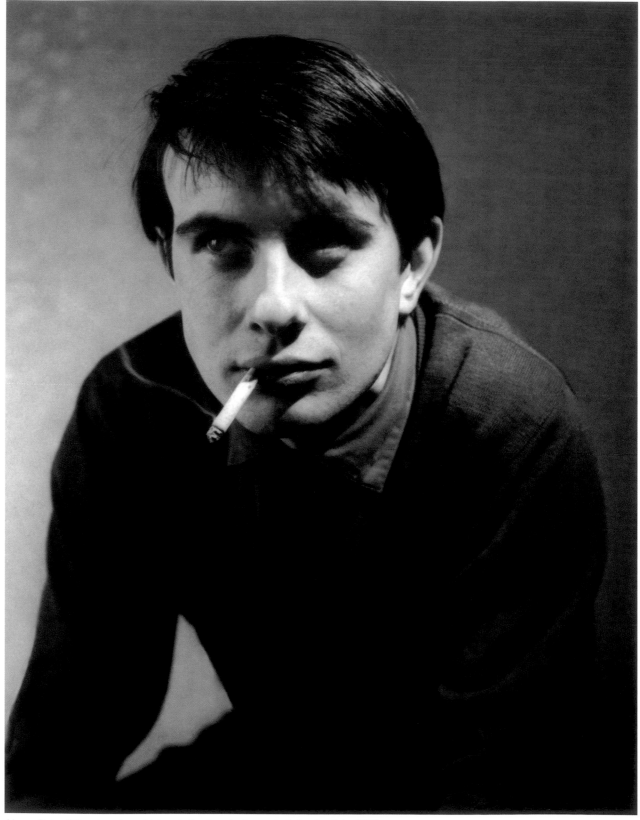

Above Peter Gill, actor, playwright and director, studio portrait for *Spotlight*, 1959

Right George Devine on the set of *Tom Jones*, 1962
I photographed George quite a bit over the years and for some reason it was really hard to find the face of the man I knew, as he looked when I sat opposite him, listening when he was talking to someone over dinner or giving notes, puffing on his pipe. But when I came across him on the set of *Tom Jones*, talking to Tony Richardson, I saw the face and concentration that I had been searching for. It's the photograph of him that my mother liked best.

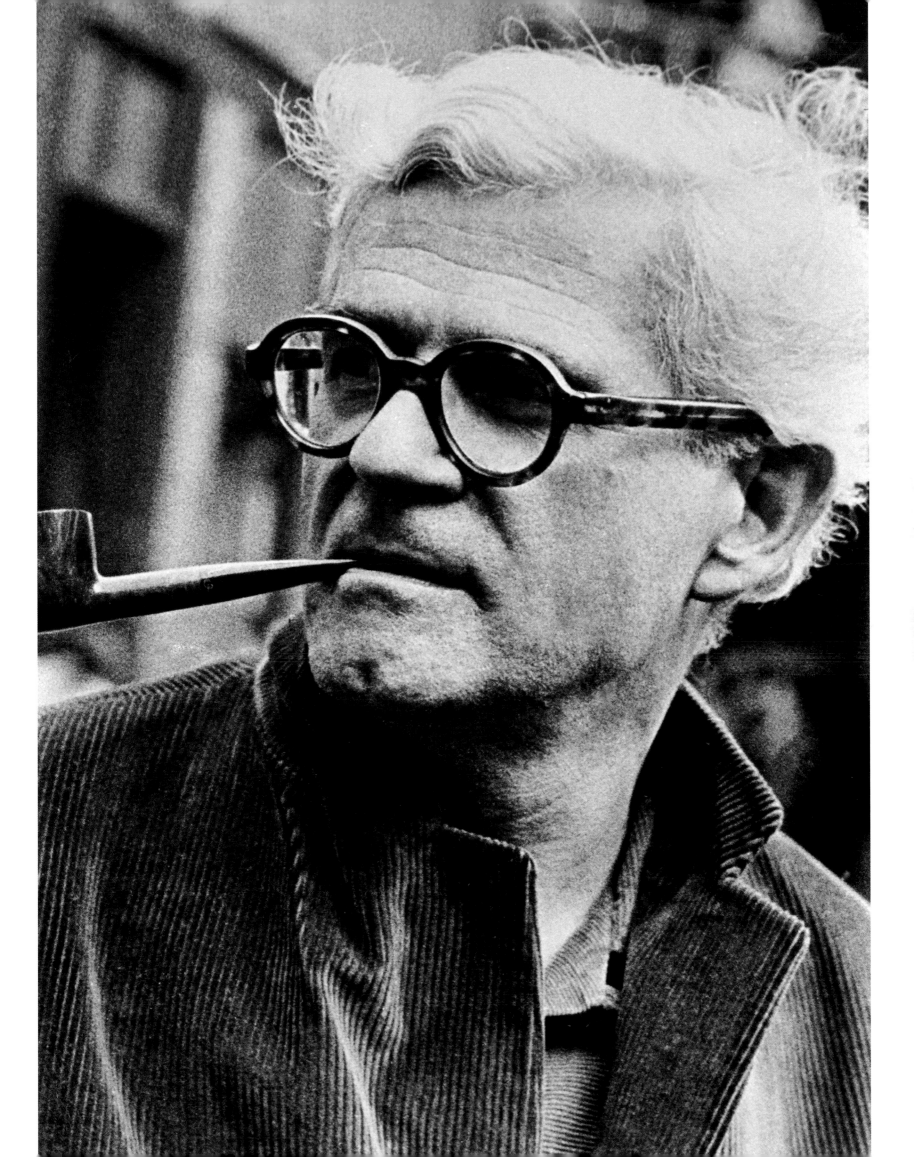

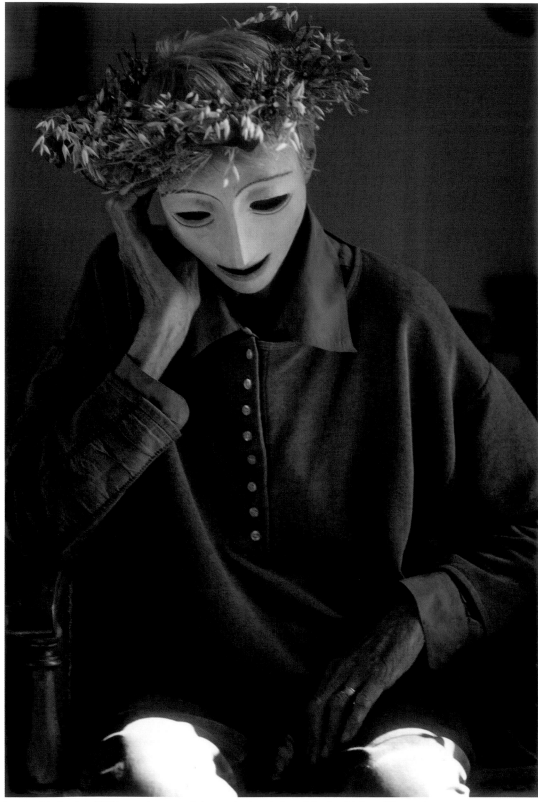

Jocelyn Herbert in 2000, wearing one of the masks she designed for the National Theatre's 1981 production of Tony Harrison's version of Aeschylus' *The Oresteia*. She is also wearing her granddaughter's wedding wreath of dried grasses.

I had asked my mother if I could photograph her hands working on the masks. Wearing them was entirely her idea and, I felt, a very generous and moving gift that produced an extraordinary set of pictures..

Jocelyn Herbert wearing a Trojan woman's mask from *The Oresteia*, in front of a picture she painted after George Devine's death in 1966

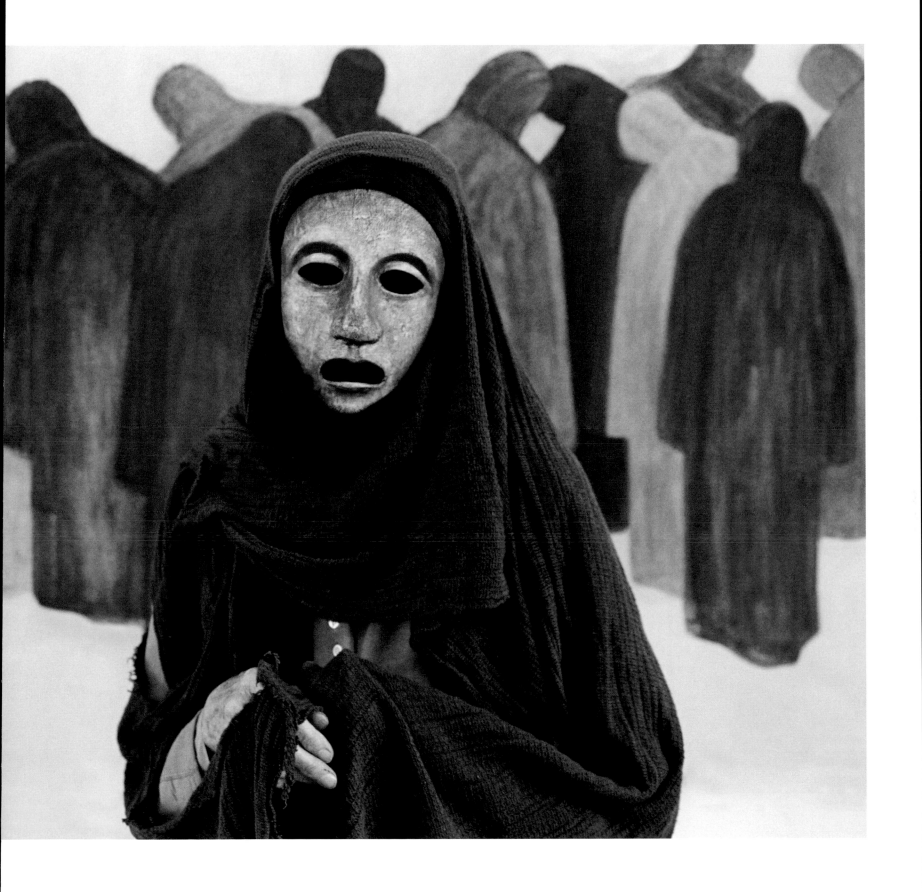

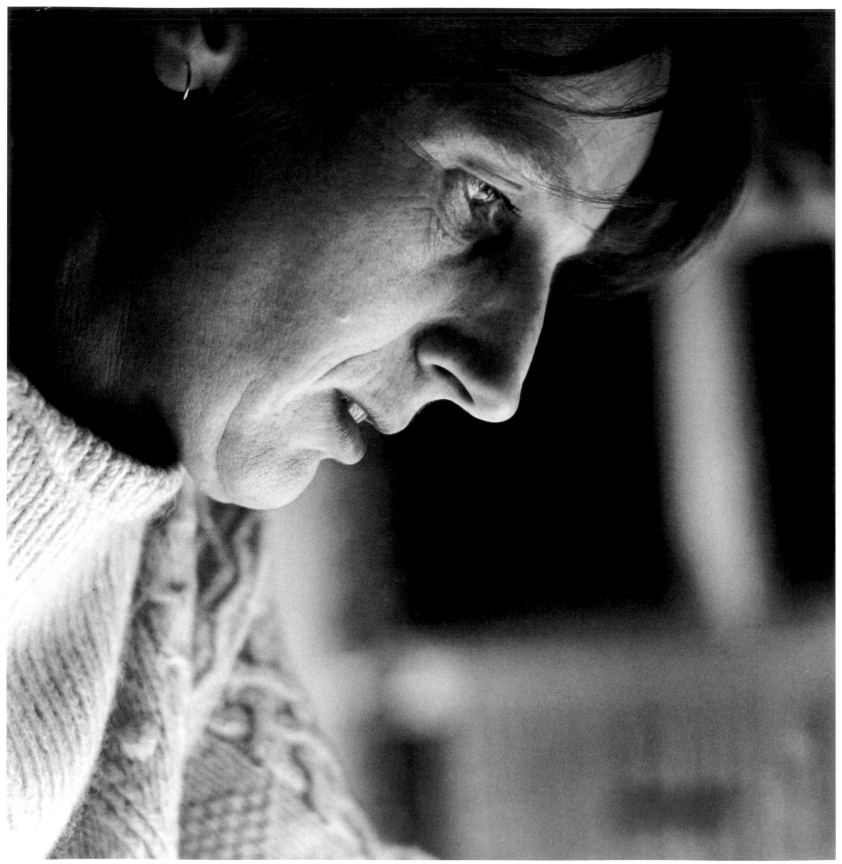

Jocelyn Herbert working on the balcony of the Chelsea studio
she shared with George Devine, 1960

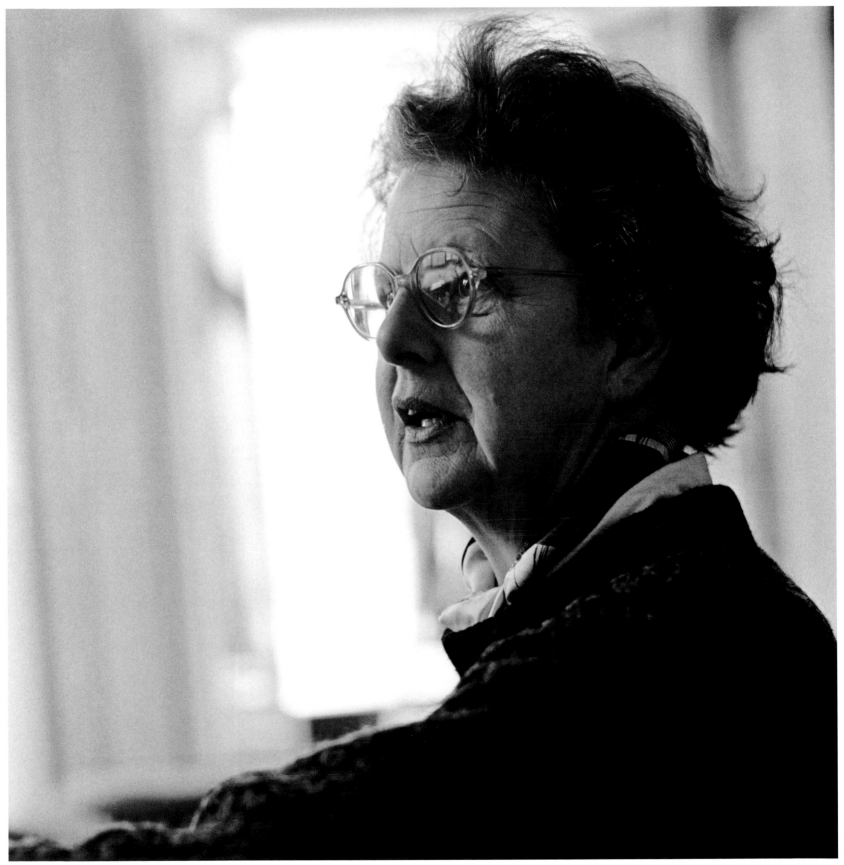

Theatre designer Margaret ('Percy') Harris of Motley, in her studio, 1960

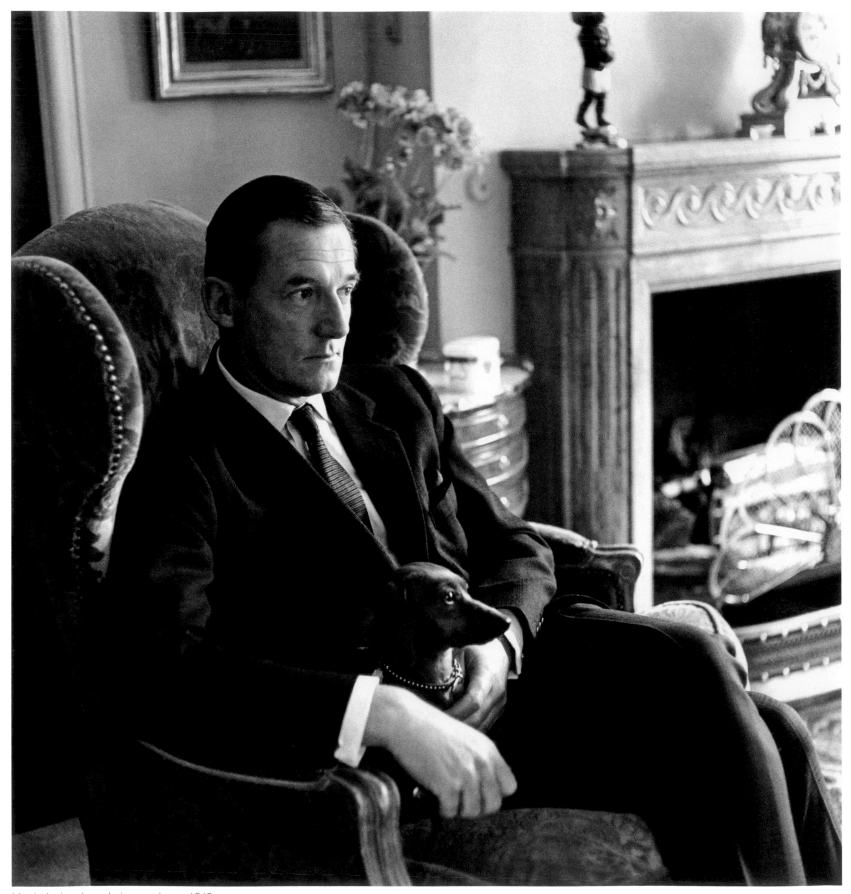

Hardy Amies, dress designer, at home, 1962

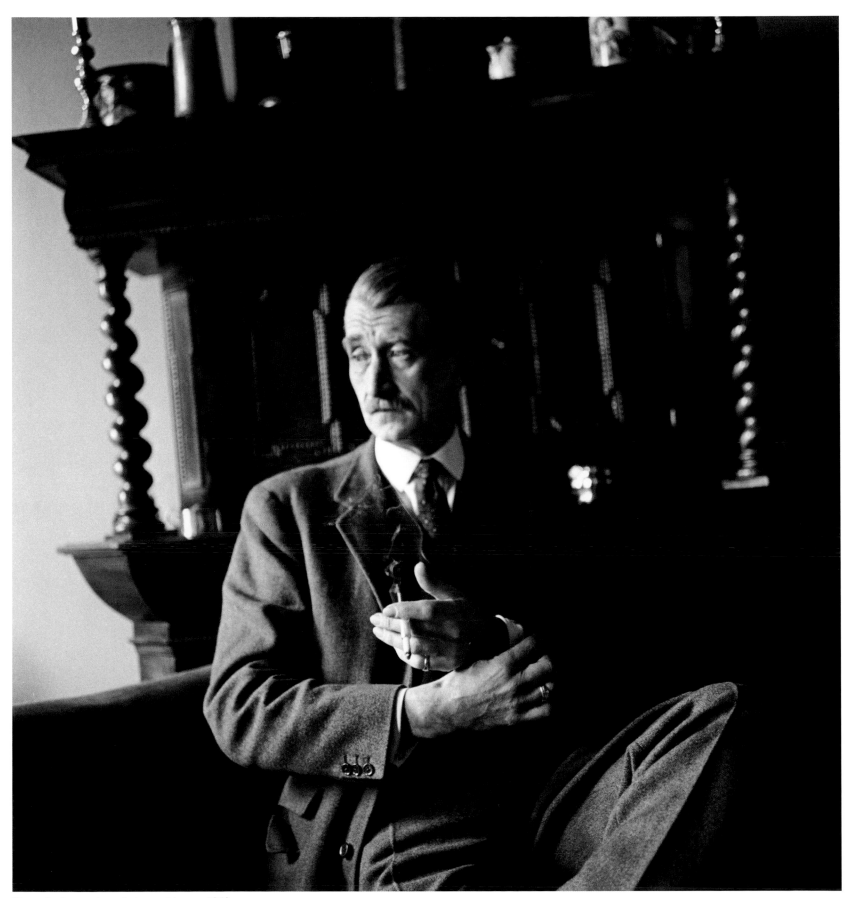

Owen Lachasse, dress designer, at home, 1962

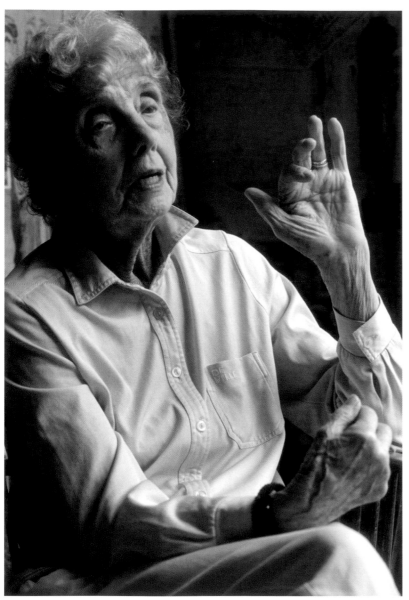

Susie Cooper, ceramicist, at home on the Isle of Man, 1992

Tom Lloyd, designer, in his studio, 1998

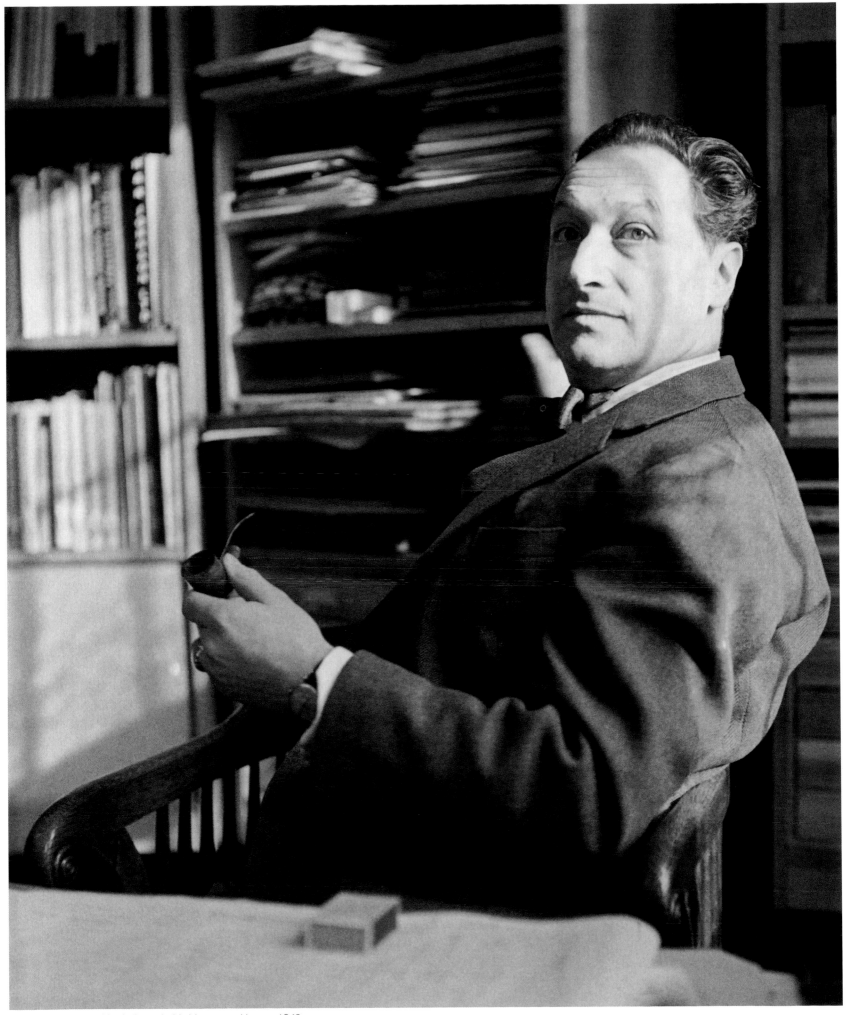

F.H.K. Henrion, graphic designer, in his Hampstead home, 1962

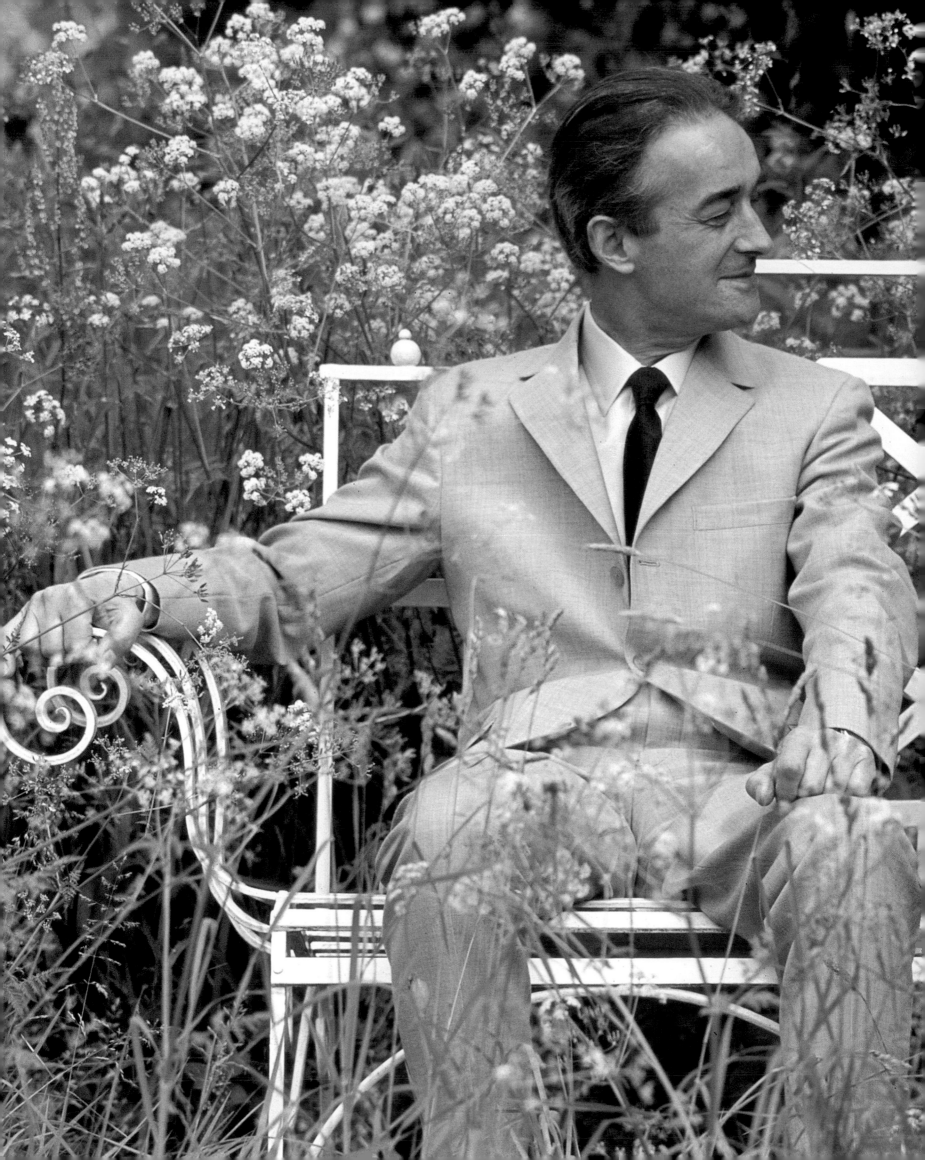

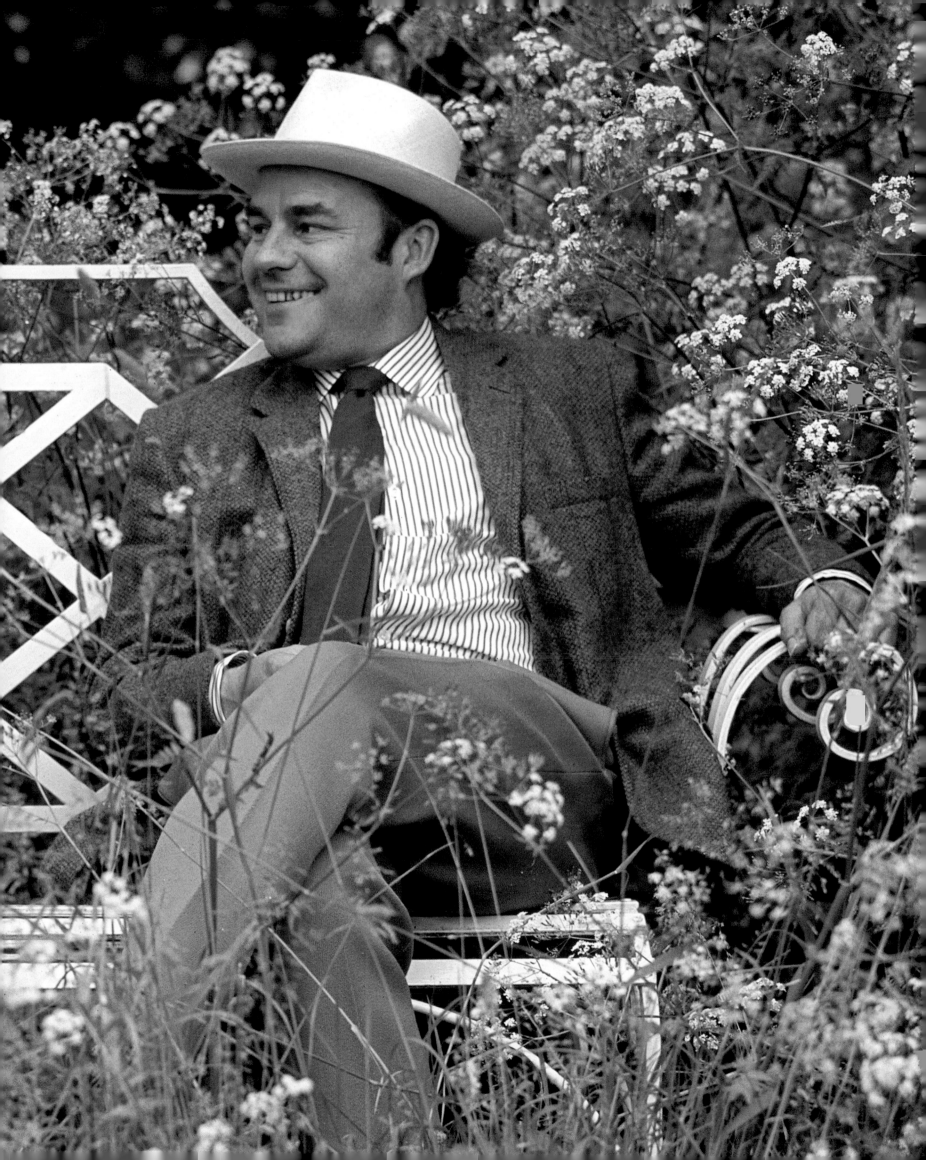

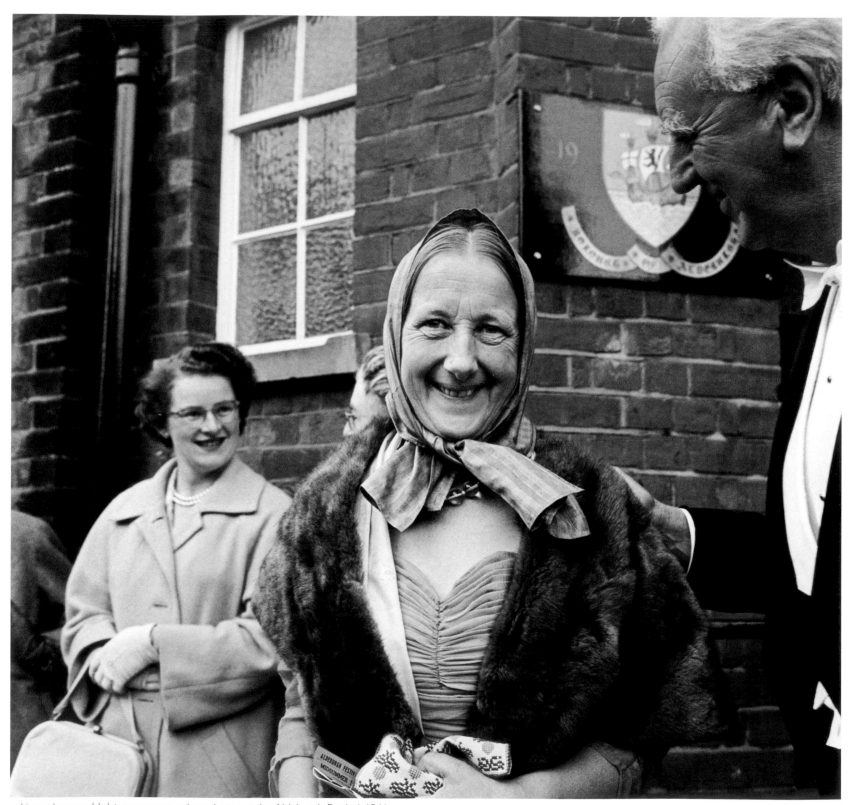

Above Imogen Holst, composer and conductor, at the Aldeburgh Festival, 1961

Pages 74 –75 George Malcolm and Julian Bream, Aldeburgh, 1961
I was four hours late for this portrait – I had a puncture – and when I arrived George Malcolm was quite rightly extremely cross and on the point of leaving. I got out of the car, the seat in the cow parsley was right there, and he gave me five minutes.

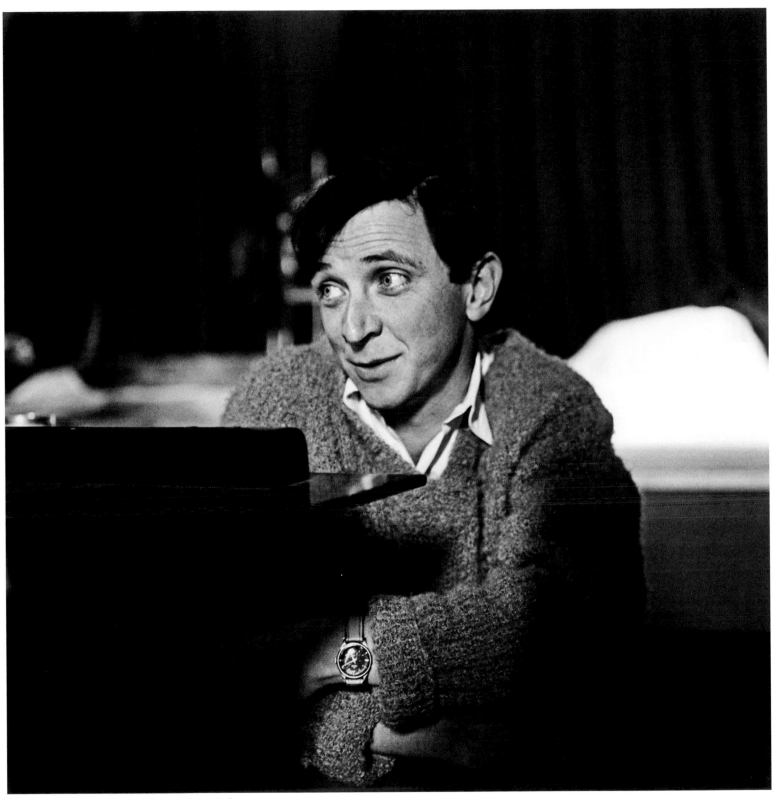

John Cranko, choreographer, during rehearsals for
Shakespeare's *A Midsummer Night's Dream*, music by
Benjamin Britten, Aldeburgh Festival, 1961

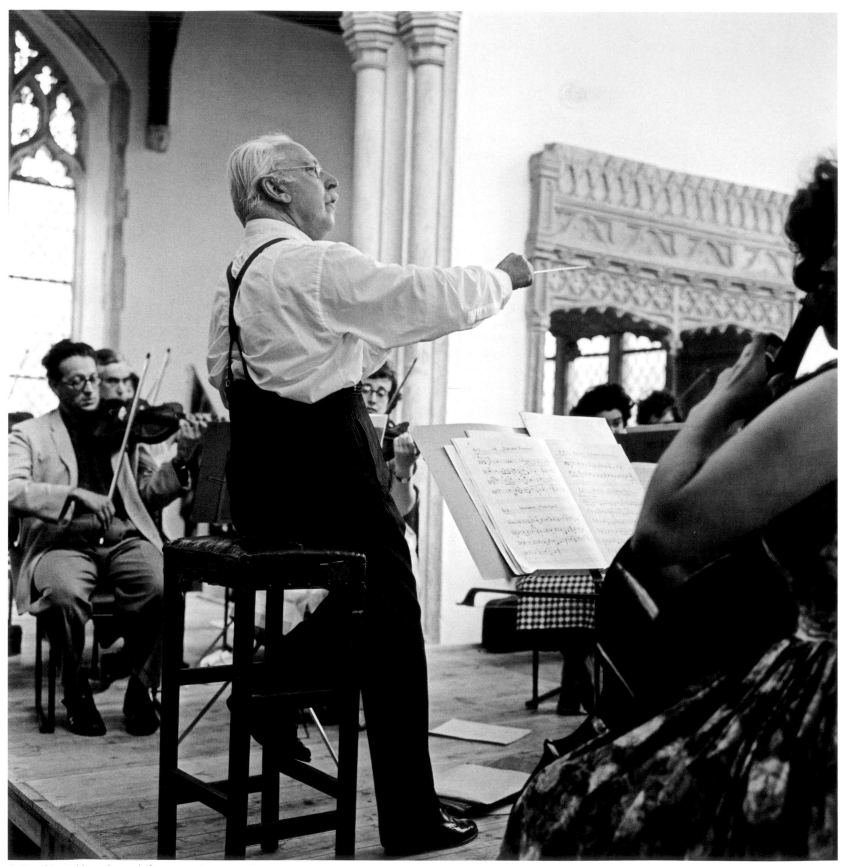

Arthur Bliss, taking rehearsals for an evening concert
in Blythburgh Church, Aldeburgh Festival, 1961

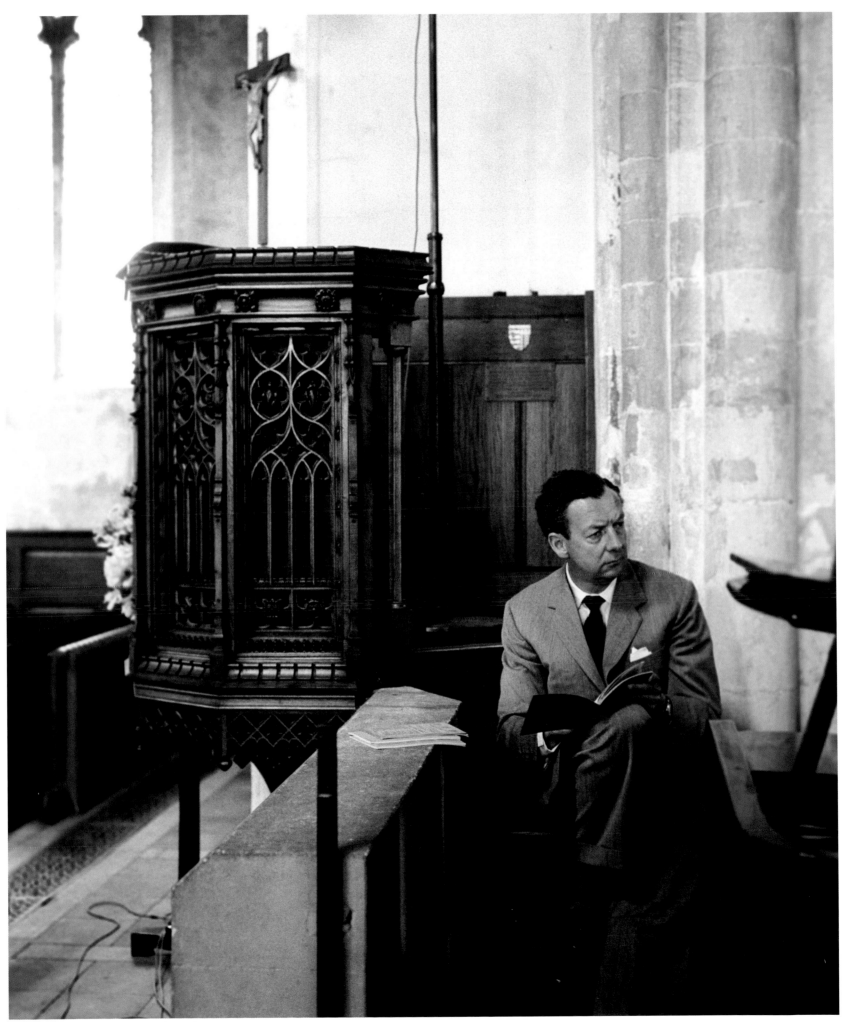

Benjamin Britten, listening to a rehearsal
in Blythburgh Church, Aldeburgh Festival, 1961

Cilla Black and Bobby Willis outside the London Palladium, 1964

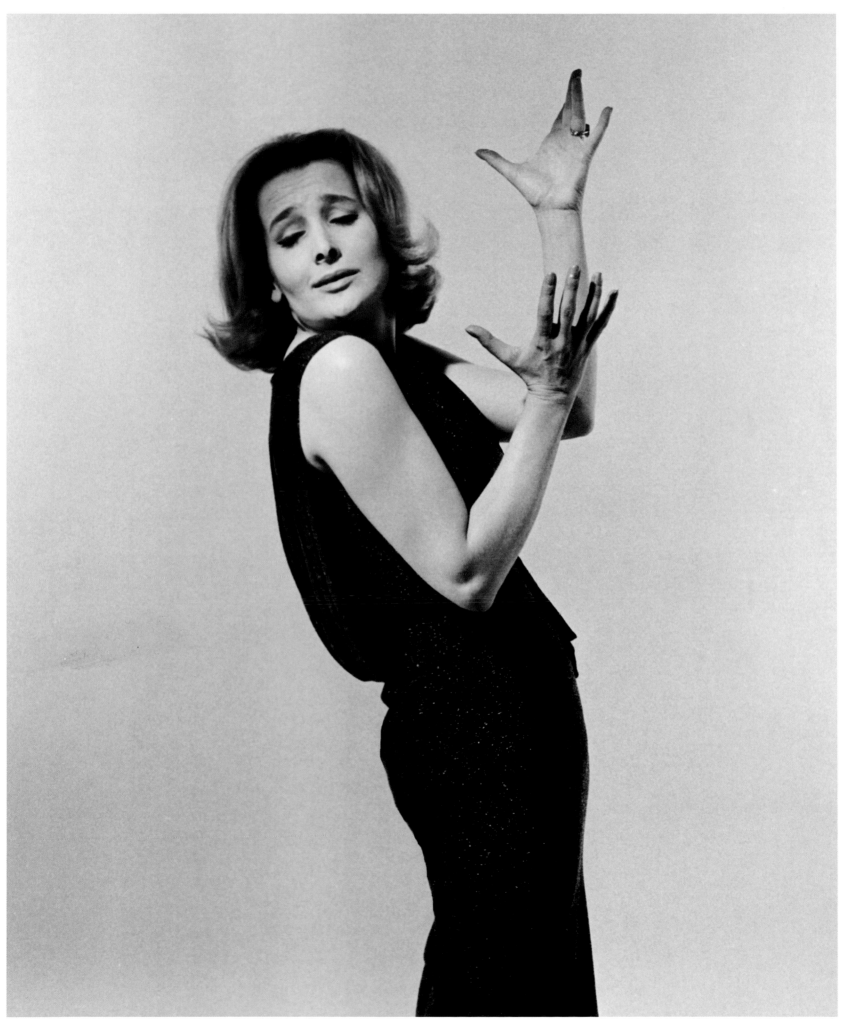

Millicent Martin singing in my studio, 1963

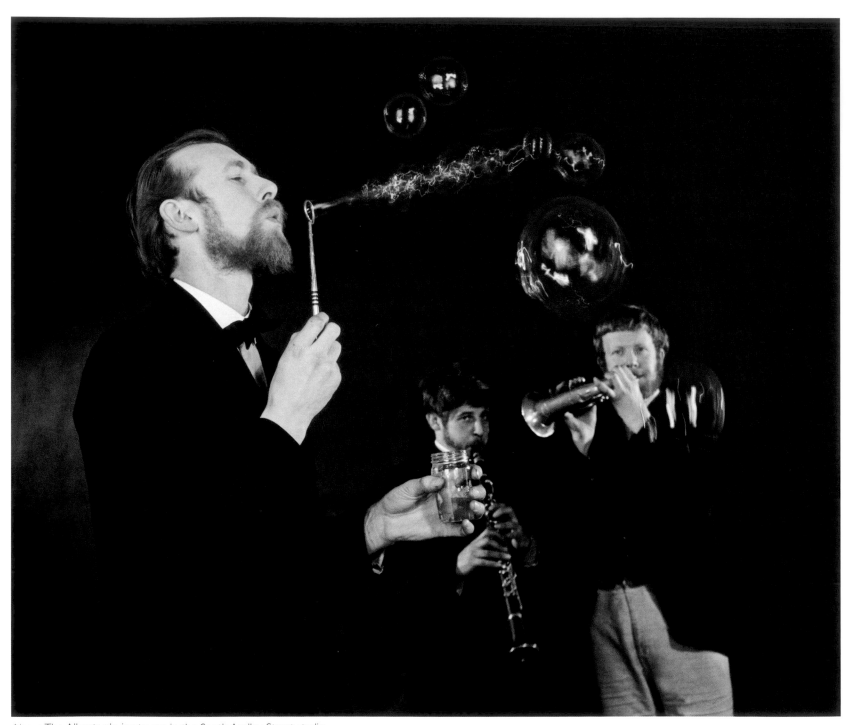

Above The Alberts playing to me in the South Audley Street studio where I had my first job as an assistant, 1958

Right Marianne Faithfull, studio portrait, 1978

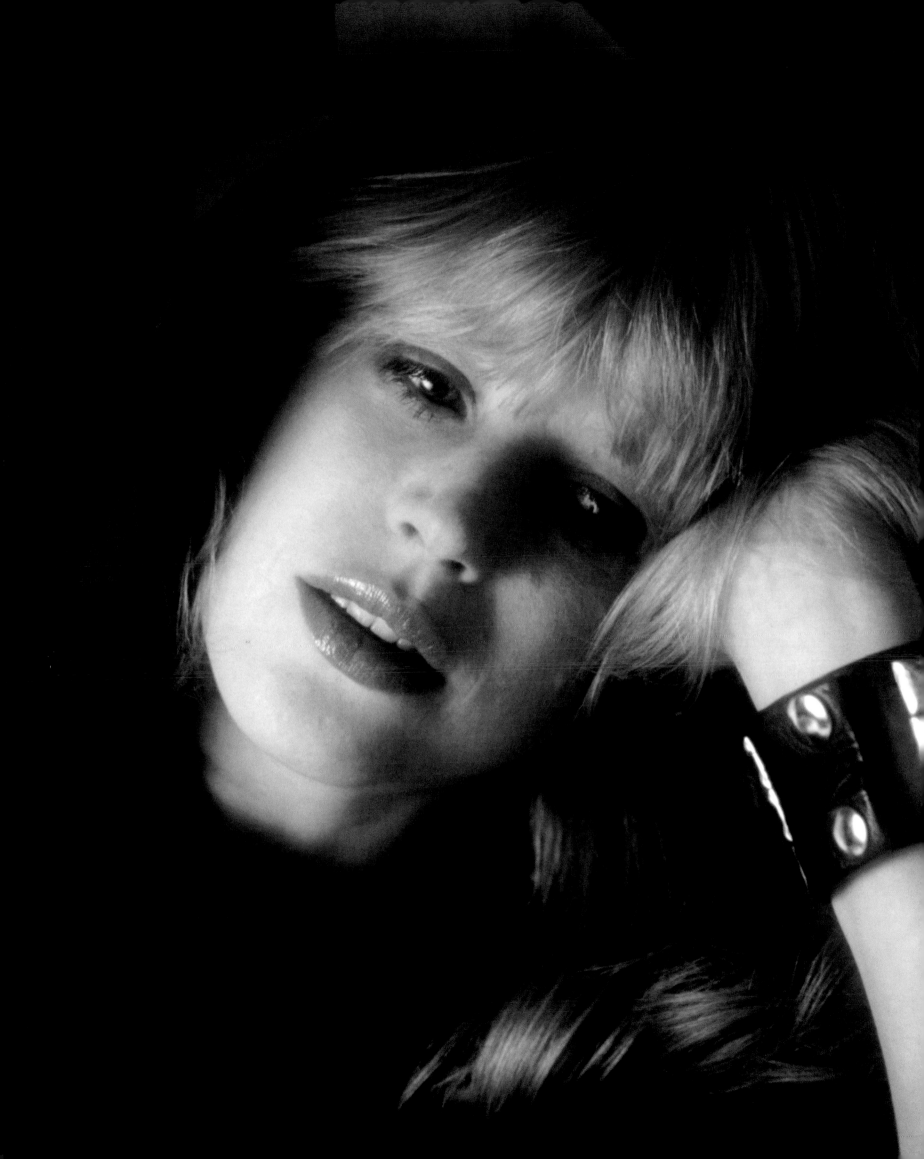

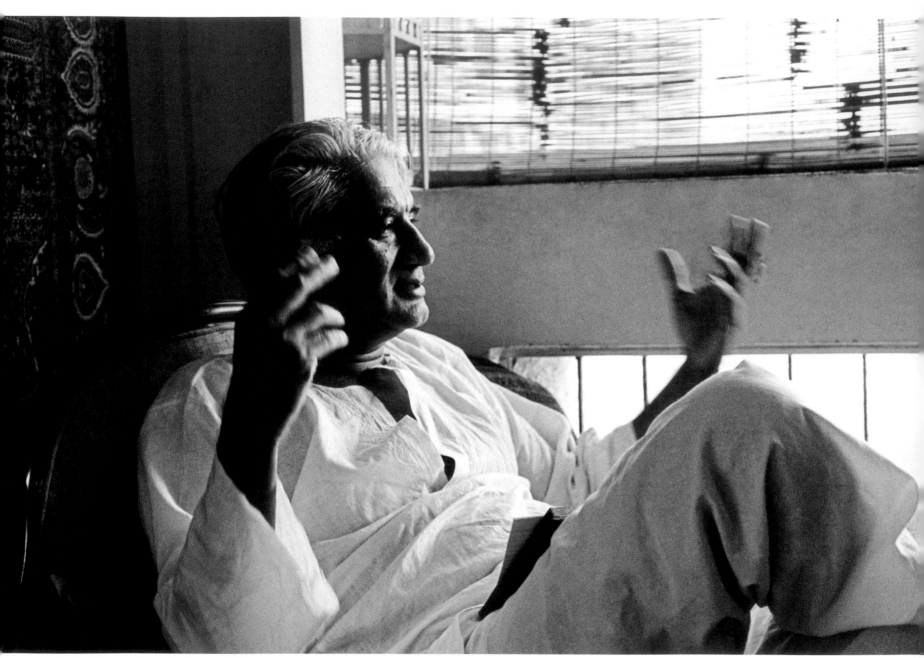

Charles Correa at home in Bombay, 1993

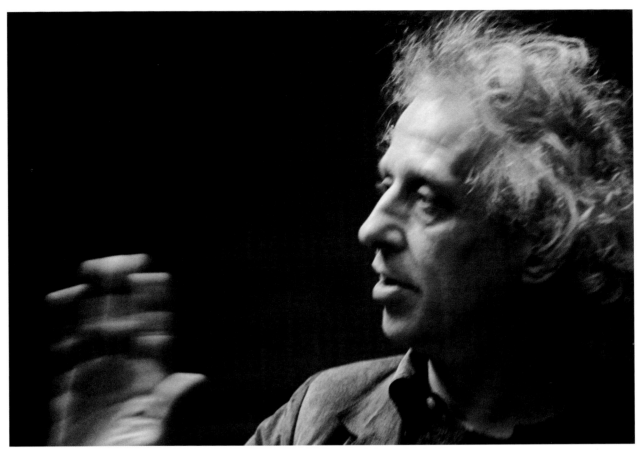

Aldo van Eyck during a Team X meeting in the church he designed
in The Hague, 1964

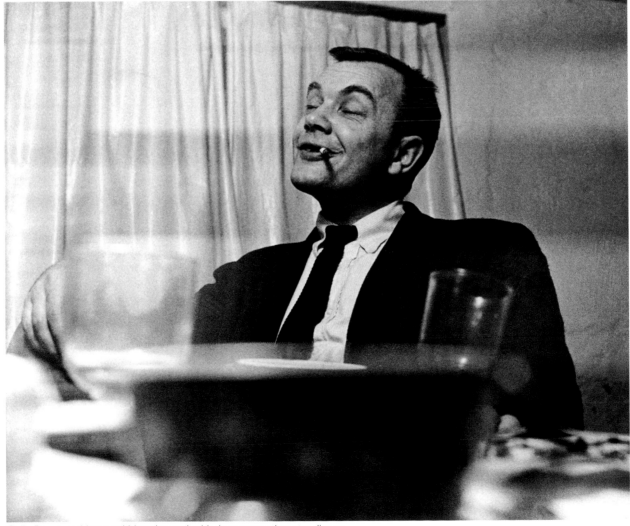

Colin Rowe, architectural historian and critic, in conversation at a dinner
in Cambridge, 1960

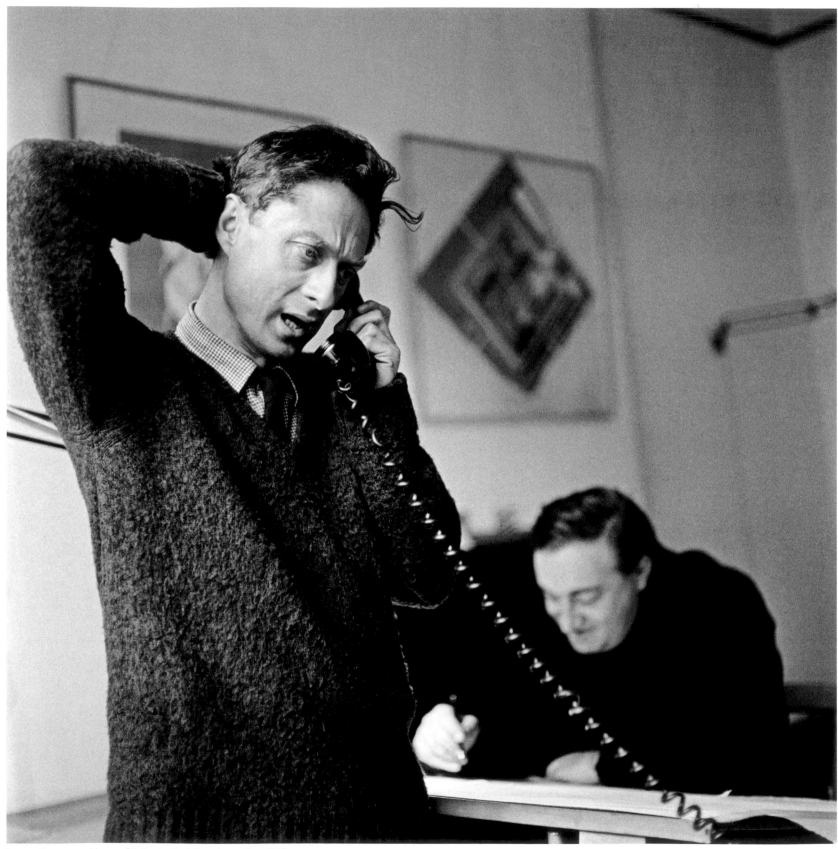

James Gowan and James Stirling in their London office, 1962

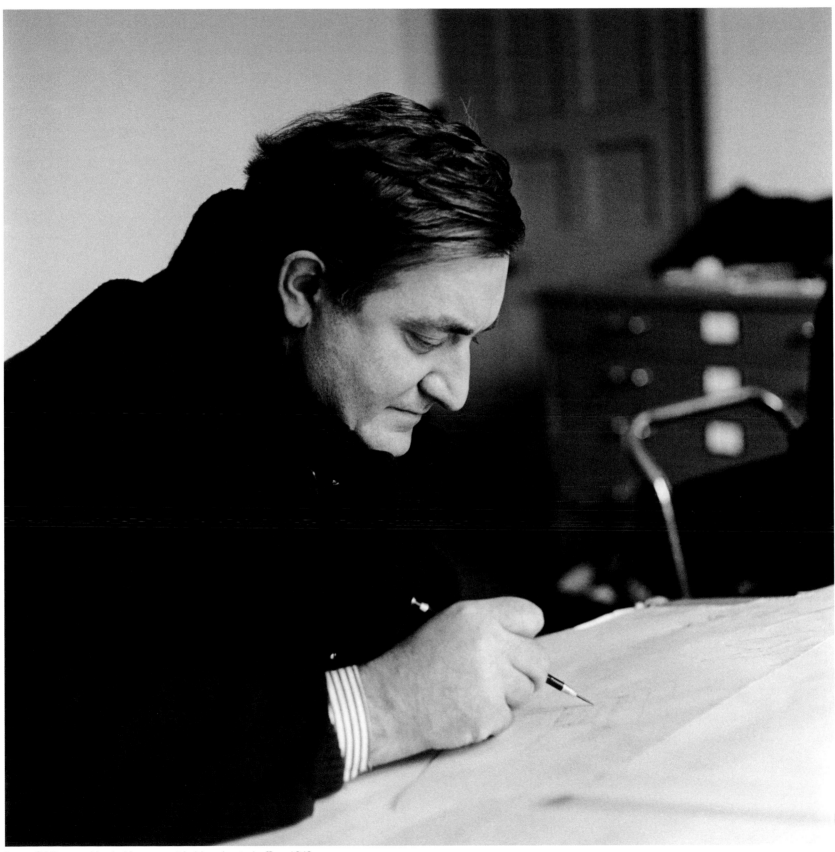

James Stirling working in his overcoat in his unheated office, 1962

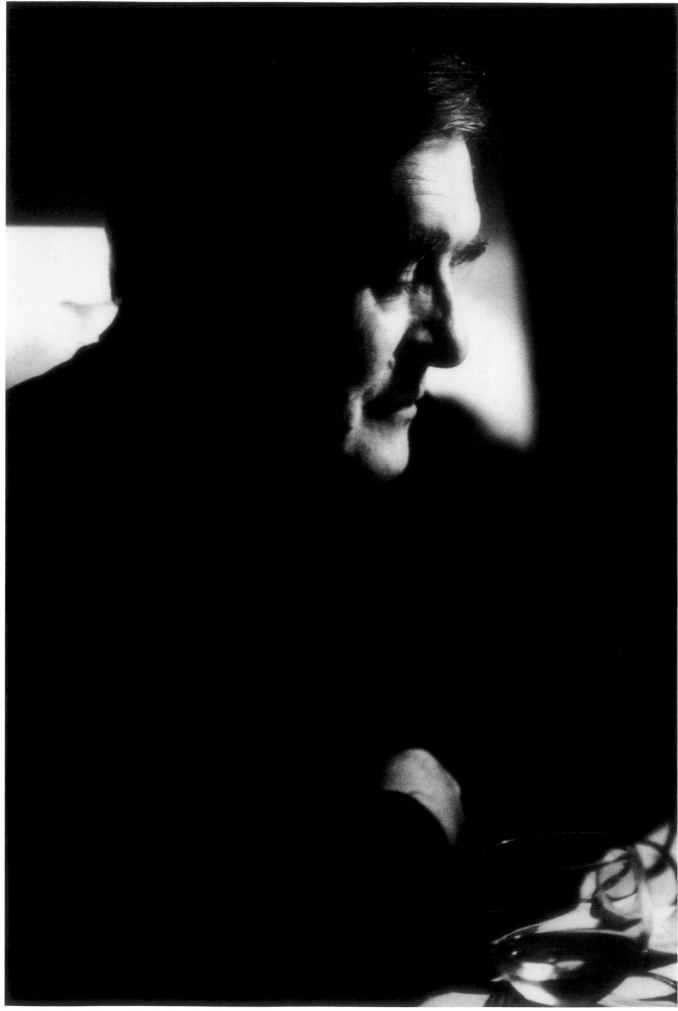

Brian Richards, architect and my husband, at home, 1994

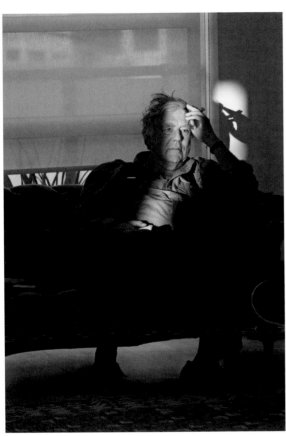

John Miller at home, 2008

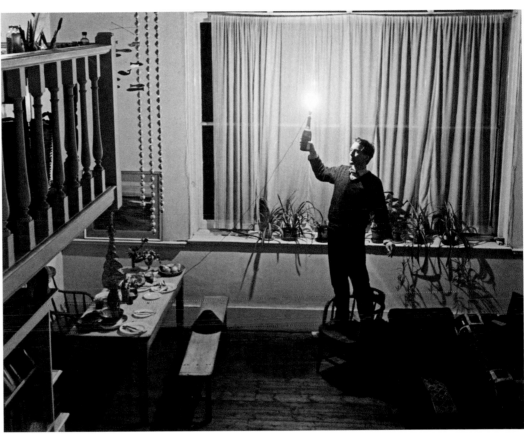

Neave Brown in Jocelyn Herbert's studio, 1960
He was holding the light so I could photograph my mother, who was working on the balcony
(see page 68). I like the Greek statue pose.

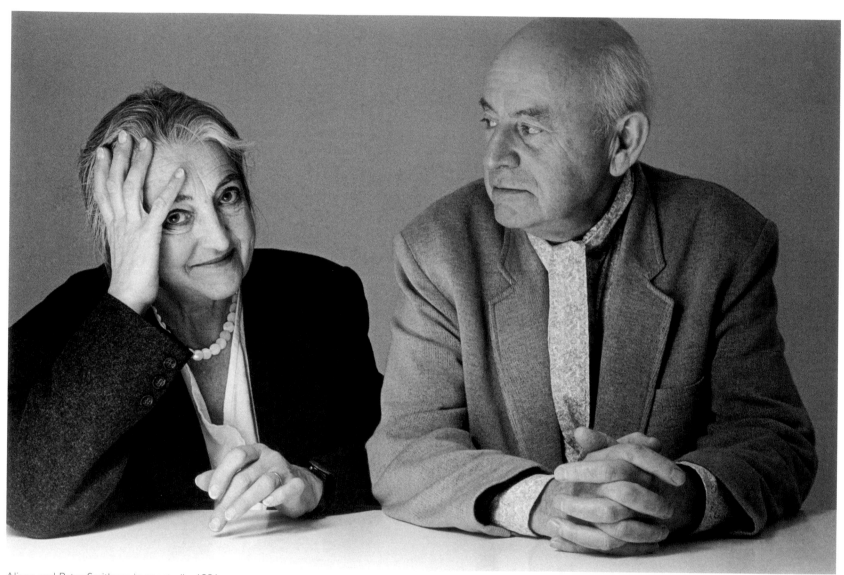

Alison and Peter Smithson in my studio, 1991
Alison had been asking for a portrait of them both for a long while, but it wasn't till I saw them give a lecture
on Team X that I could see how to make it work. This is just how they were together.

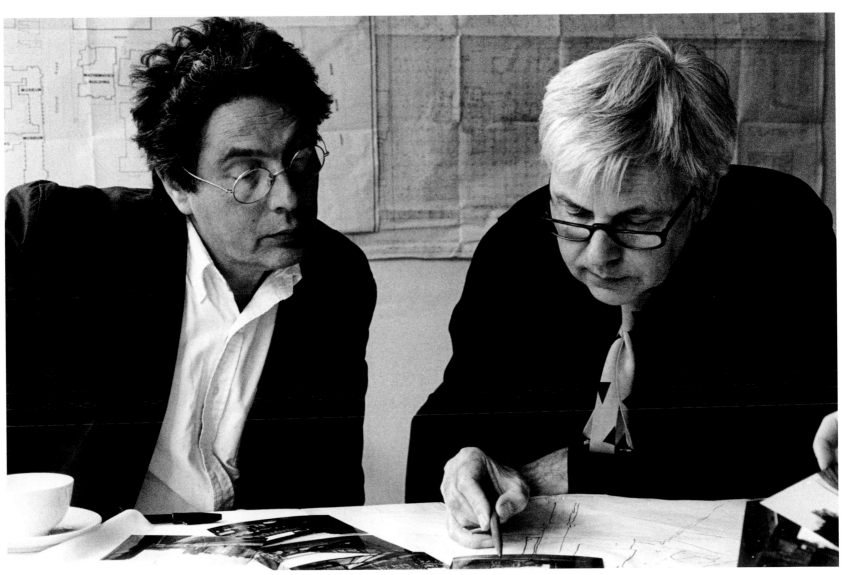

Jeremy Dixon and Edward Jones in their office, 1994

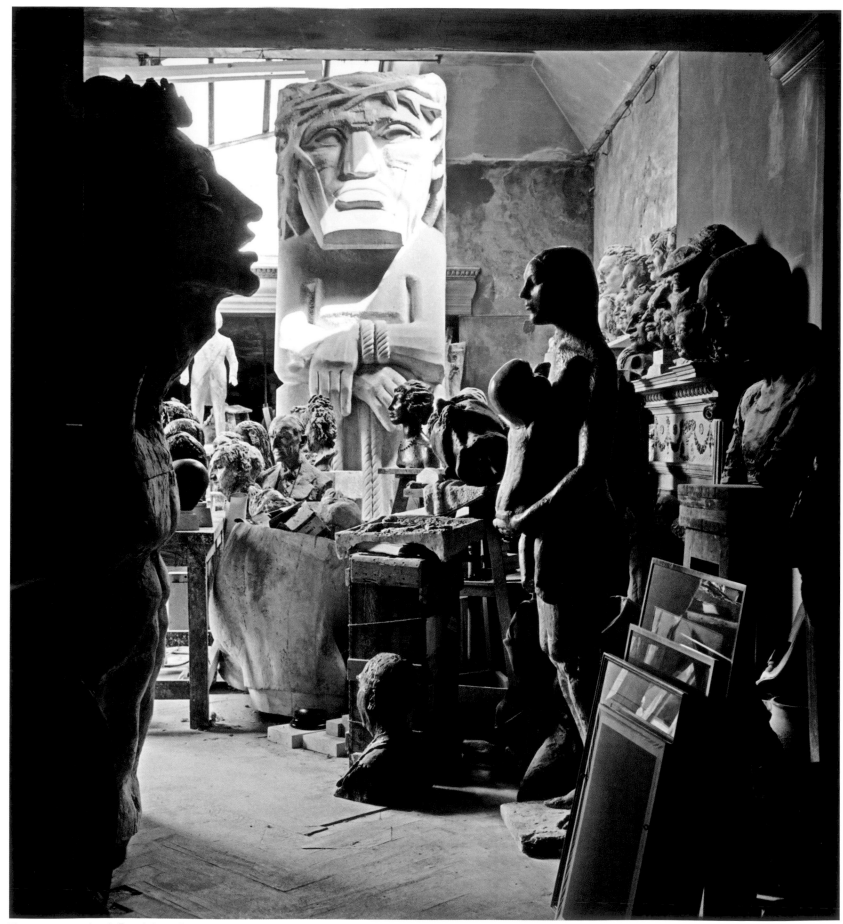

The entrance to Jacob Epstein's studio, a few months after he died, 1960

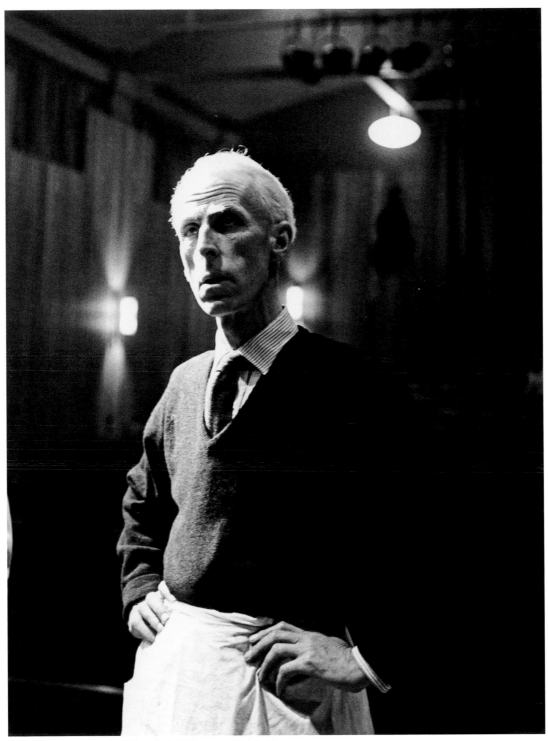

John Piper on the set of Britten's *A Midsummer Night's Dream*,
Aldeburgh Festival, 1961

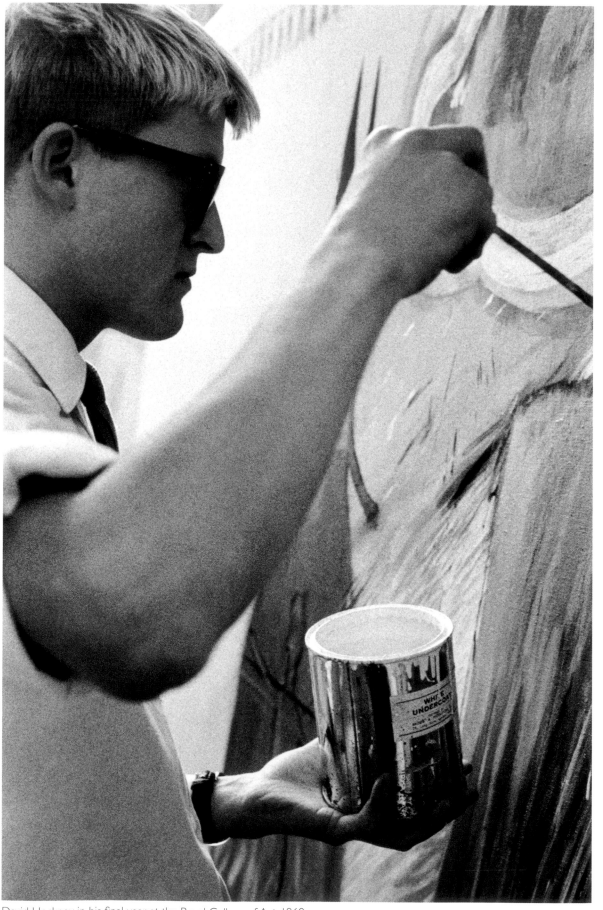

David Hockney in his final year at the Royal College of Art, 1960

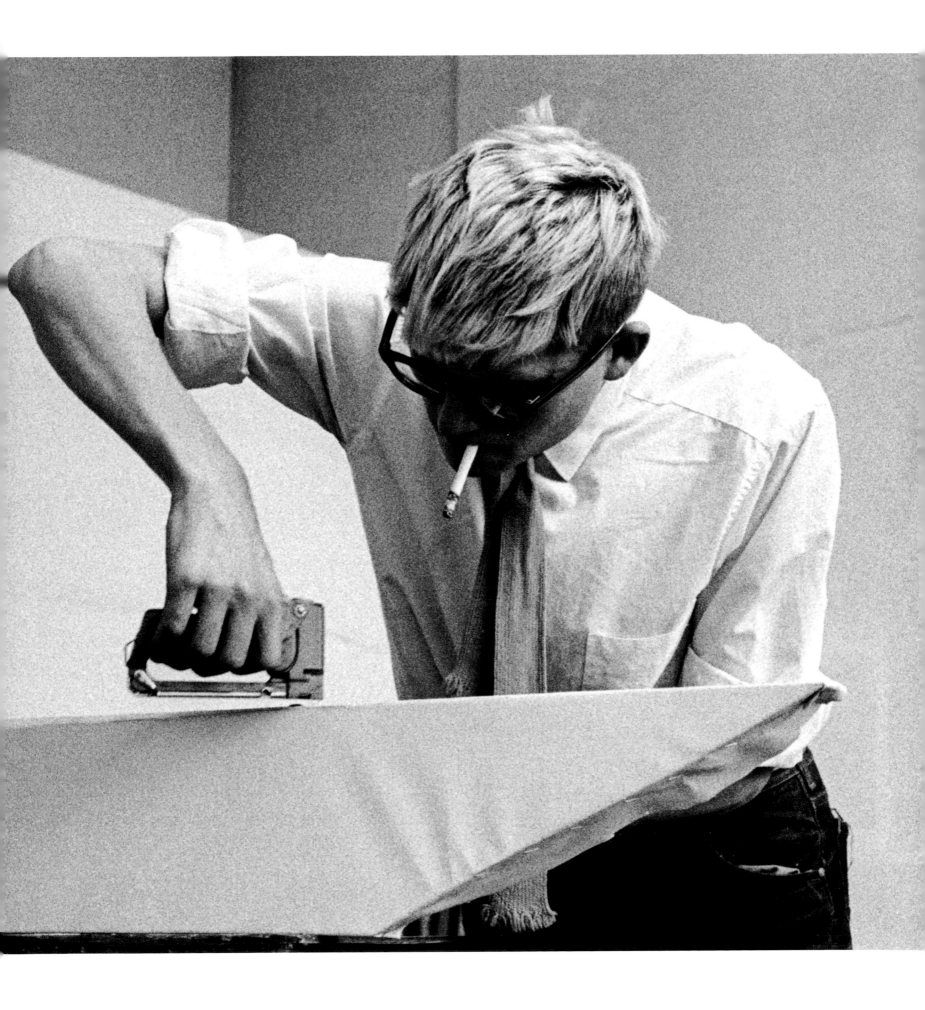

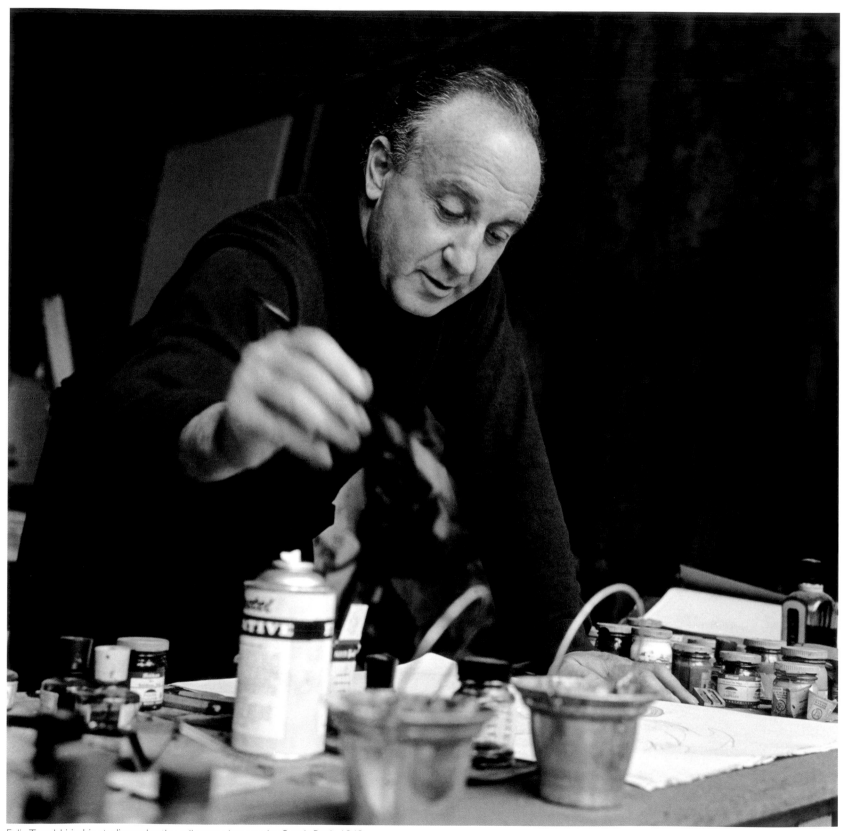

Felix Topolski in his studio under the railway arches on the South Bank, 1963

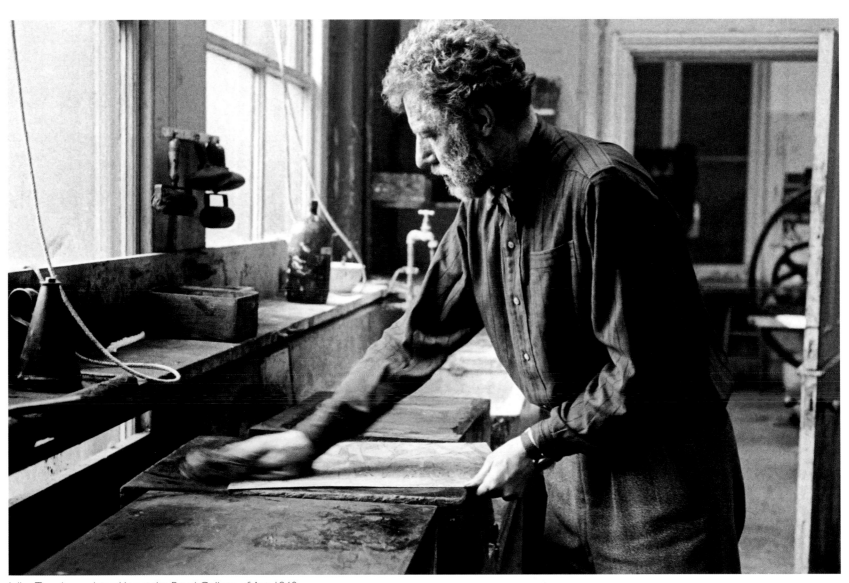

Julian Trevelyan printmaking at the Royal College of Art, 1960

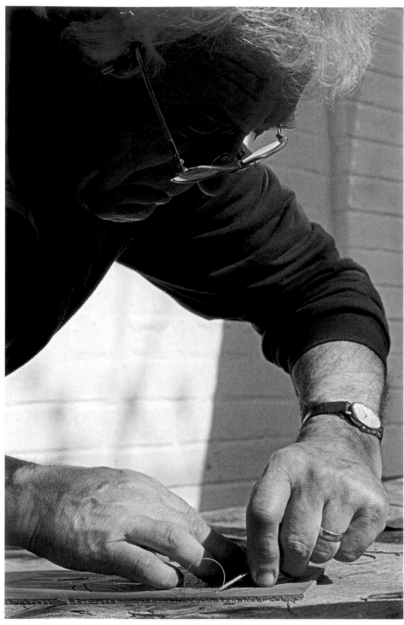

Benedict Rubbra making a lino cut in his studio in the
Chilterns, 1994

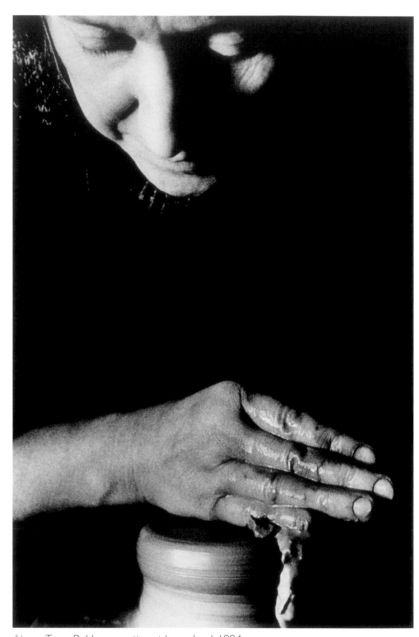

Above Tessa Rubbra, a potter at her wheel, 1994

Right Eduardo Paolozzi in his studio near Thorpe-le-Soken, Essex, 1959

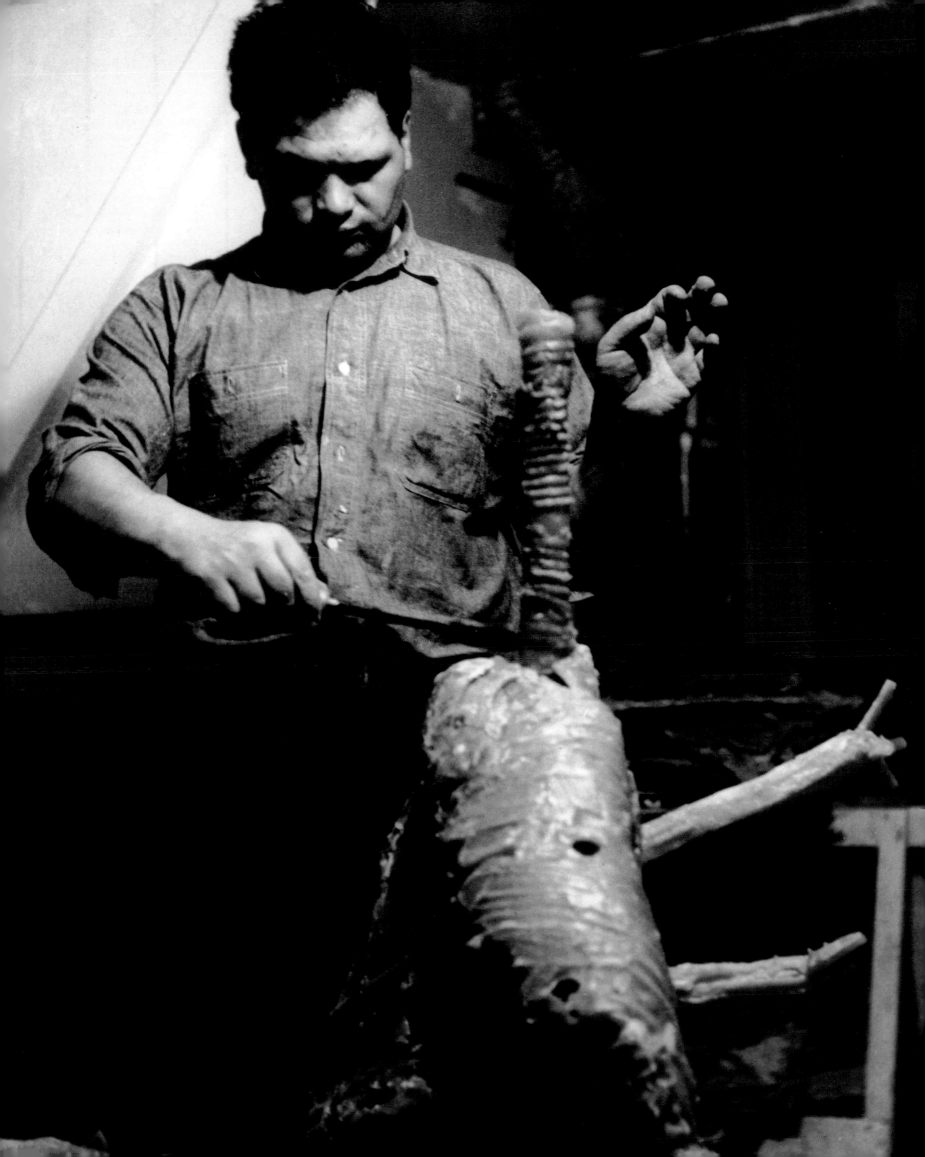

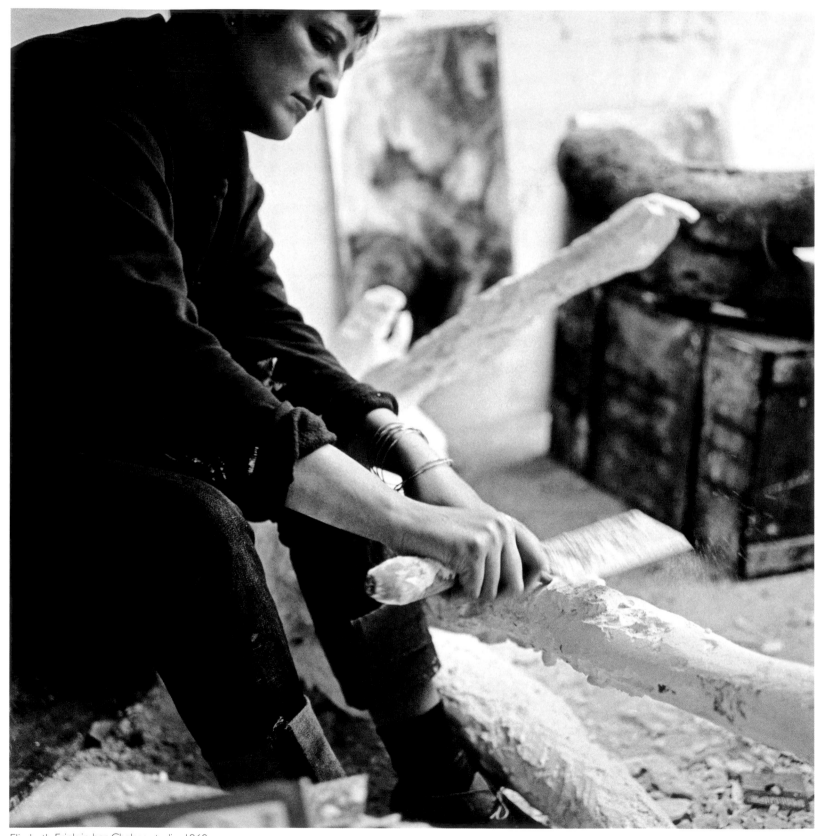

Elisabeth Frink in her Chelsea studio, 1960

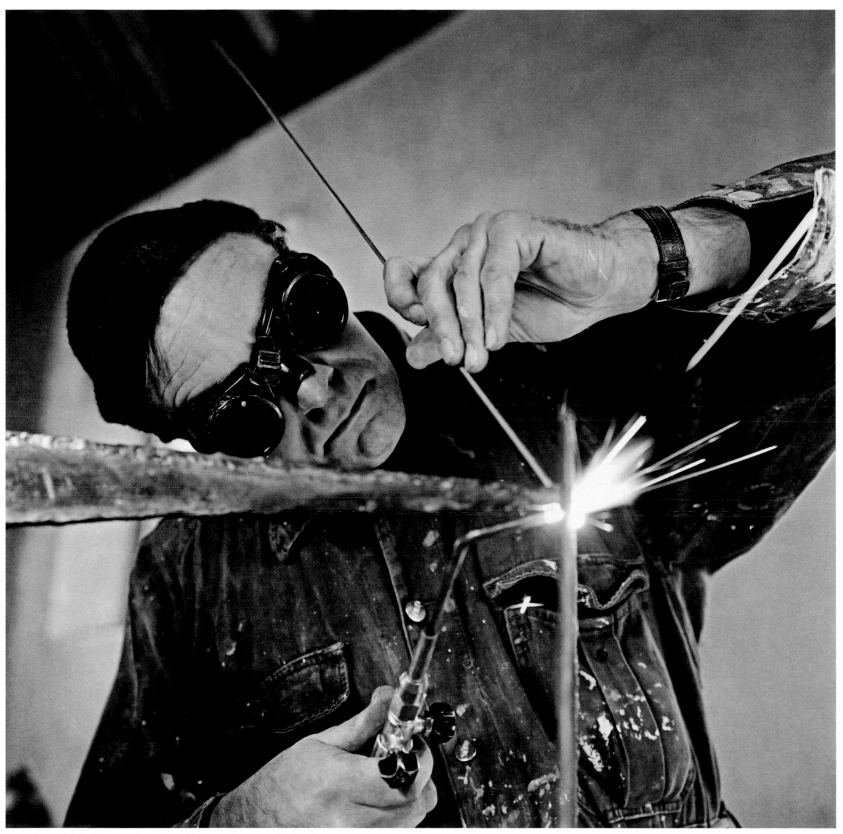

Lynn Chadwick in his chapel studio at his home in Lypiatt Park, Gloucestershire, 1960

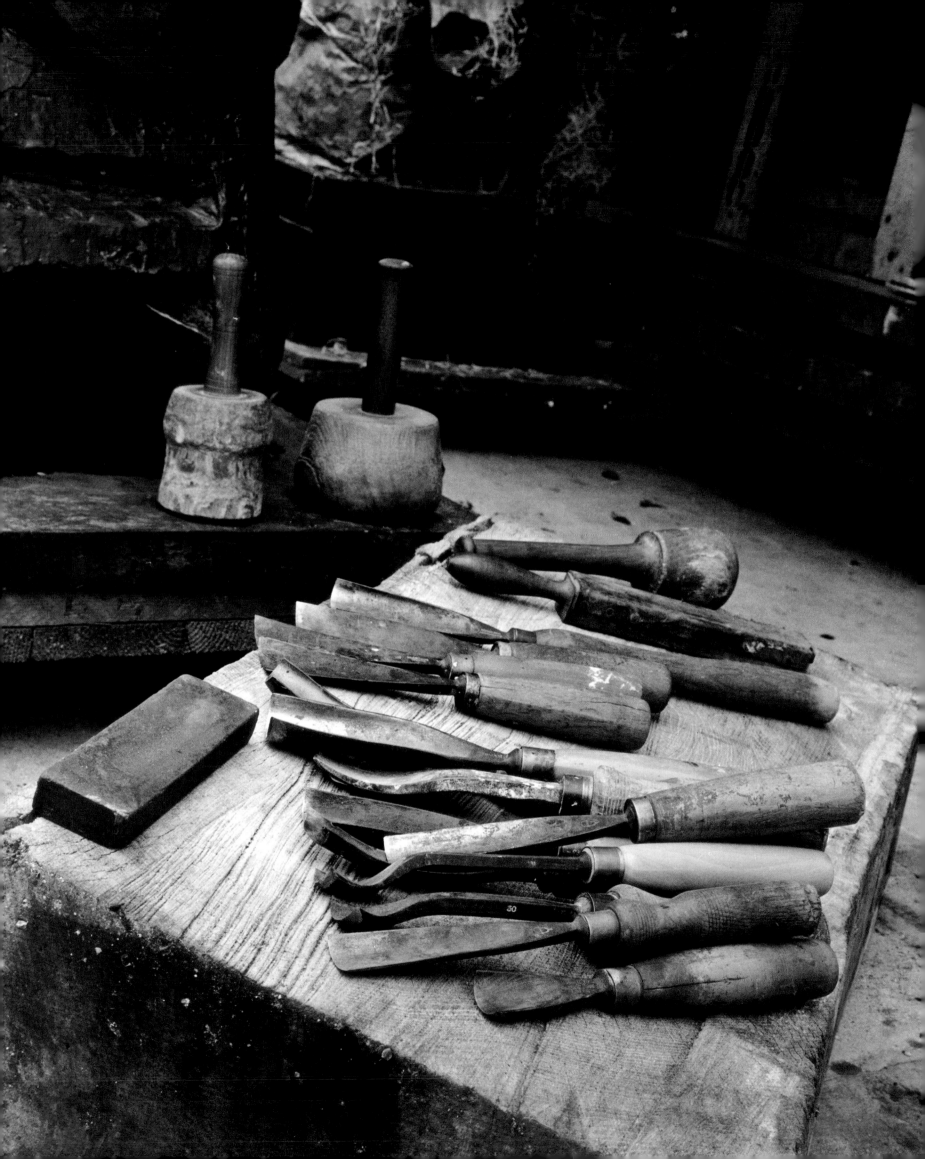

Henry Moore and his tools in his studio at Perry Green, Hertfordshire, 1960

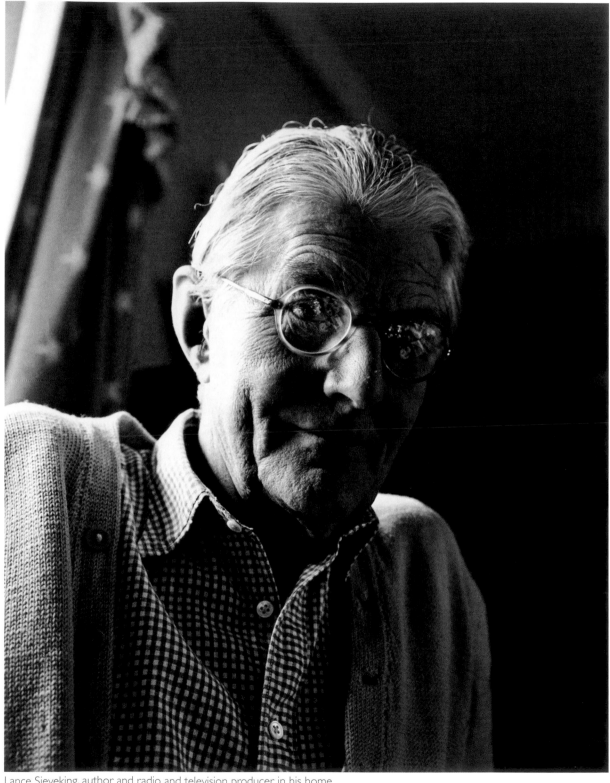

Lance Sieveking, author and radio and television producer, in his home
at Snape, Suffolk, 1961

Sir Alan Herbert, humorist, novelist,
playwright, Member of Parliament, law
reformer – and my grandfather, 1970
I often saw him looking out across the
Thames from his garden or the wheel of his
boat, the water sparkling in the sunlight as
he waved to the passing pleasure boats.

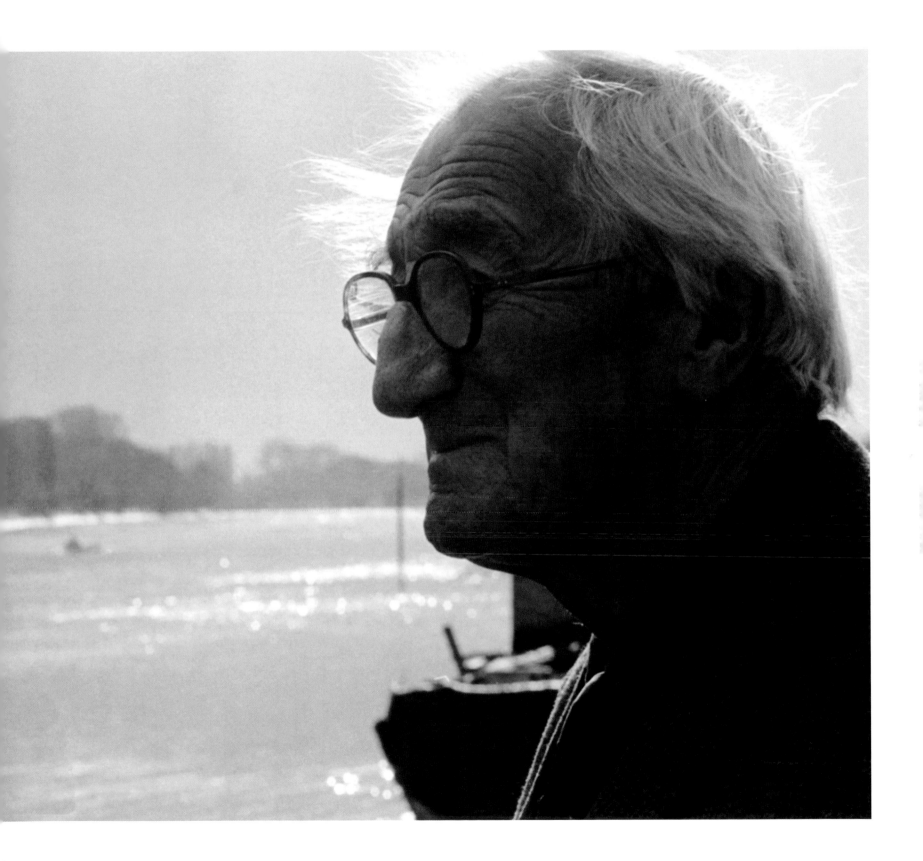

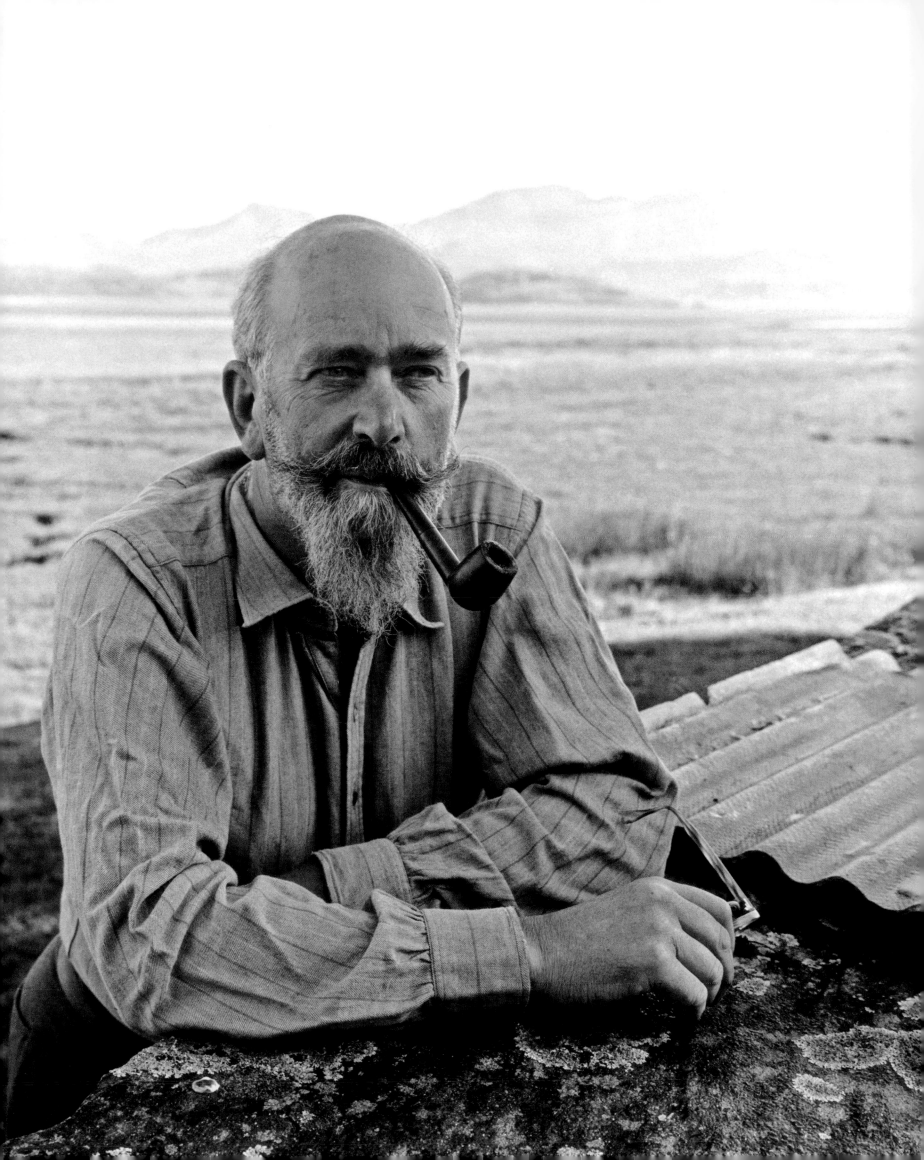

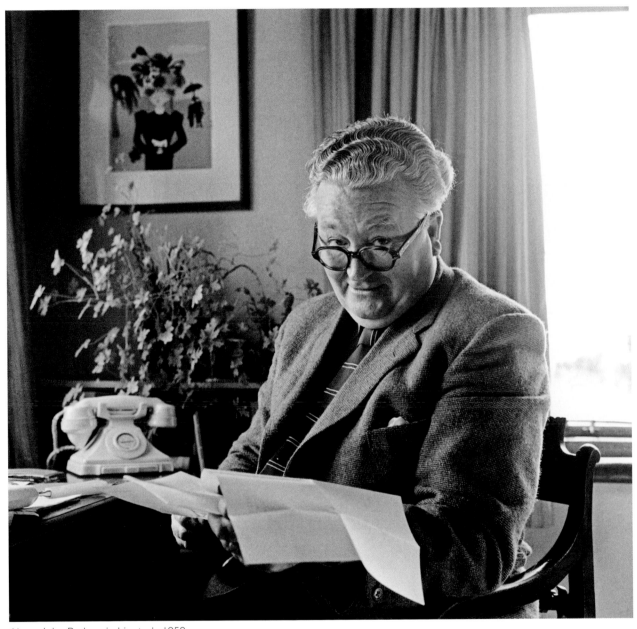

Above John Pudney in his study, 1959

Left Richard Hughes at his home near Harlech, 1961

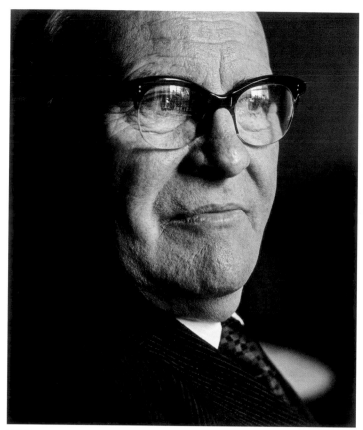

V.S. Pritchett in his study in his London home, 1961

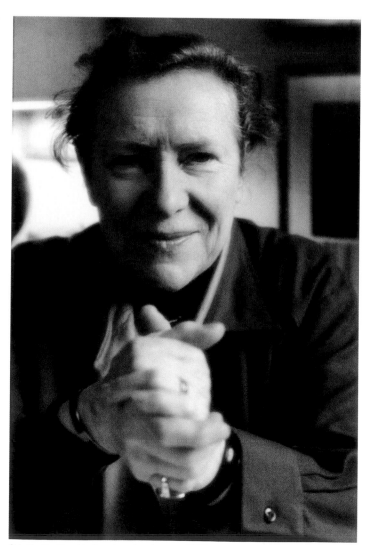

Sybille Bedford in her London home, 1973

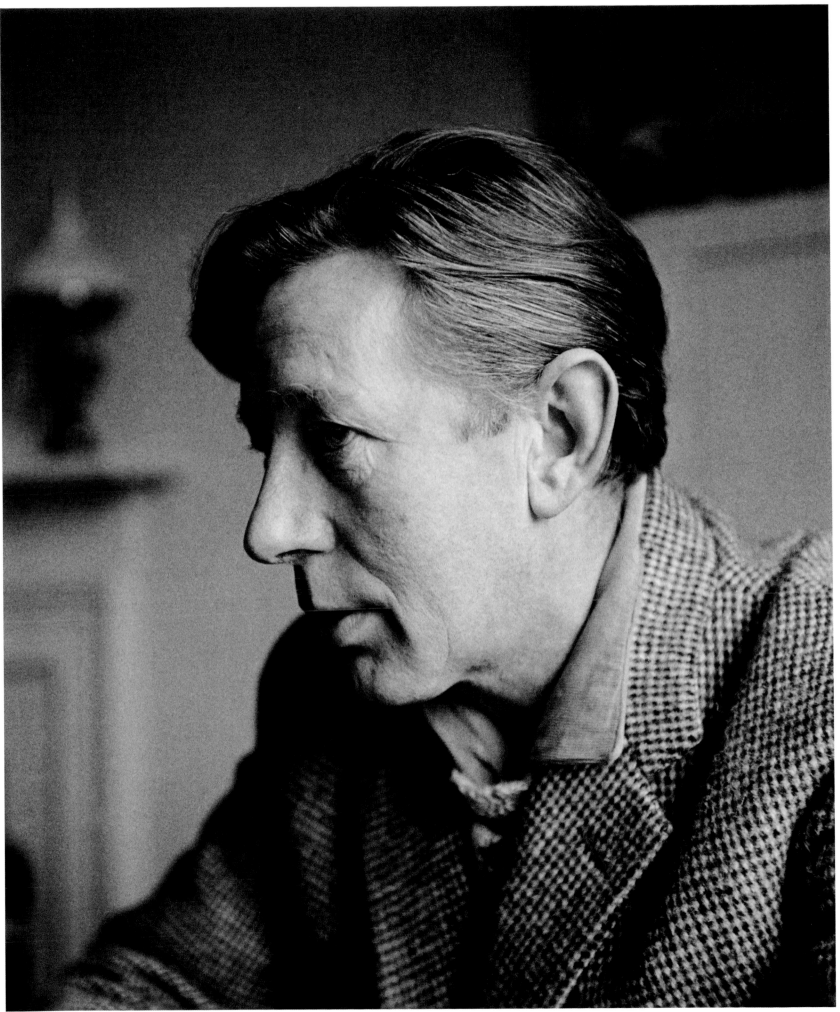

Laurie Lee at his Chelsea home, at the time when *Cider with Rosie* was first published, 1959

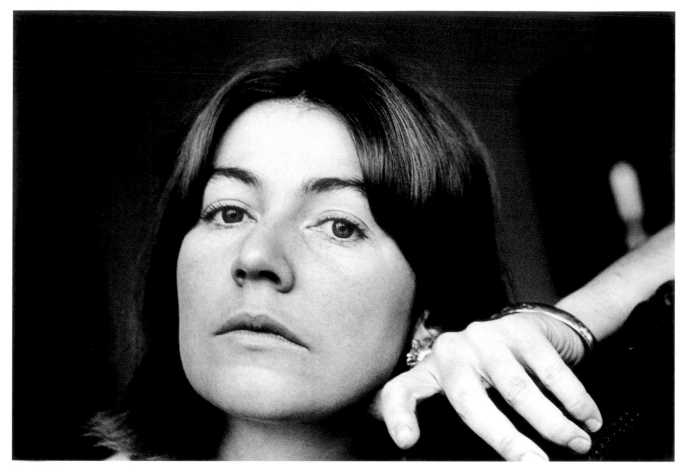

Edna O'Brien at home, 1964

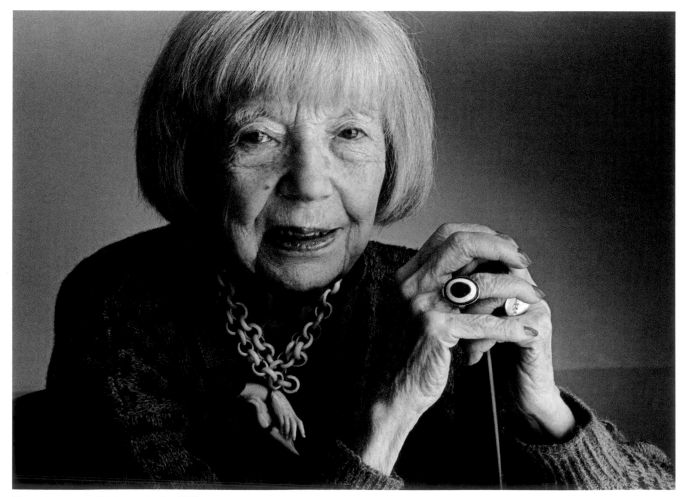

Eileen Agar, surrealist, in my studio, 1990

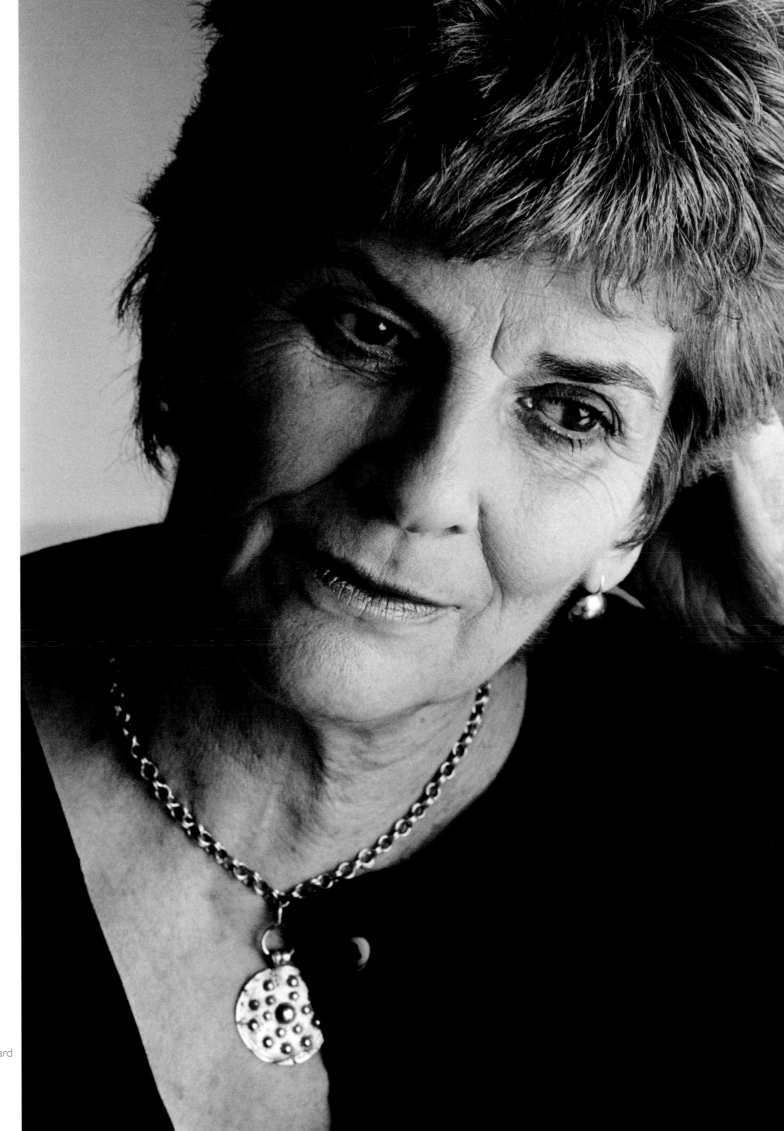

Elizabeth Jane Howard
in my studio, 1990

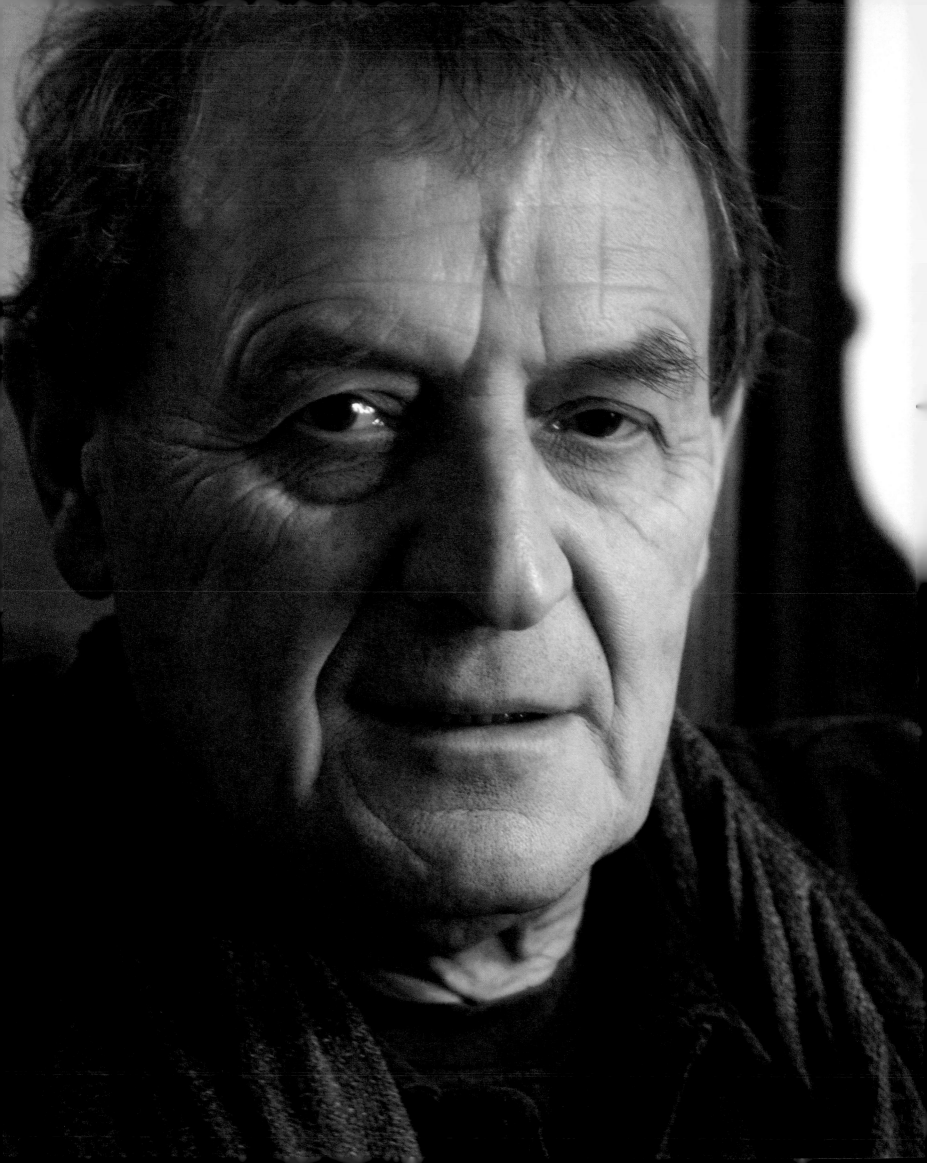

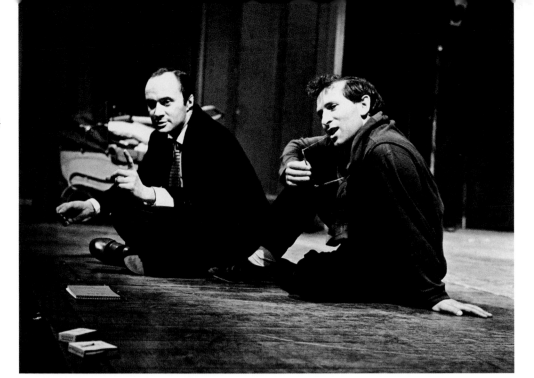

Left Tony Harrison, at his home in Gosforth, Newcastle, 2007

Right John Dexter and Arnold Wesker after a dress rehearsal of
Wesker's *Chicken Soup with Barley* at the Royal Court Theatre, 1964
John, who was always serious when giving notes after rehearsals,
was sitting on the stage facing the actors, who were in the
auditorium. Arnold was sitting just behind, listening, and all of a
sudden he started making faces and mimicking John. The actors
had a hard time keeping a straight face. I think it was only when
I showed him the photographs that John realized what had been
going on behind his back.

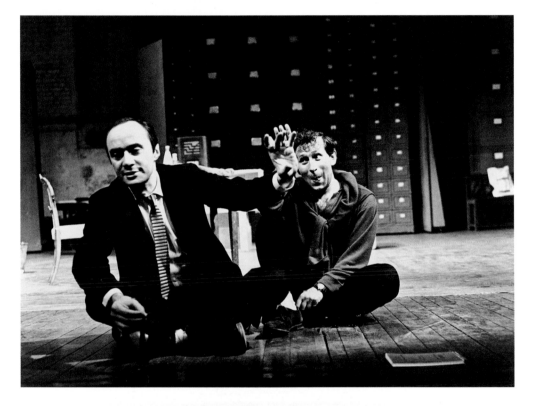

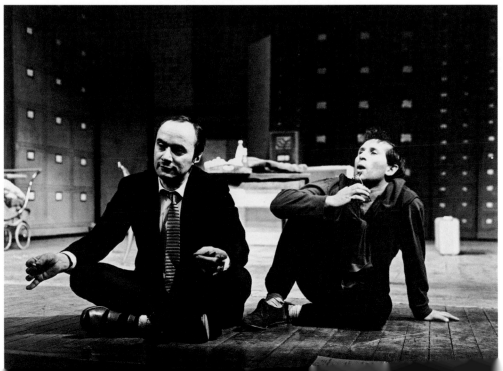

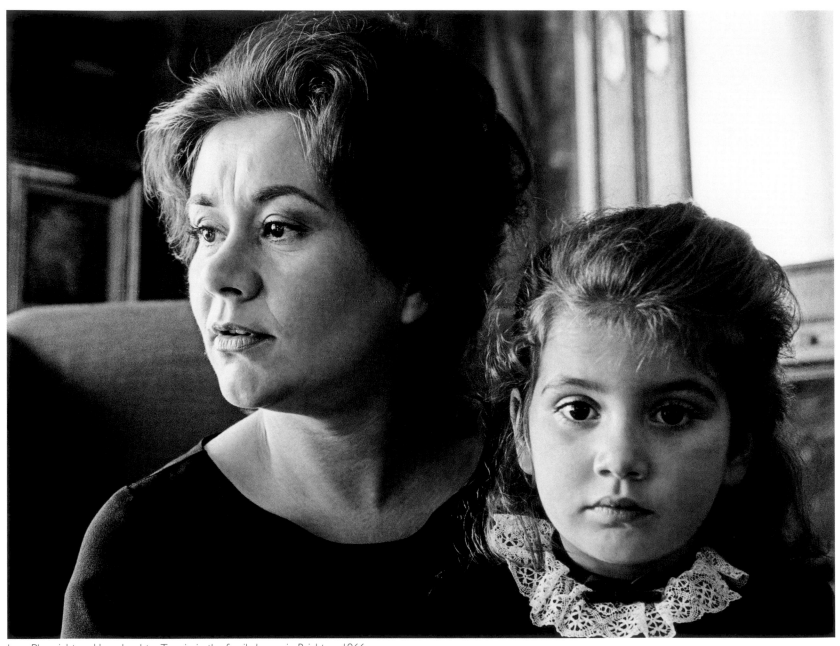

Joan Plowright and her daughter Tamsin in the family home in Brighton, 1966
I like the calm beauty of these two, feeling secure in their own space.

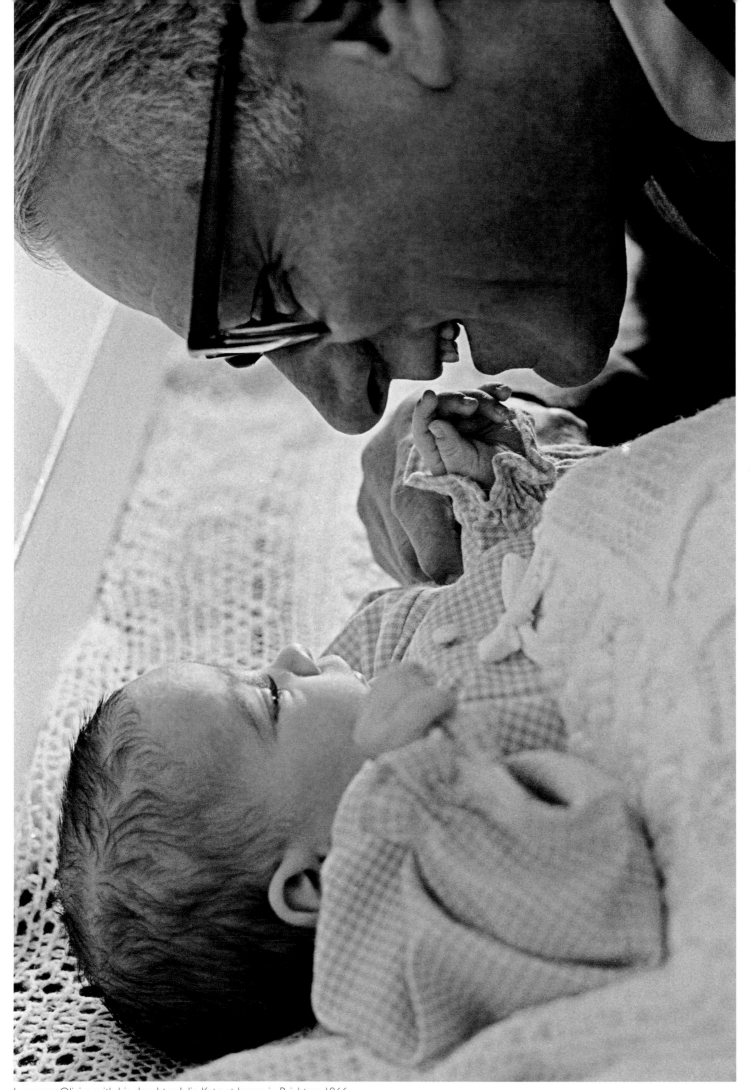

Laurence Olivier with his daughter Julie Kate at home in Brighton, 1966
The baby was lying on a soft mat on the table and he leant over to say hello.

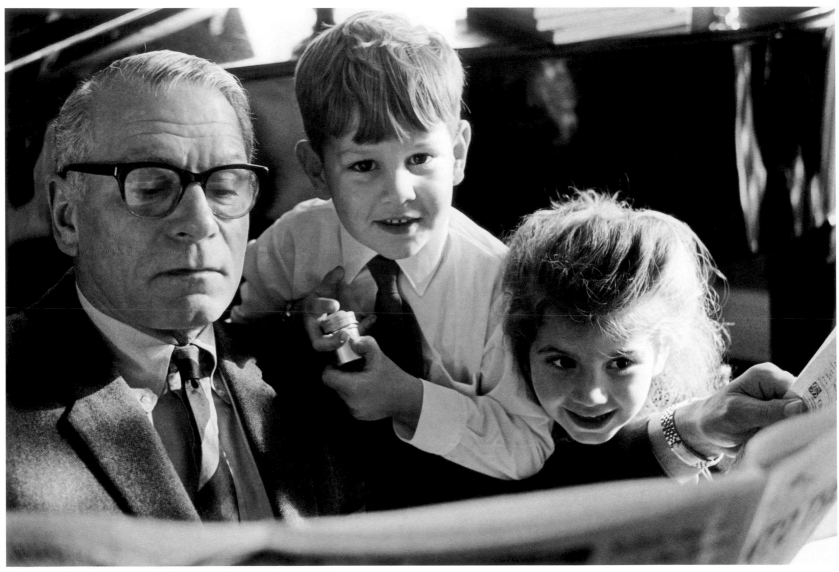

Laurence Olivier with his children Richard and Tamsin
in Brighton, 1966
They were very mischievous when he was reading the paper,
Tamsin with the same twinkly eyes as Joan.

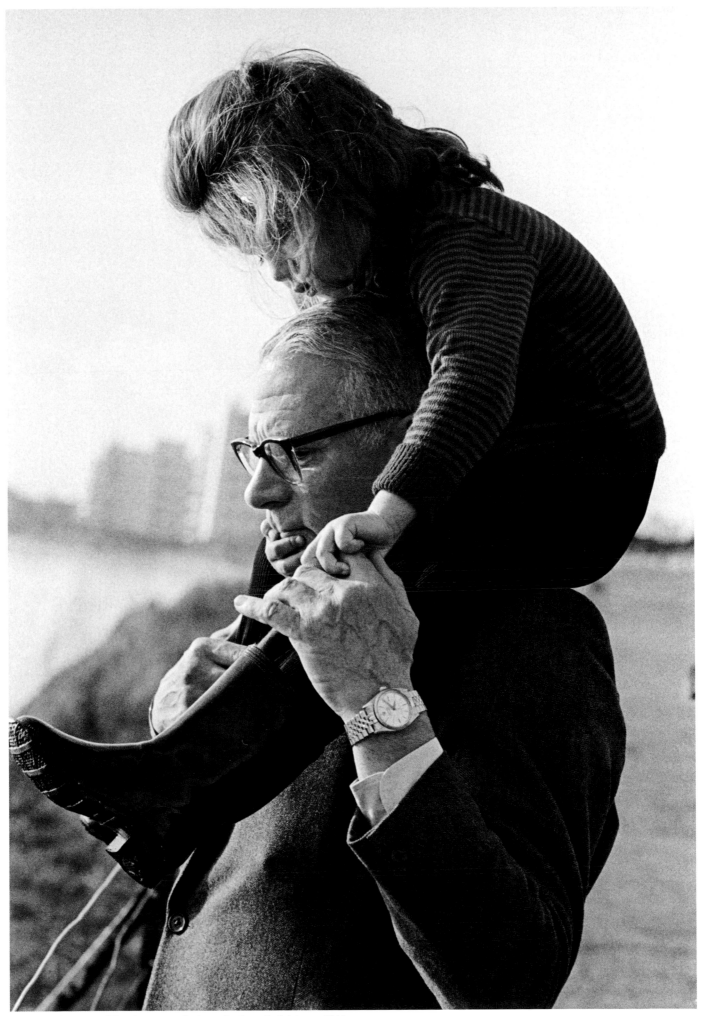

Laurence Olivier and Tamsin on a walk along the front in Brighton, 1966
I love the tenderness of the holding hands.

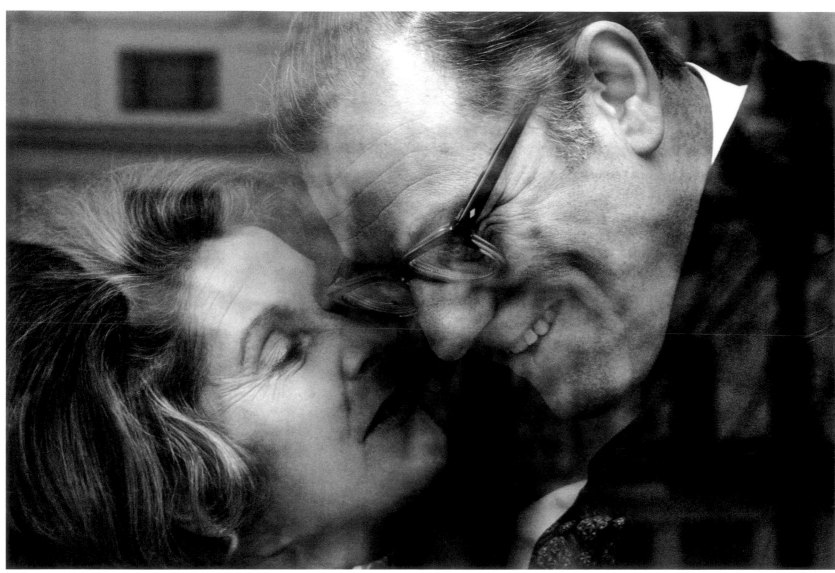

Reginald and Beryl Maudling at home, 1969
He was stiff, upper crust, and didn't want to show his feelings, or for me to hear
what he was saying. So I went outside on the balcony and shut the window. I said to
his wife – who was an actress, Beryl Laverick – 'Just please whisper him something,
anything. I won't hear a word because I'm outside.' I would rather not have the
reflections in the window, but there wasn't any other way.

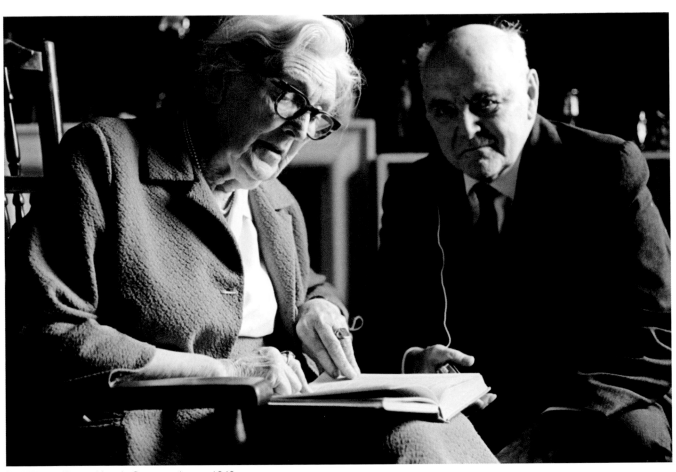

Sybil Thorndike and Lewis Casson at home, 1969
Sybil was reading to Lewis while he listened and kept a beady eye on me. I could let them be
themselves as they sat where they always did in their own chairs. It was a great thrill to be read
to by Sybil and I found at one moment I was listening rather than working.

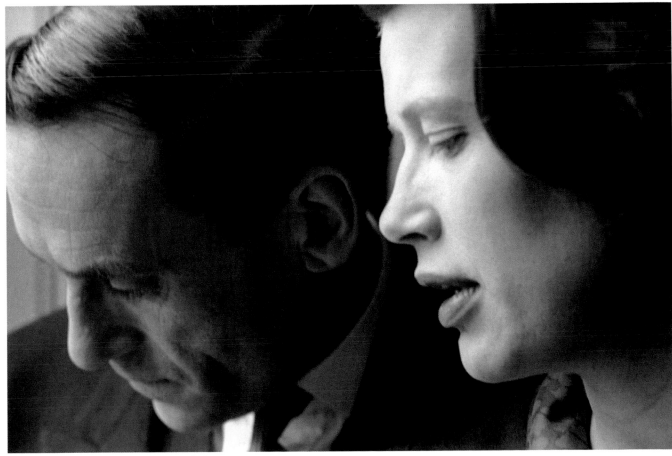

Jeremy and Caroline Thorpe at home, 1969
They were sitting talking on the sofa but it wasn't working, so I got them to stand by the window and
describe what they were looking at. Then suddenly they were really talking and almost forgot I was there.

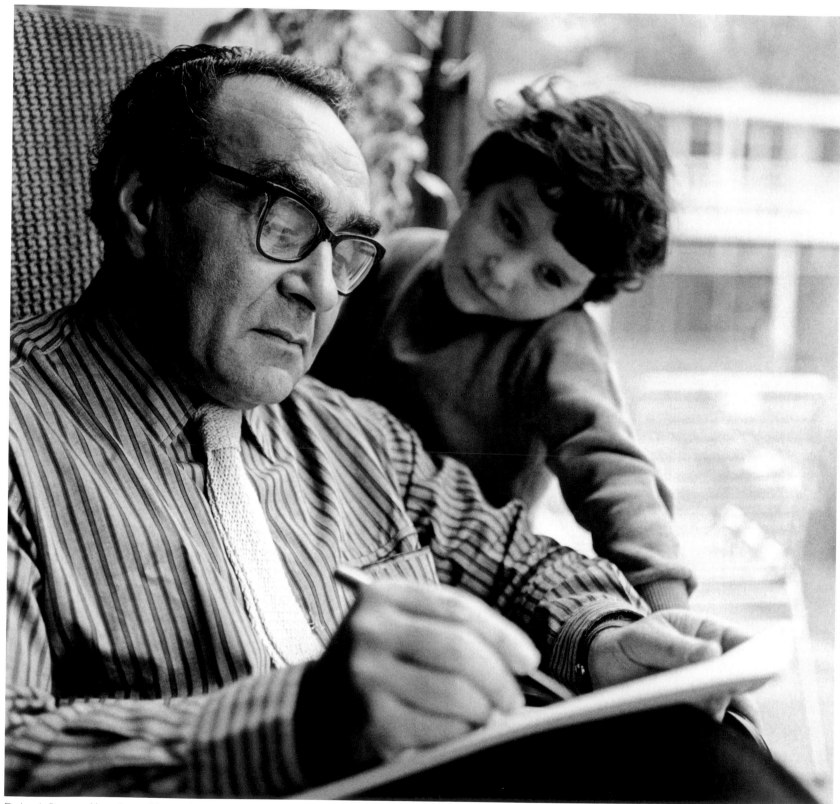

Dr Jacob Bronowski, mathematician and biologist, at home with his daughter, 1961

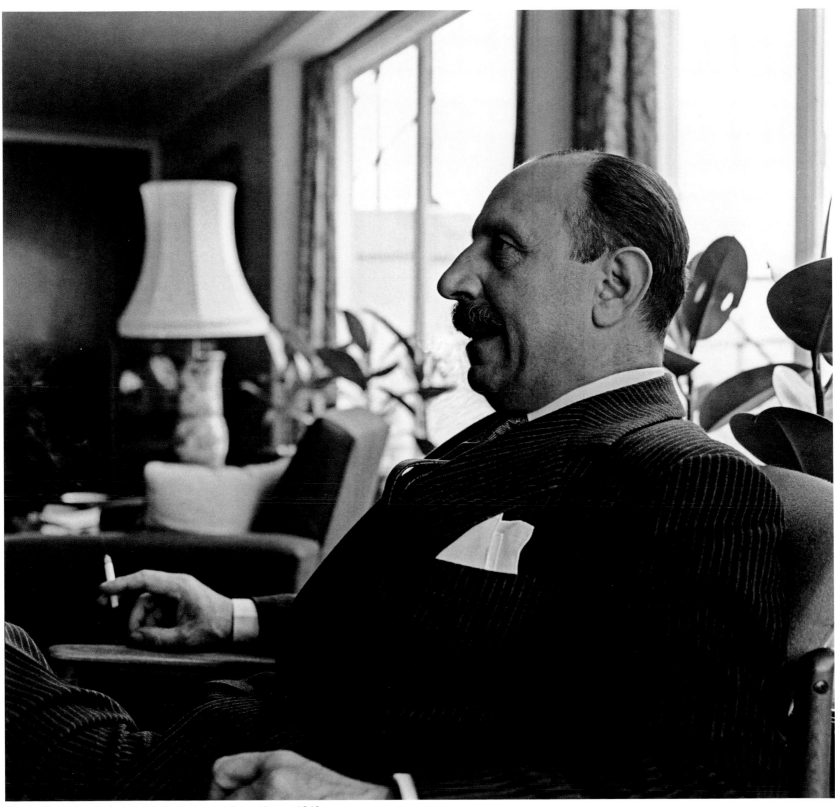

Charles Forte, head of a hotel and catering empire, at home, 1960

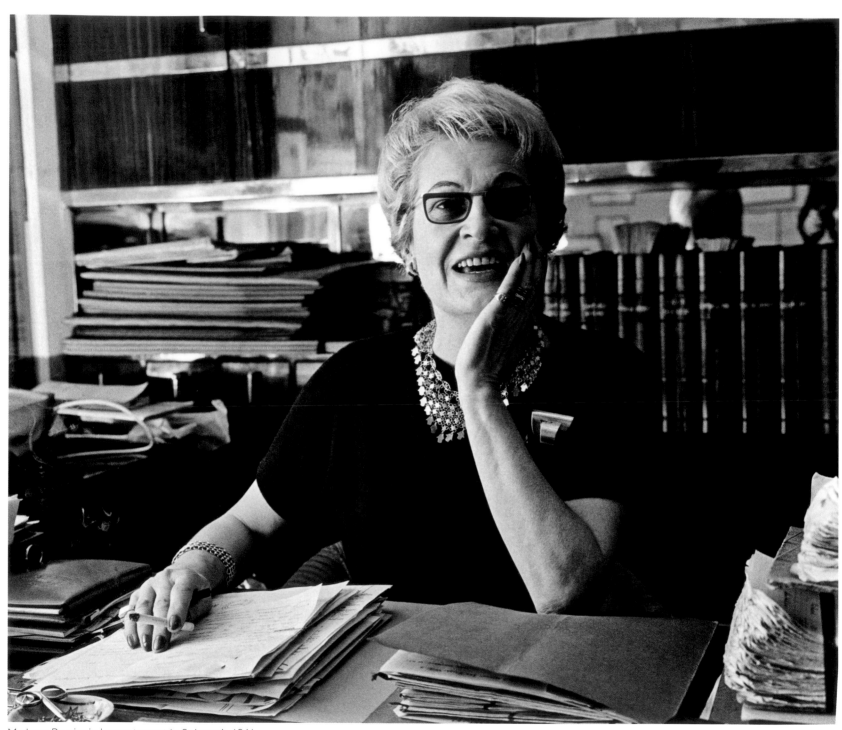

Madame Prunier in her restaurant in St James's, 1961

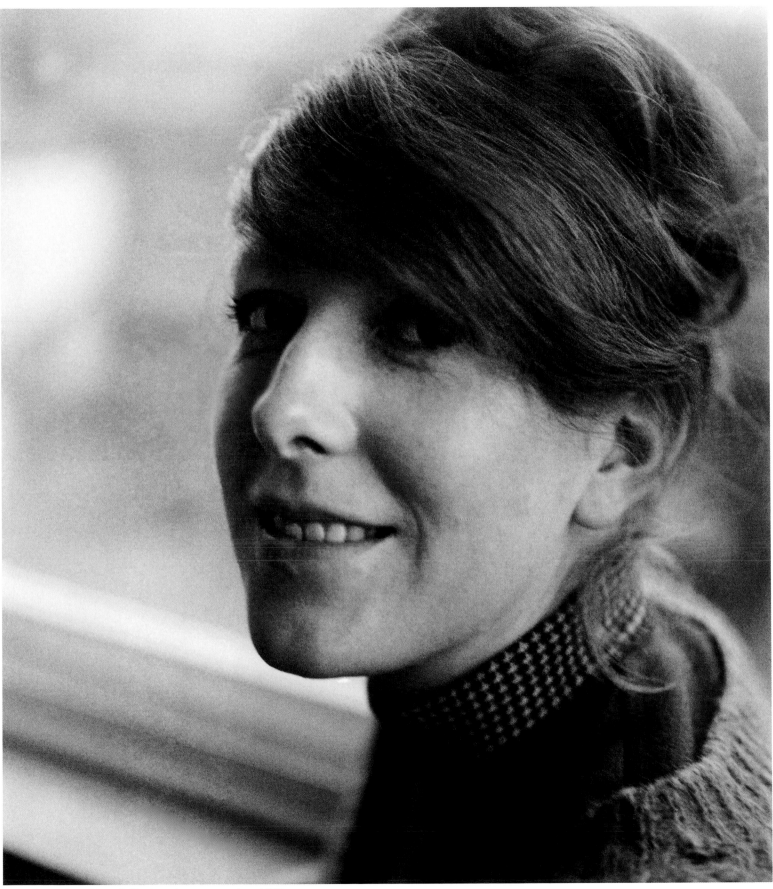

Rose Gray, of the River Café, when she was a student, 1959

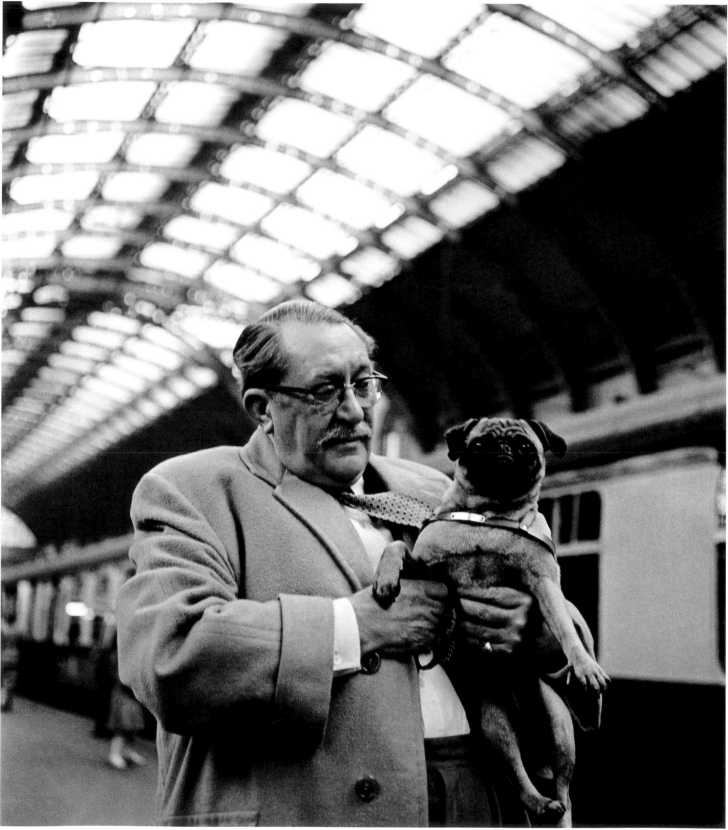

Gilbert Harding at Paddington Station, 1960
This was one of a series for *Queen* on owners and their dogs and
similarities between the two. Broadcasting personality Gilbert Harding
gave me five minutes on Paddington Station. He was very, very grumpy,
but clearly loved his dog.

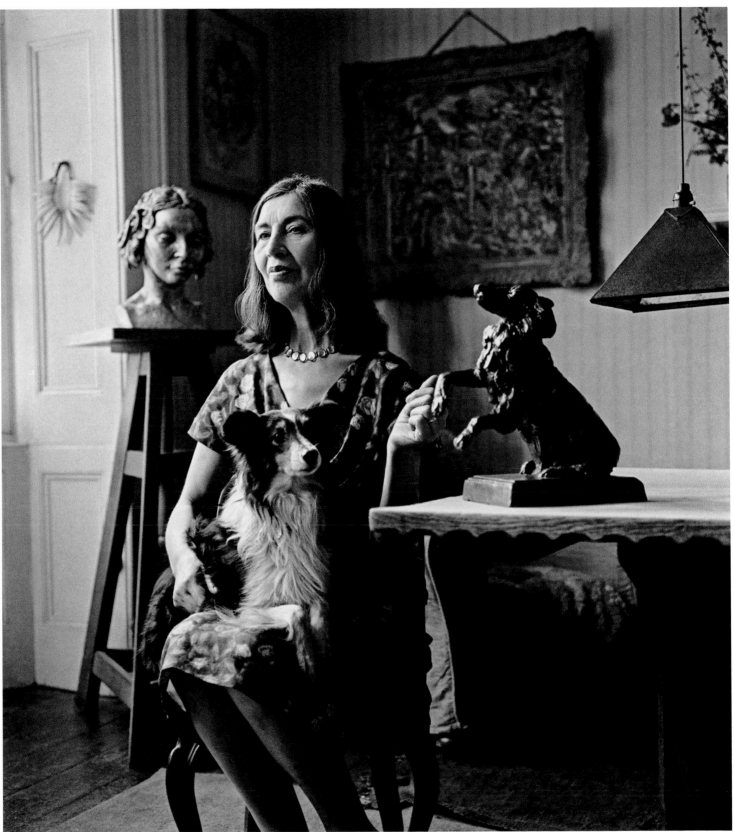

Kathleen, Lady Epstein, at home, 1960
This photograph was part of the same series. It was taken just after
Epstein died, and I was rather surprised that she agreed to it. But
she very much entered into the spirit of the shoot and particularly
wanted the dog to interact with the bronze Epstein had made of it.

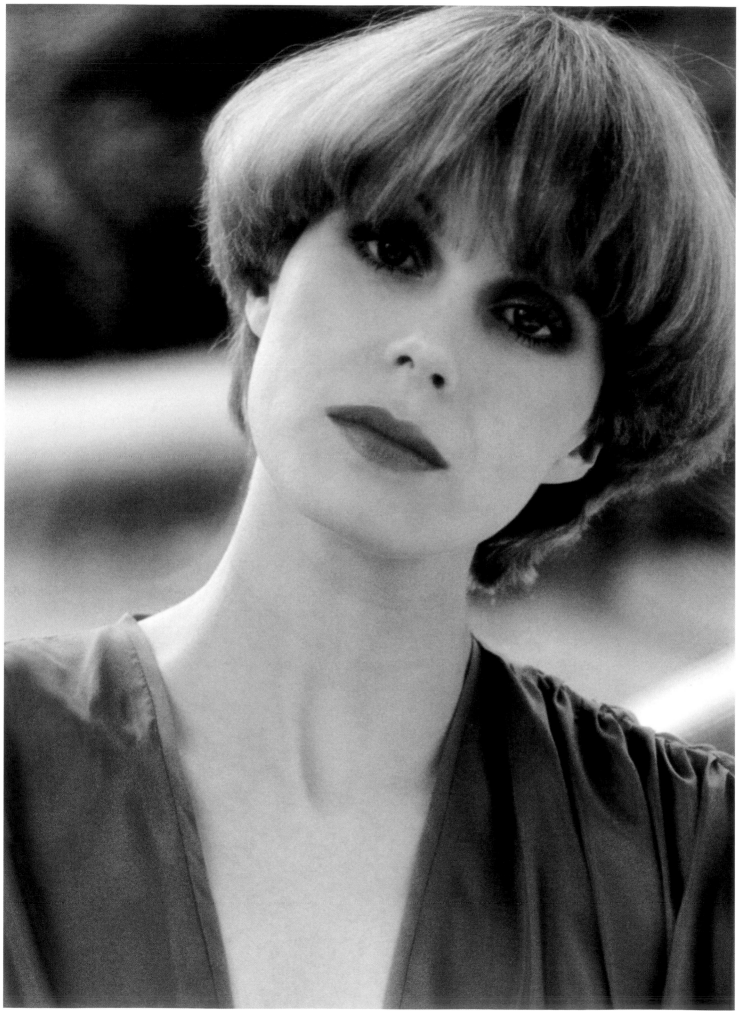

Joanna Lumley on location for *The New Avengers*, 1976

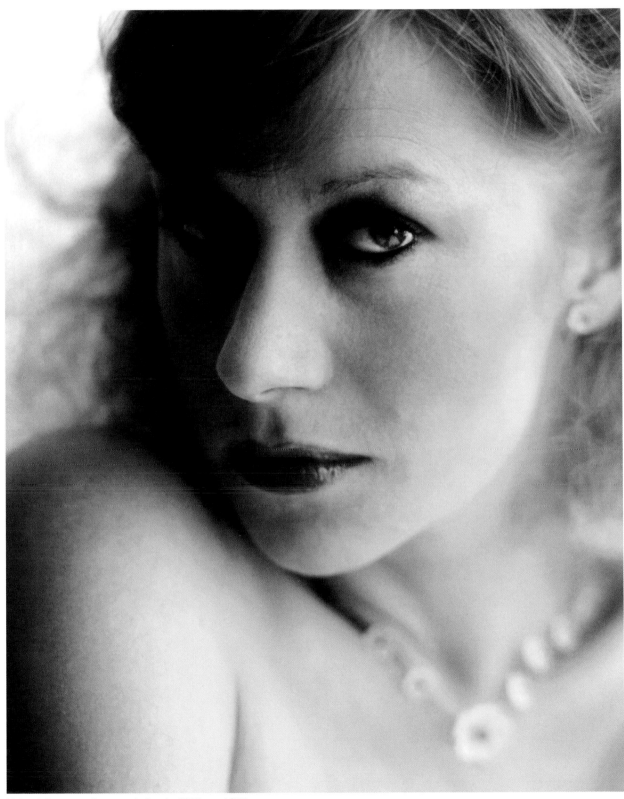

Helen Mirren, studio portrait for the *TV Times*, 1976

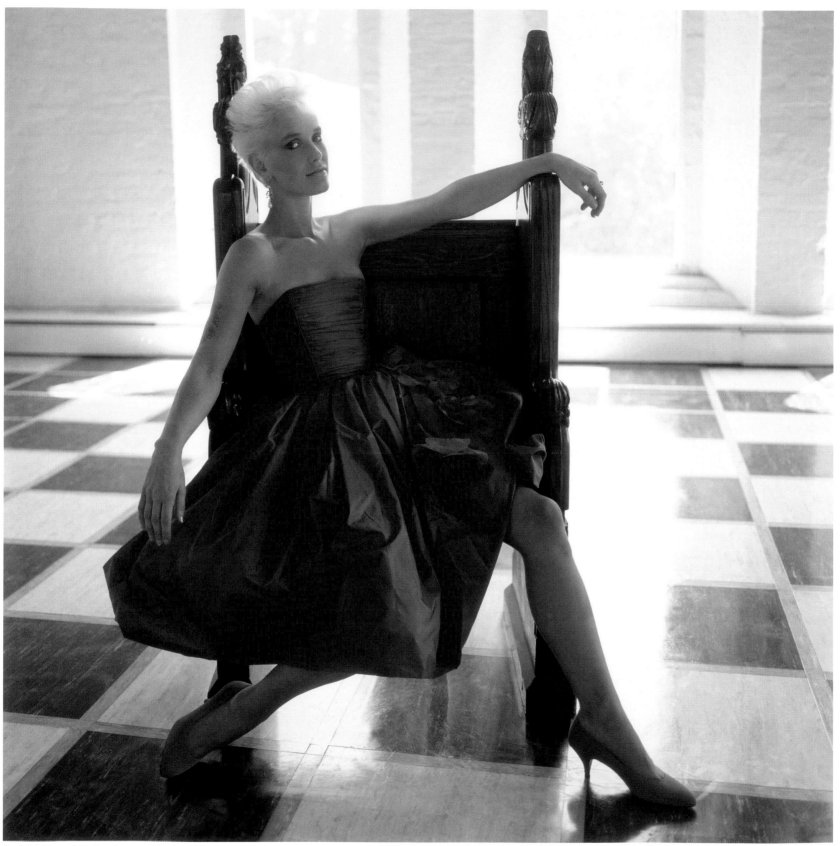

Paula Yates on location for an advertising campaign, 1982

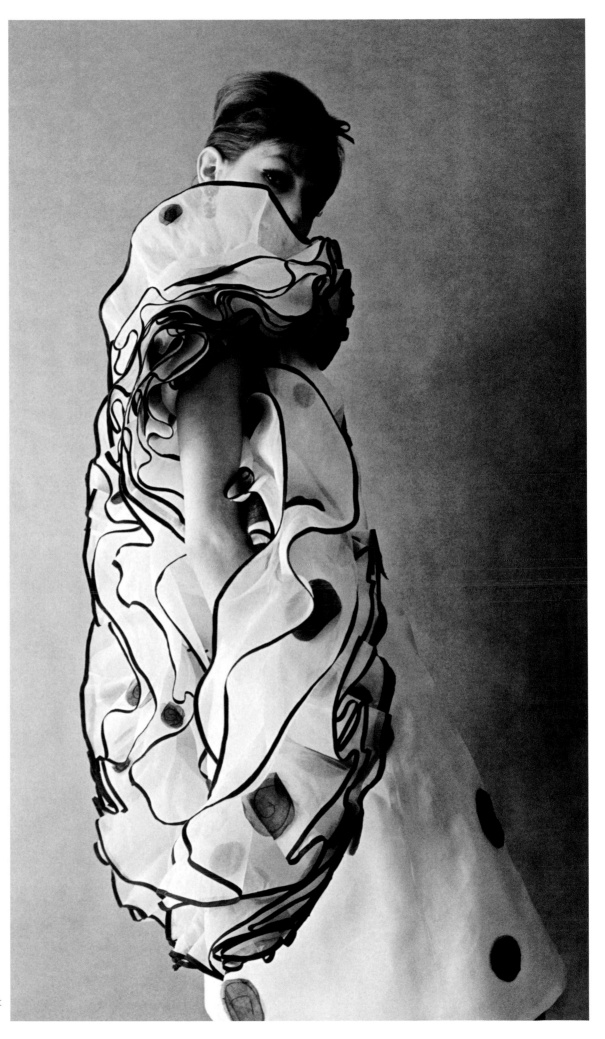

Black spotted stole: a fashion shoot
for *Queen*, 1962

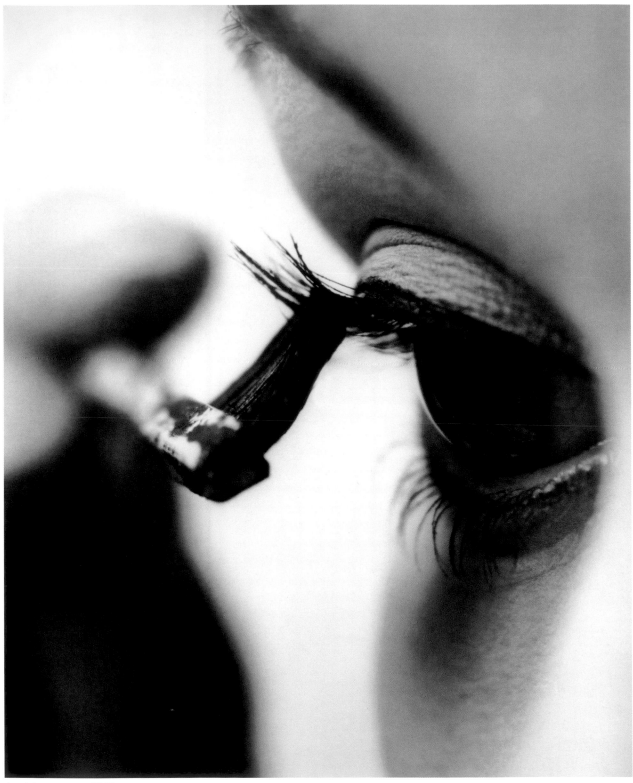

Applying mascara, 1961

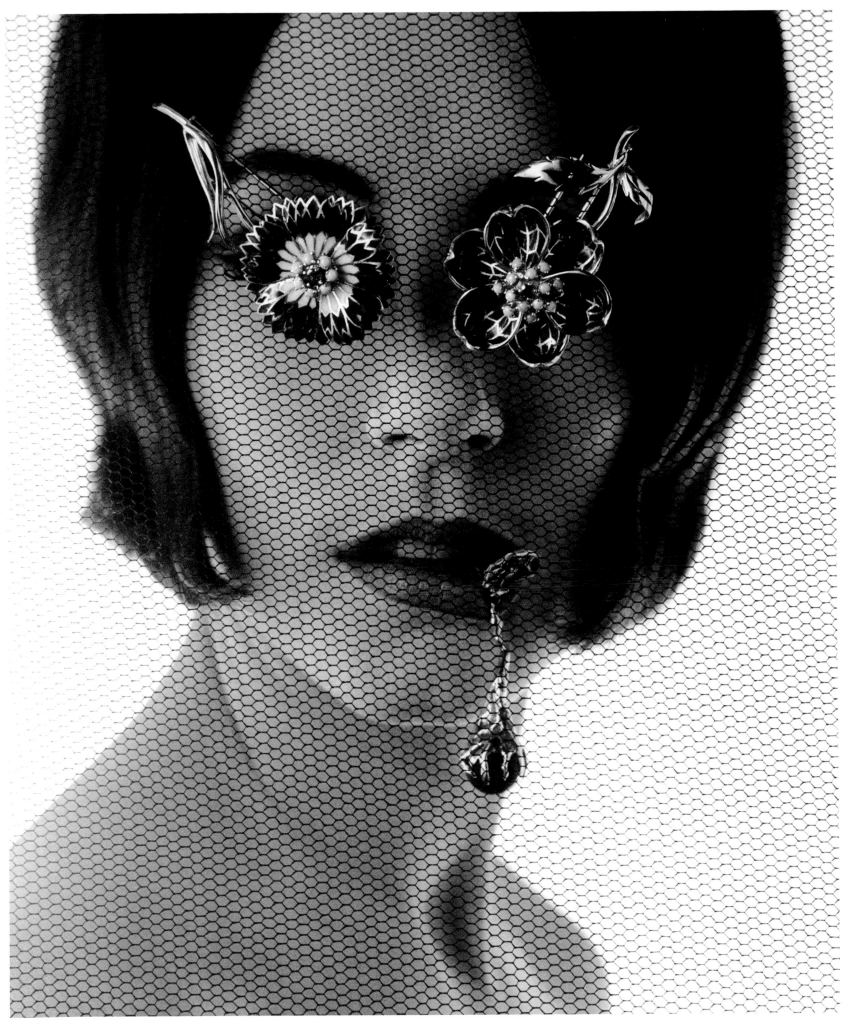

A jewellery shoot for *Queen*, 1962

Jean Shrimpton on location for a *Queen* fashion shoot, 1962

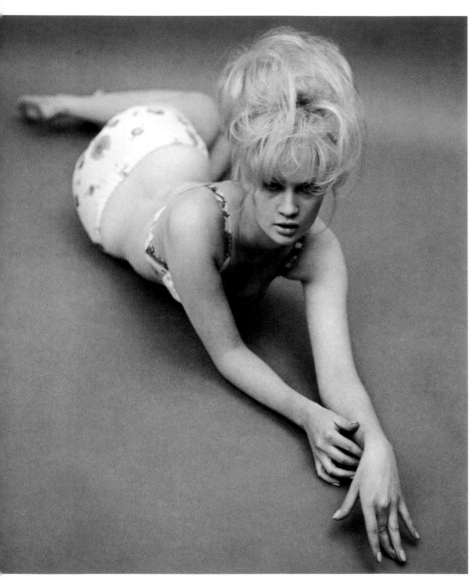

Above Celia Hammond in the 'Seven Ages' series
for *Queen*, 1962

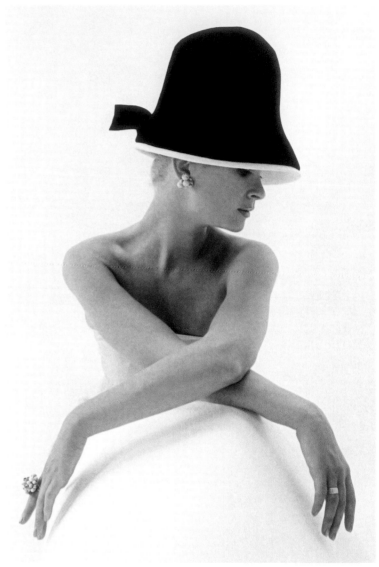

Above Erica de Leewe, a fashion shot for *Vogue*, 1962

Right Celia Hammond in another of the 'Seven Ages' shots
for *Queen*, 1962

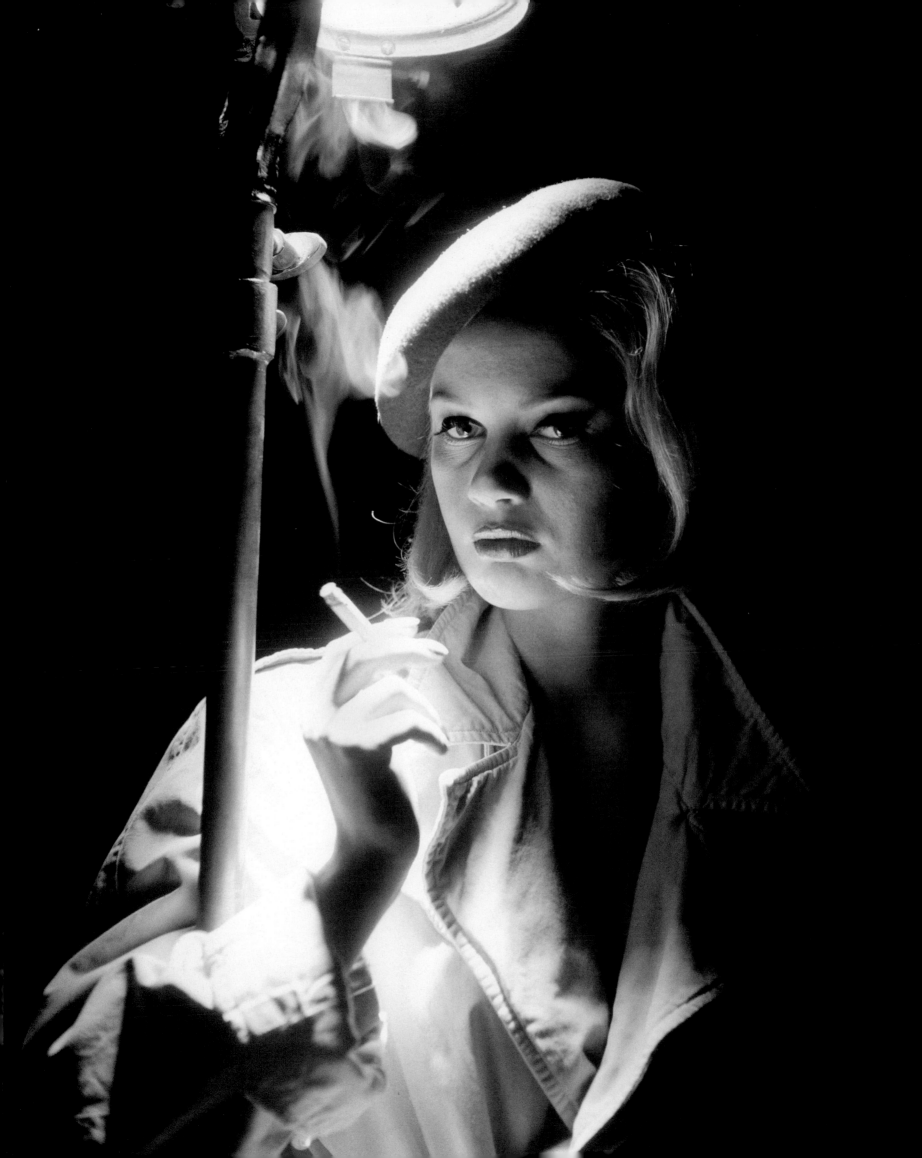

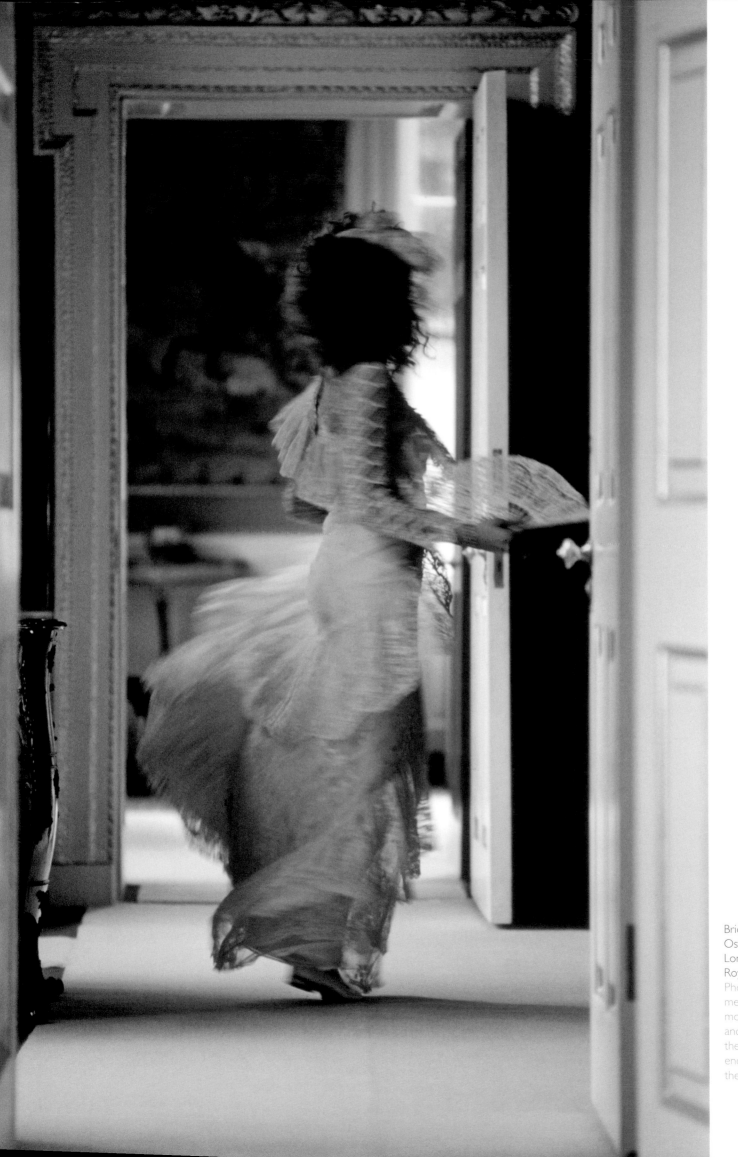

Brides, photographed in
Osterley Park, south-west
London, for *Harpers & Queen*
Royal Wedding Issue, 1981
Photographing long dresses for
me was a joy. It was all about
movement, light and dancing,
and getting the essence of
the shape of the dress. Also
encouraging the girls to enjoy
themselves, which they did.

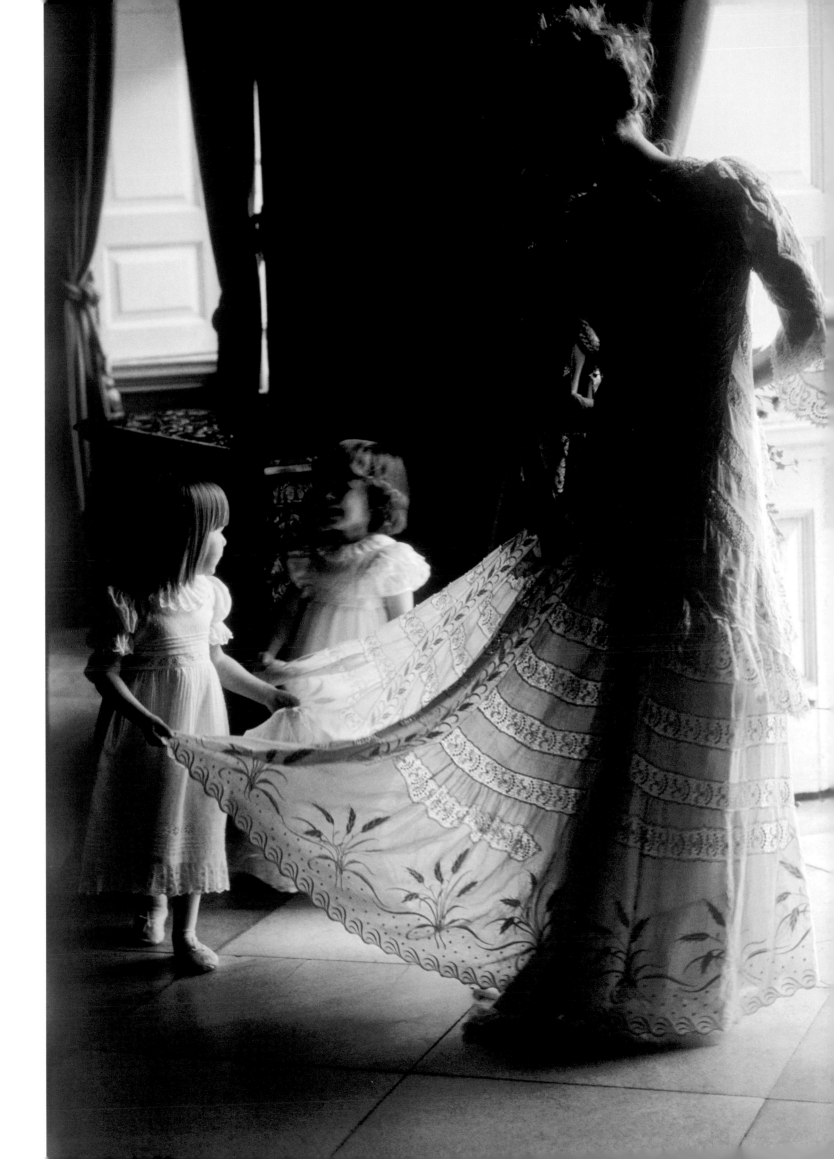

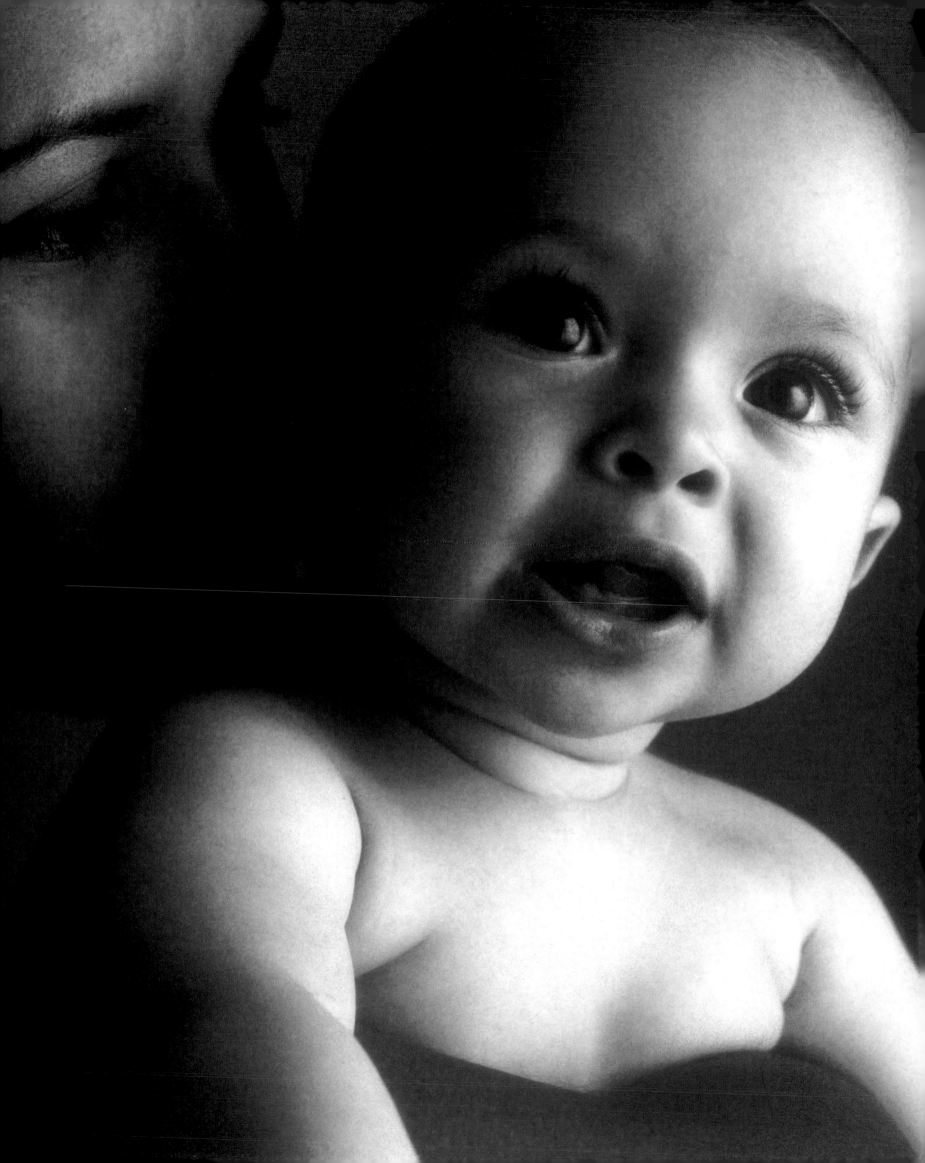

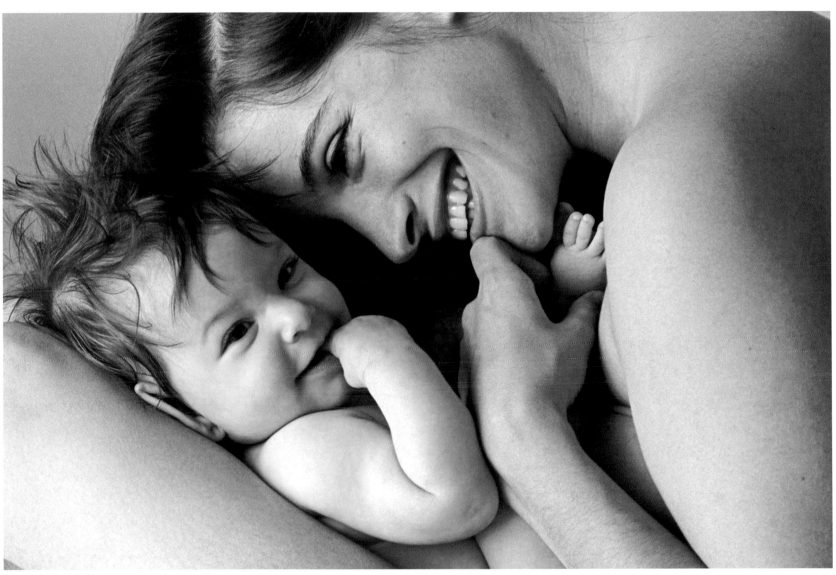

Above Rachel de Thame and her daughter, Lauren,
for a Cow & Gate advertising campaign, 1987

Left Emerald and her mother, Cecily,
for Cow & Gate, 1994

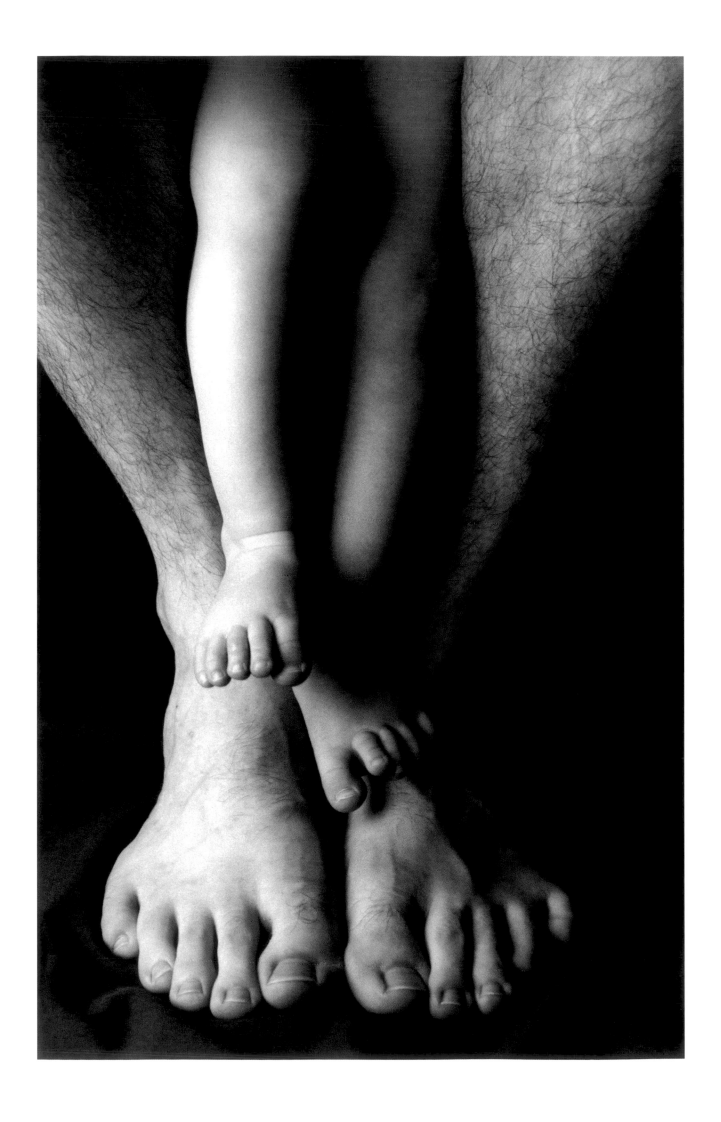

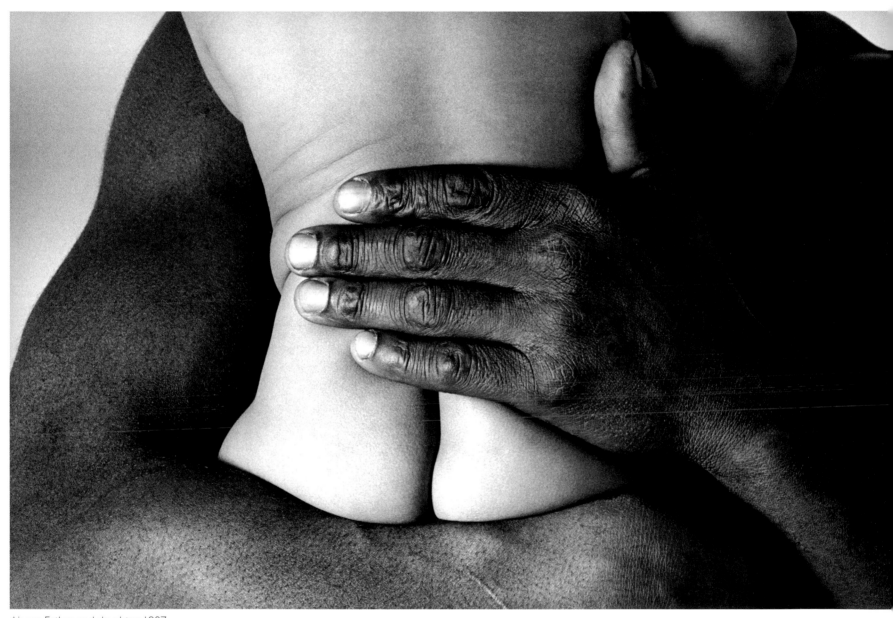

Above **Father and daughter**, 1987
This shot was commissioned by Terence Conran for the back cover of the
Mothercare catalogue.

Left **Father and son for the Mama Toto campaign for Body Shop**, 1990
I made a studio in the crèche at the Body Shop factory in Littlehampton
and used the people who worked in the factory, with their children, as my
models. The brief was skin tones and relationships and no recognizable faces.

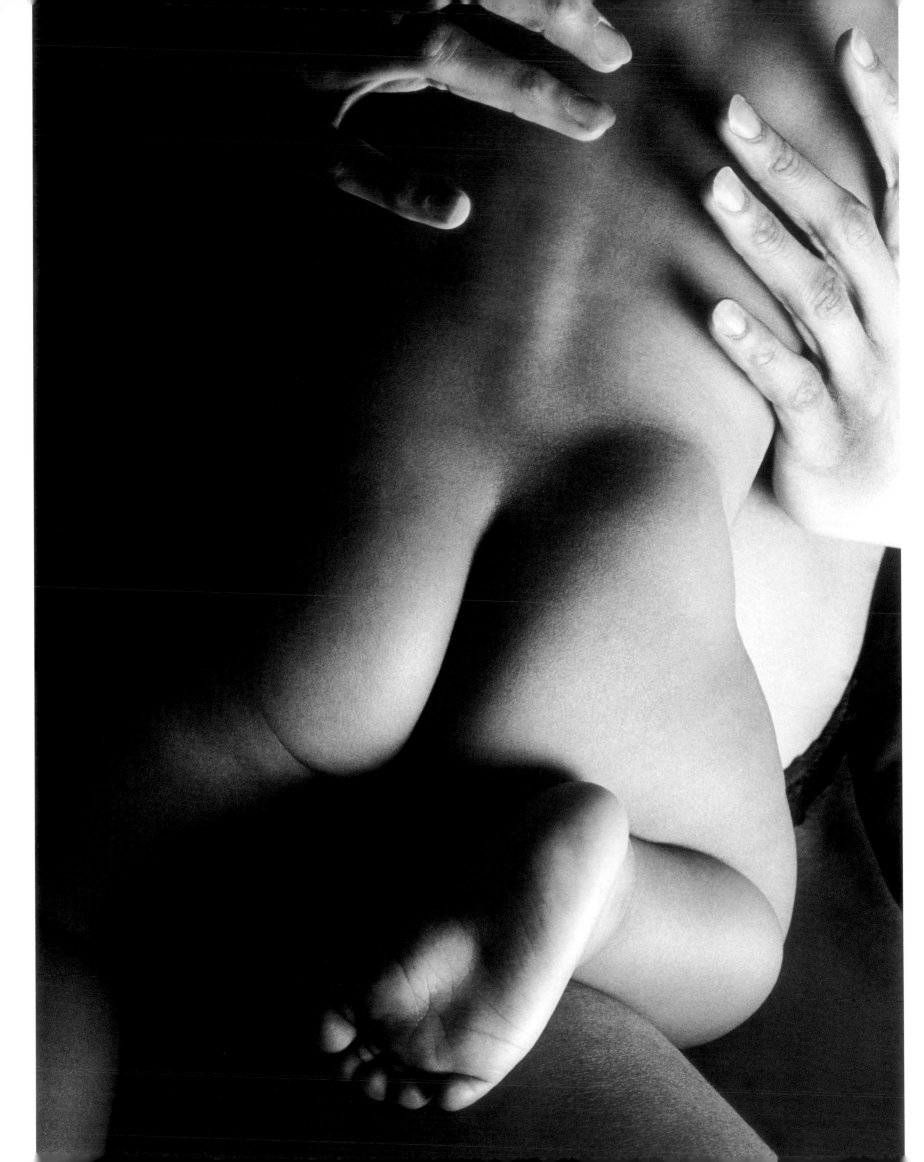

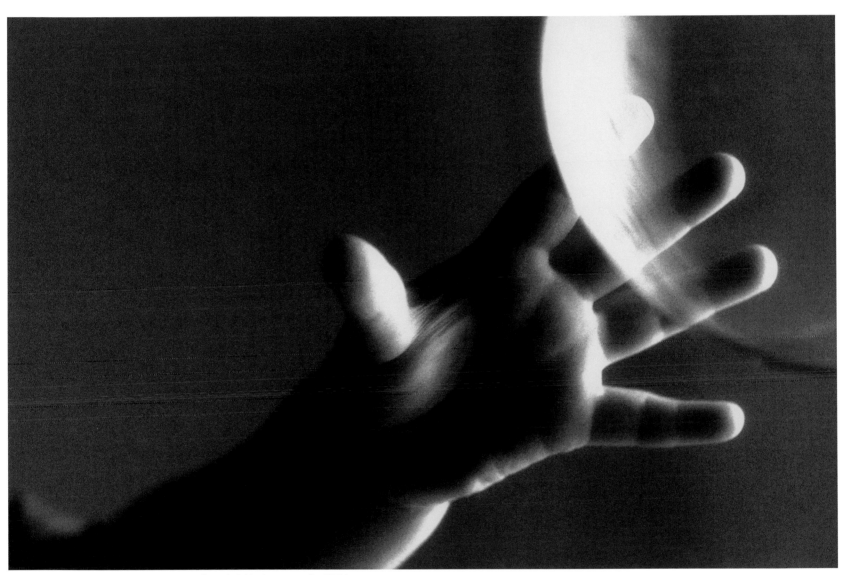

Above My niece Stroma's hand reaching for a bubble, in my studio, 1994

Left Che and his mother, Vanessa, in my studio, for the Body Shop campaign, 1990

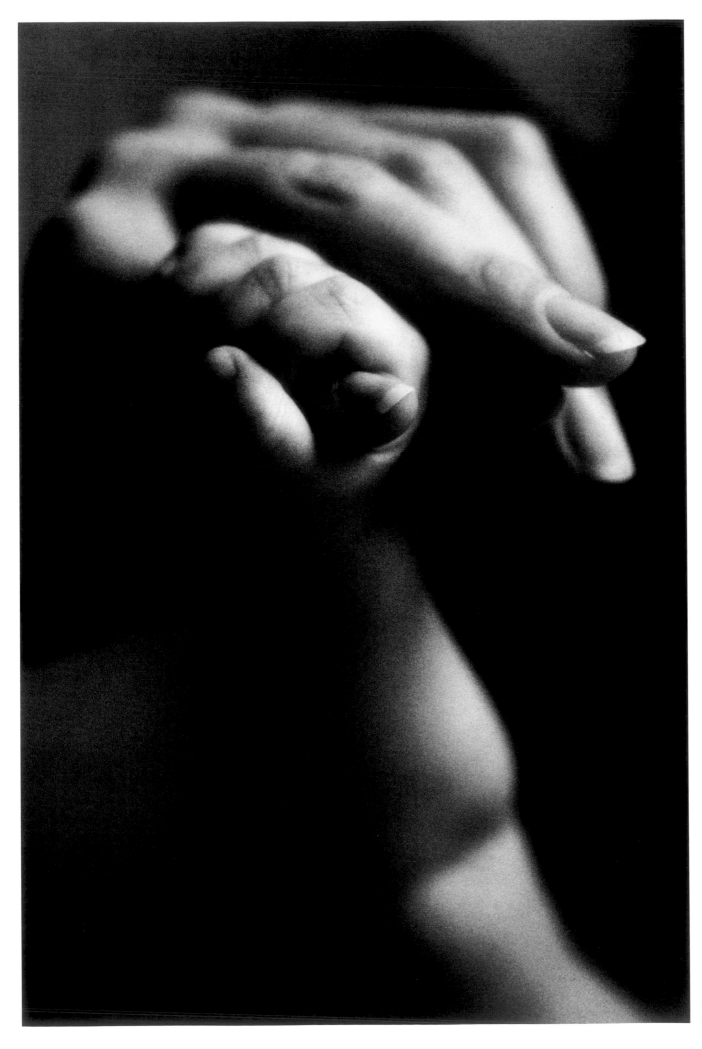

Gem and his mother, Jade,
holding hands in my studio, 1994

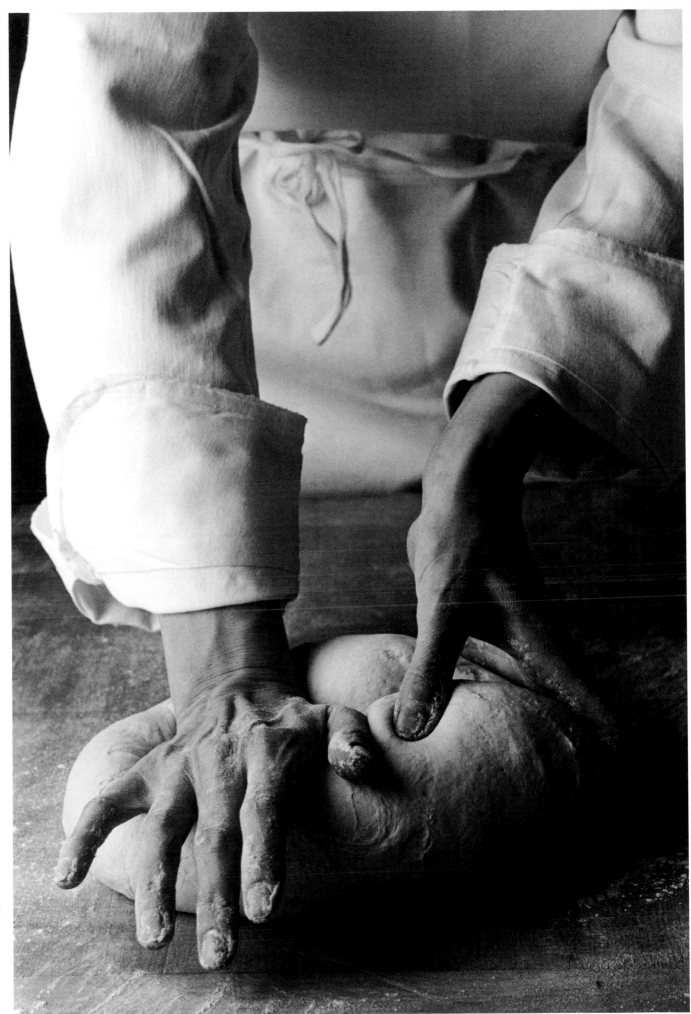

Sally Clarke, 1992
One of a series on working hands for *Woman's Journal*. Chef Sally Clarke arrived in my studio in her whites with a wooden board, a big lump of dough and some flour. I gave her a table to put it all on and she got to work. She was up and away within twenty minutes, having kneaded her dough to perfection.

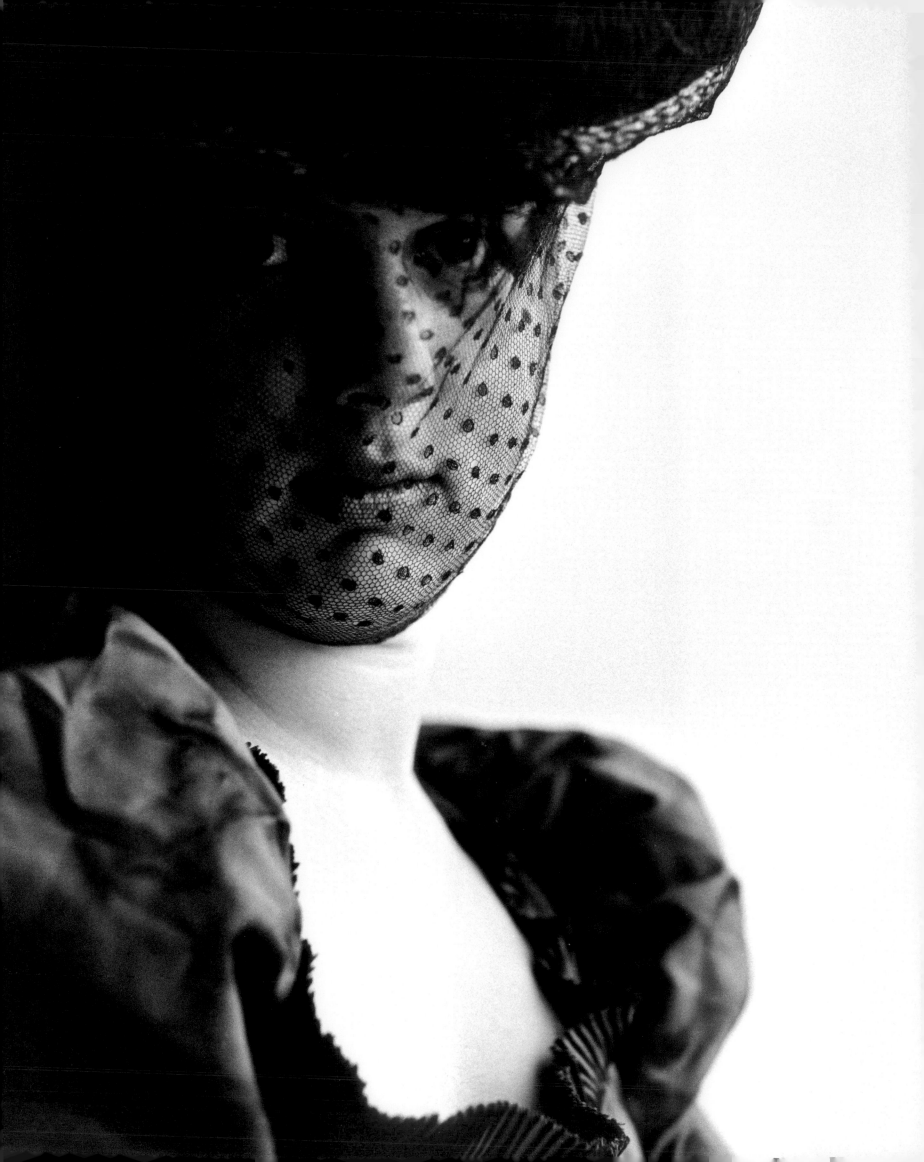

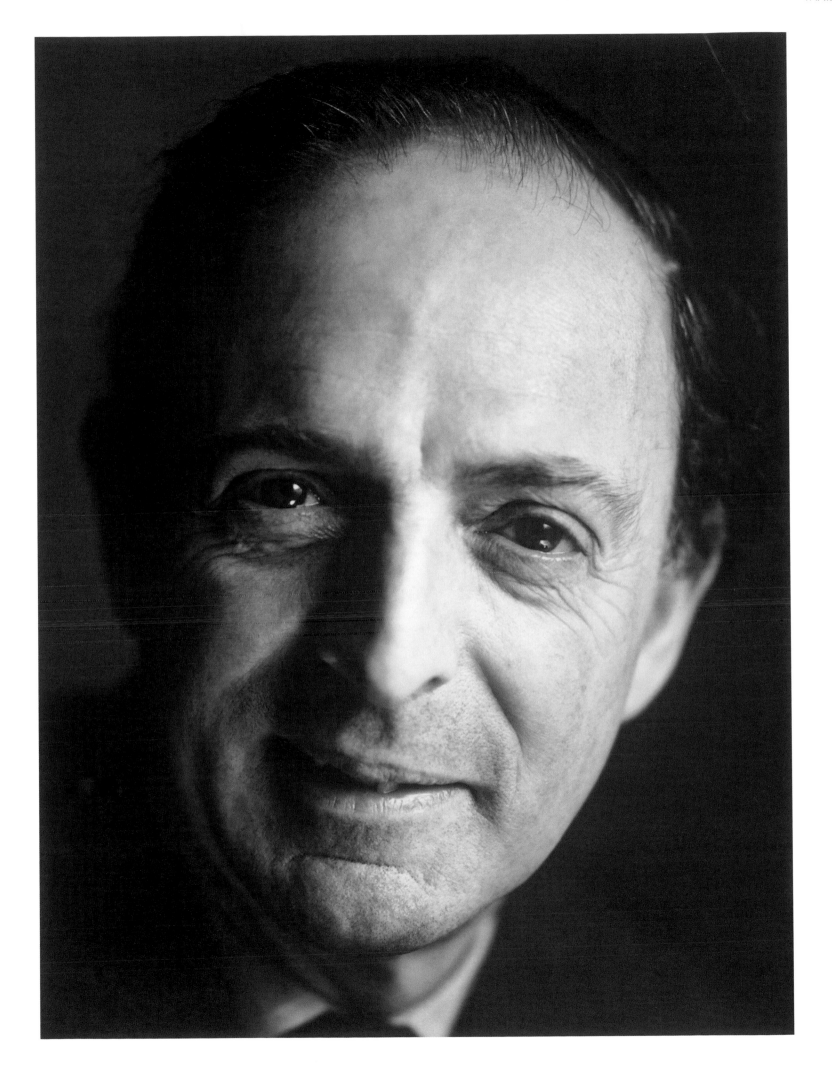

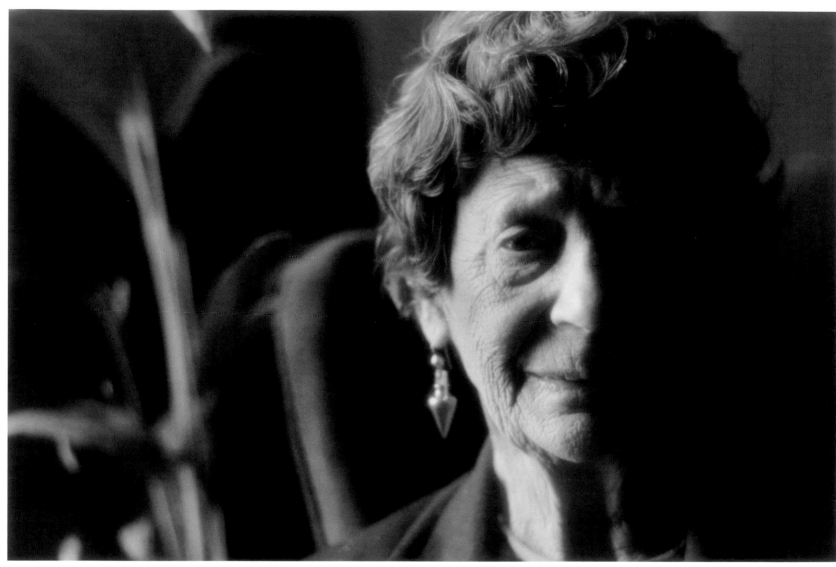

Above My grandmother, Gwendolen Herbert, just about to play chess, in her home on Hammersmith Terrace in the late 1970s

Right My sister Jenny West in the family home on Chiswick Mall, 1956/7 She is wearing the dress that our mother had worn to be presented to Queen Mary when she was eighteen. The dress had been relegated to the dressing-up box.

Page 146 My sister Olivia Lousada in the family home, 1956/7 Wearing an evening dress, hat and veil belonging to our mother

Page 147 Anthony Lousada in my Chelsea studio, 1970 One of the few portraits I took of my father

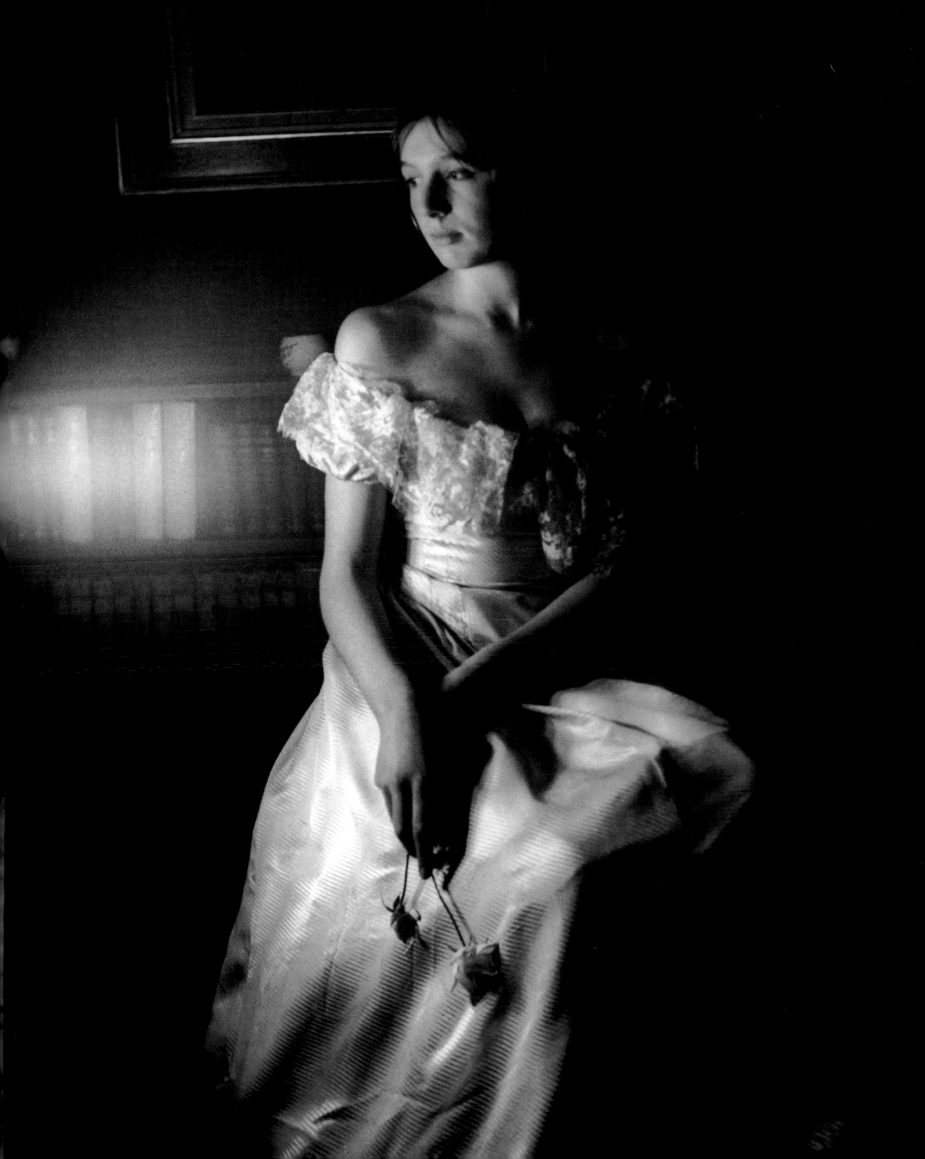

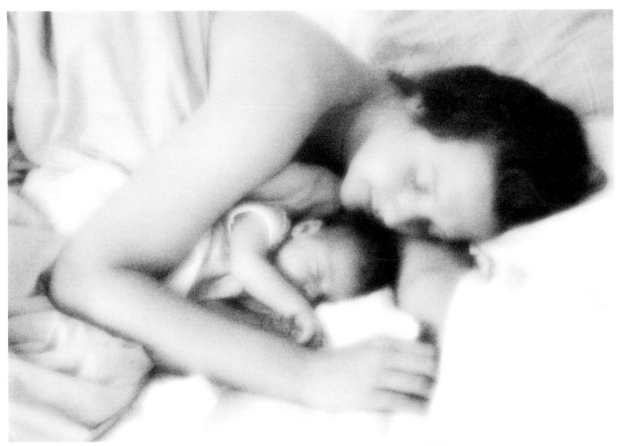

Above My daughter, Polly Richards, with her first child, Molly Lloyd, one day old, at home, 2001

Right My son, Sam Richards, aged two, at Andrews Farm, my mother's house in Hampshire, 1968

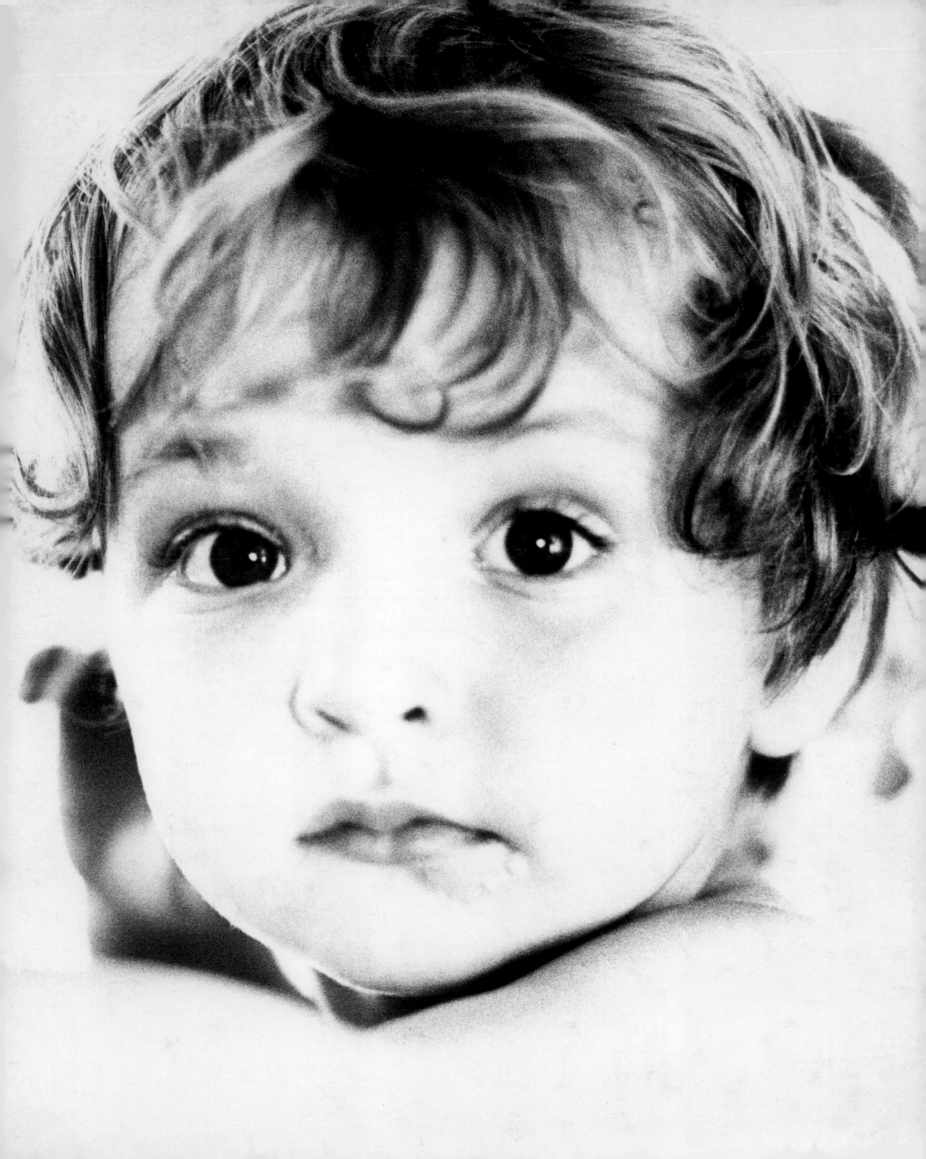

ACKNOWLEDGEMENTS

Getting to this moment in life where one bares one's soul and begins to look at past successes and failures is extremely daunting. It is strangely exciting and stimulating when you find long-forgotten emotional photographic moments that flood back in such a strong way. You remember those people who became part of your working life and without whose encouragement you would probably not have gone forward to keep learning and trying new things.

If it wasn't for my family and friends, especially my children, Sam and Polly, and their families, who have given me the most wonderful support of love, care and interest in what I have been doing since their Dad died, I doubt I would have got this far.

Then there are the critics, of whom the strictest is my fantastic agent and friend Bo Steer, backed up by his lovely wife, Elaine. His crits and guidance and passion for good photographs have been a delight (not always) to work with over the last fifteen years. He has encouraged, bullied and stood by me when I made dangerous decisions and has made all things possible. He and my friend and former agent Susan Griggs have spent many competitive hours looking at my experimental new work and as they are both such good editors I have had excellent advice that has helped me to keep going forwards.

A huge thank you to the editors and art directors who have given me so much work over the years and especially to all those at Frances Lincoln who have given me so many interesting and challenging books to work on; most of all to Anne Fraser, who not only gave me subjects to capture that I had never tried before but also became such a valued critic and friend. Special thanks, too, to Jo Christian, a deft no-nonsense editor who has been so enthusiastic about publishing my work, and to Becky Clarke, who seems to have endless patience when laying out pictures.

And then of course enormous thanks to Cathy Courtney, who wrote the essay at the beginning of this book and with whom I have discovered so much about my life and what shaped it through doing recordings for the British Library Sound Archive. Quite a revelation!

I have been lucky enough for many years to work with great technicians who are without doubt the backbone of my career: my film printer/processors, Terry and Bob at Grade One, who worked so hard to make the prints I wanted from negatives that weren't always up to scratch, Howard Woodruff, from Flash Photodigital, Lyn Driscoll, who processed many of my colour transparencies, Ben Boswell and Nobby Clark who, wherever they were, loaned me the latest photographic equipment to experiment with. And above all in the last few years all my friends at Fixation, without whom I would never have progressed to digital.

And, lastly, the two people who were the most important influences, who guided me through so much, and who sadly disappeared out of my life within a year of each other: my husband and friend, Brian Richards, with whom I travelled and talked and looked and met so many different interesting people and places; and my mother, Jocelyn Herbert, who taught me how to look and work in a different way, which even now is opening a whole new set of ideas that I am looking forward to working on.

I thank you all for everything you have helped me achieve. This is real team effort.

Cathy Courtney is grateful to Felicity Clark, David and Ilse Gray, Lottie Johansson and Willie Landels for sharing their accounts of working with Sandra Lousada.

The text for the extended captions and quotations within the introductory essay have been edited from Sandra Lousada's recording made with Cathy Courtney for *An Oral History of British Photography*, British Library Sound Archive, catalogue reference C459/198.

The British Library Sound Archive has an active fieldwork recording programme, and has been recording life stories with British photographers for the Oral History of British Photography collection since 1990. All recordings that are open for listening can be accessed at the British Library: go to www.bl.uk and search for 'Oral History of British Photography'. Academic users can also access selected interviews from this collection at http://sounds.bl.uk/

Magazine credits

Country Living: 12; *Daily Mirror*: 81; *Fashion*: 118, 119; *Flair*: 110 (top); *Harpers & Queen*: 136, 137; *Mademoiselle*: 50, 80; *Nova*: 114, 115, 116, 117; *Queen*: 2, 124, 125, 129, 131, 132, 133, 134 (left), 135; *Show Business Illustrated*: 21; *Sunday Times*: 54–5, 56, 57; *Tatler*: 22–3, 68, 69, 70, 71, 73, 86, 87, 96, 100, 101, 102, 103, 120, 121, 122; *TV Times*: 126, 127; *Vogue*: 134 (right); *Woman's Journal*: 83, 110 (bottom), 111, 145

Photograph page 2: Fashion shoot for *Queen*, 1962

Frances Lincoln Ltd
4 Torriano Mews
Torriano Avenue
London NW5 2RZ
www.franceslincoln.com

Public Faces Private Places
Portraits of Artists 1956–2008
Copyright © Frances Lincoln 2009
Photographs copyright © Sandra Lousada 2009
Introduction copyright © Cathy Courtney 2009

First Frances Lincoln edition: 2009

Sandra Lousada has asserted her right to be identified as the author of this work in accordance with the Copyright, Designs and Patents Act 1988 (UK).

All rights reserved. No part of this publication may be reproduced, stored in a retrieval system or transmitted in any form, or by any means, electronic, mechanical, photocopying, recording or otherwise, without either permission in writing from the publisher or a licence permitting restricted copying. In the United Kingdom such licences are issued by the Copyright Licensing Agency, Saffron House, 6–10 Kirby Street, London EC1N 8TS.

A catalogue record for this book is available from the British Library.

ISBN 978-0-7112-3049-1

Designed by Becky Clarke

Printed and bound in China

9 8 7 6 5 4 3 2 1